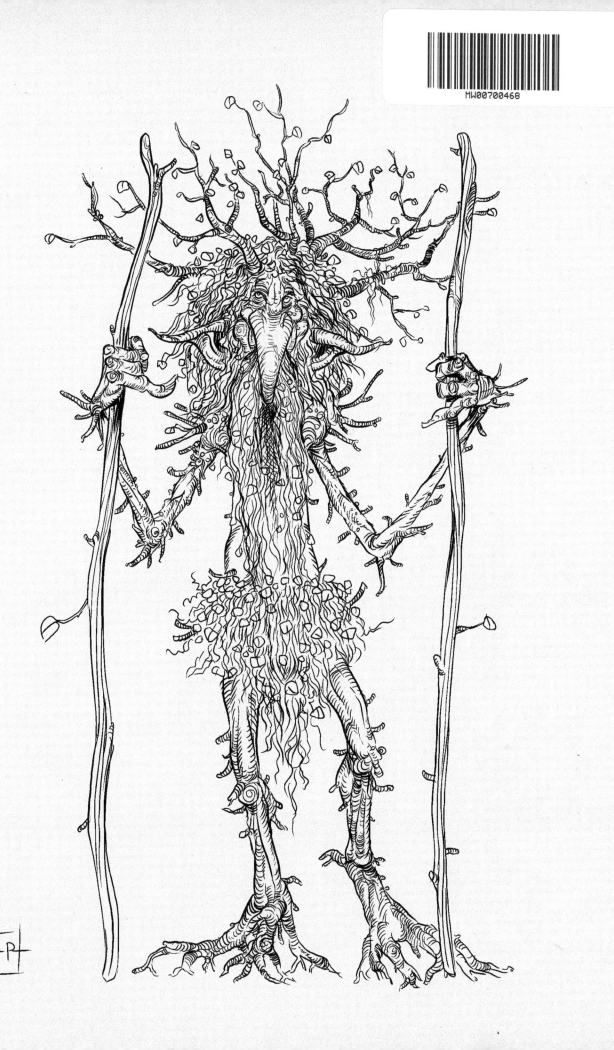

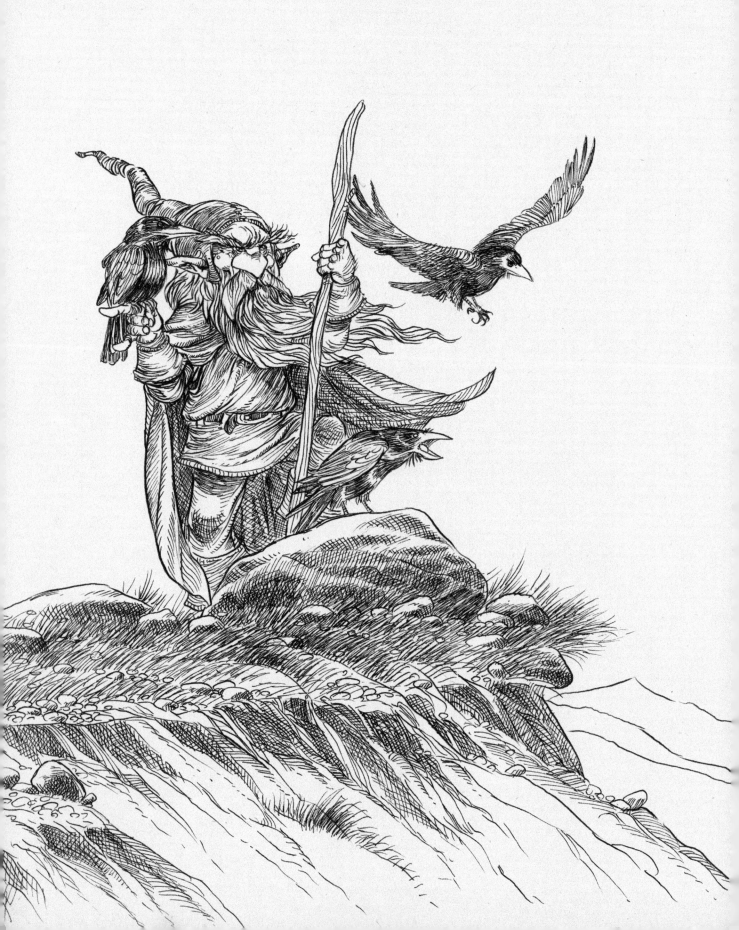

THE Fantasy ARTROOM

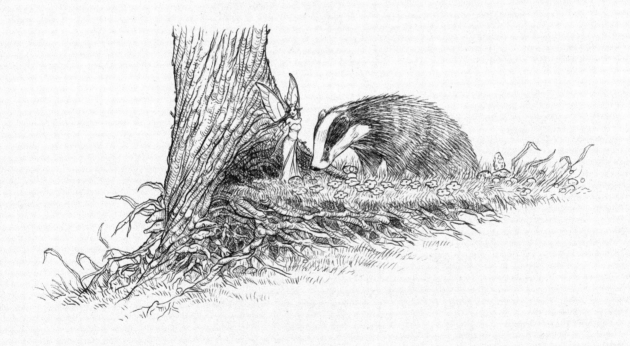

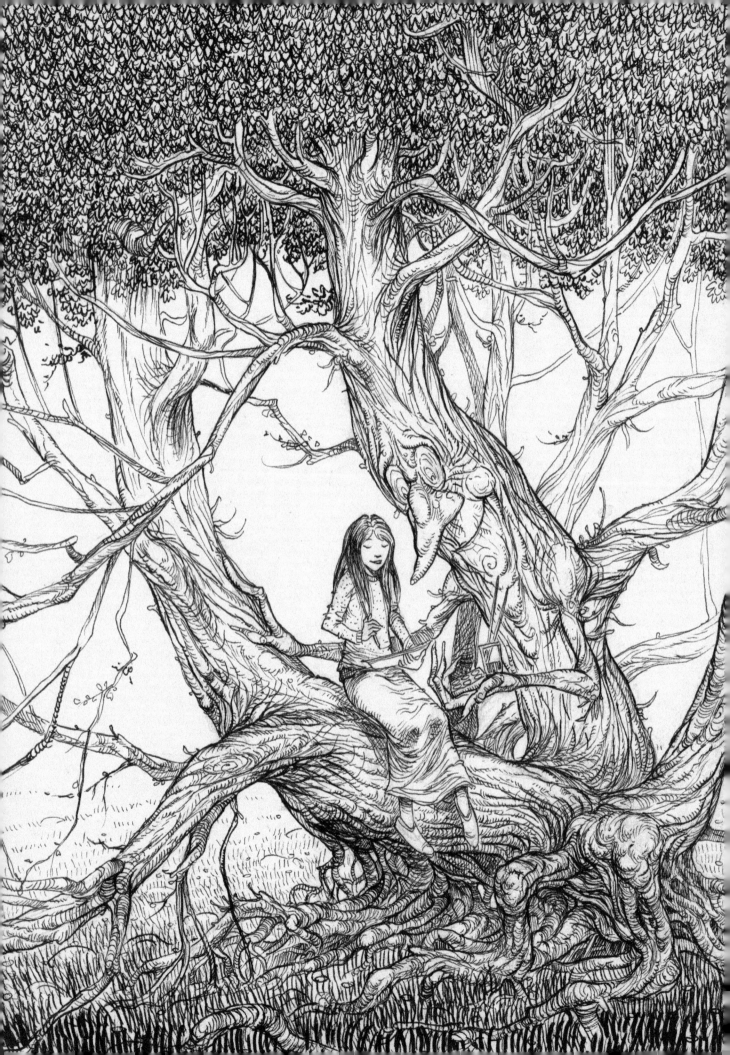

THE FANTASY ARTROOM

BOOK ONE
Detail and Whimsy

An all-in-one travelling companion into the world of fantasy art

AARON POCOCK

DOVER PUBLICATIONS, INC.
Mineola, New York

CREDITS

Firstly, to my long suffering wife Katrina
and our beautiful children, Niall and Finn—
For putting up with me, my 'Arty' temperament,
my music blaring and the irregular hours.

For Mum, Dad, Nan, and Ricky.

Thanks also to all the followers, backers and well-wishers for
helping this book come to life, especially to: Erin Clark,
Thorun Ledger, Travis, Mathieu, Justin, Sonja, Ian, Sam,
Julia, and Juan for your sage advice.

To David Wyatt, for helping me back onto the path...

To Charles Vess, for allowing me the use of 'that' letter.

To Alexandra, Ida, Lindsey, Freyia, Elandria, and Janna for being such
beautiful and generous models, you make my job a lot easier.

To Phish and Marillion, I played you endlessly whilst working on this...

And finally, to Mother Nature, for the endless
inspiration; some of us still love you...

—————◆—————

Bibliographical Note

The Fantasy Artroom: Book One, Detail & Whimsy, first published by Dover Publications, Inc.,
in 2016, is a republication of the work published by The Fantasy Artroom in 2014.

Library of Congress Cataloging-in-Publication Data

Pocock, Aaron, author, illustrator.
The fantasy artroom. Book one, Detail and whimsy / Aaron Pocock.
 p. cm.
 ISBN-13: 978-0-486-80124-7 (pbk.)
 ISBN-10: 0-486-80124-1 (pbk.)
 1. Fantasy in art. 2. Art—Technique. I. Title. II. Title: Detail and whimsy.
N8217.F28P63 2015
743'.87—dc23

 2015029885

Manufactured in the United States
80124103 2019
www.doverpublications.com

TABLE OF CONTENTS

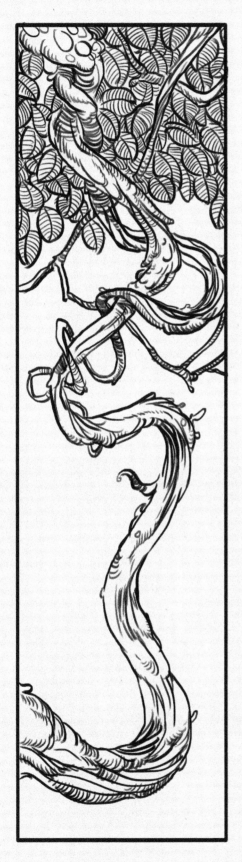

ABOUT THE AUTHOR

Aaron Pocock was born in a large town in the south of England and has been living in Brisbane, Australia, since November 2000.

Art (particularly Fantasy Art) has been a lifelong passion, and it eventually became his day job in 2007. Having freelanced semi-professionally since 1991, Aaron has never looked back.

In 2011, Aaron was delighted to be chosen to illustrate the Australia Post Commemorative Stamp Set 'Mythical Creatures' for Australia's **Children's Book Week**, a career highlight so far; the set was also produced in a 3D capacity (a first for Australia).

Aaron has illustrated and continues to illustrate children's books, book covers, and CD sleeves. He works in a fine art capacity as time allows.

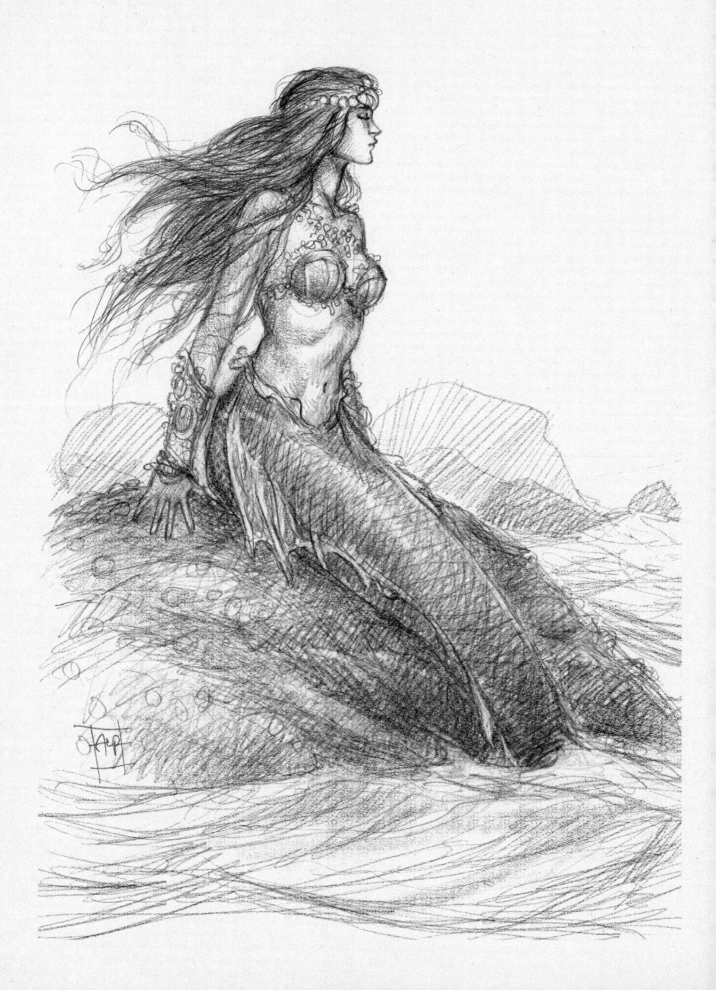

AUTHOR'S NOTE

*I often have people asking me how I manage to stay so productive
The answer might surprise you. I see each and every piece of art I produce,
from a sketch to a full-blown finished painting, as a story that wants to be
told; I'm simply the way it makes itself into the world. I don't become overly
attached to them, unless I have a sentimental reason for doing so. Putting
a little distance between you and the work might just help your productivity.
Being overly precious about what you do can put unnecessary barriers in
your way. Step aside, let it flow . . .*

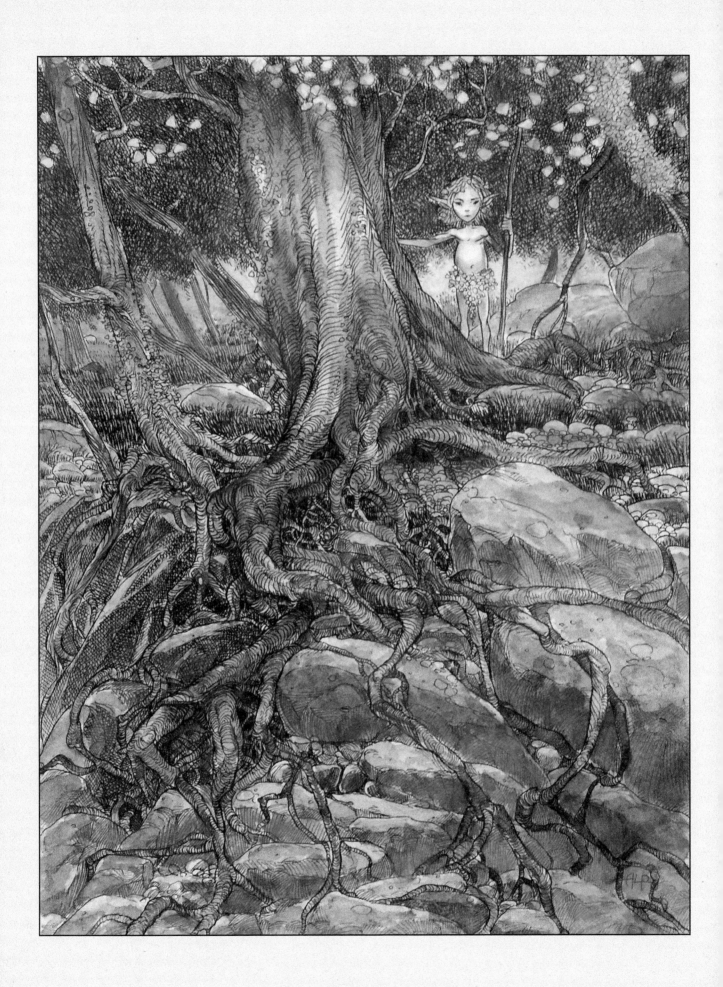

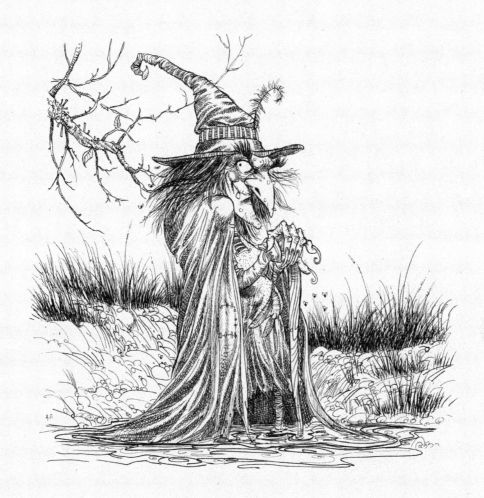

"Ready, Dearies? . . ."

THE Fantasy ARTROOM

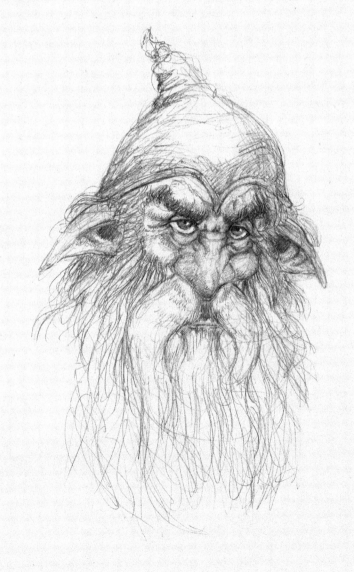

SKETCHING AND DRAWING

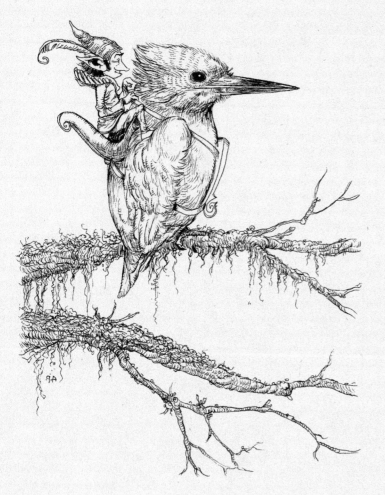

This is probably the most important chapter of all. This is where it all starts, where your art stands or falls.
Good drawing is the foundation upon which ALL of your art is built.

So, what is the difference between a sketch and a drawing? Essentially they're both the same thing, but they both have different reasons for being:

SKETCHING
is most often a quick gestural drawing used to warm up the hand and mind, work out a composition, or to hone elements within the composition.

THE FINISHED DRAWING
is far more than a sketch. It's taking everything you've worked out and creating an end product for a particular purpose. It usually involves more concentration and precision when it comes to the actual rendering.

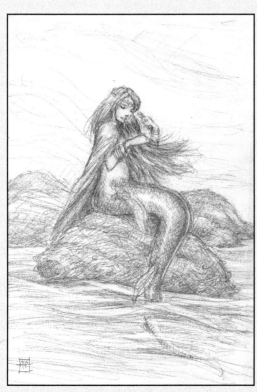

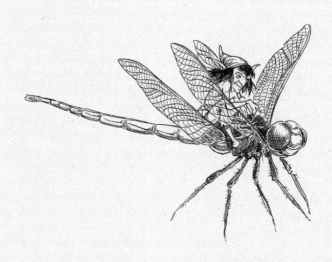

WHAT YOU'LL NEED

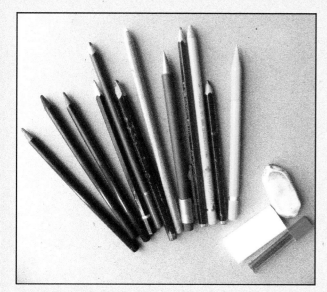
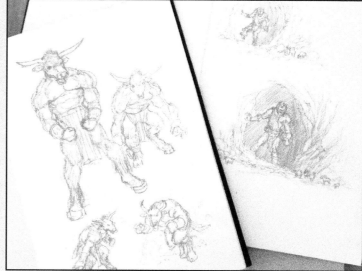

PENCILS

A good selection of pencils for different applications is a must. I find **solid graphite pencils** are lovely for filling large areas, and they're capable of making thin strokes when sharpened.

Standard wood encased pencils. My favourite grades are HB, 2B and 4B (HB being the hardest and 4B being the softest).

Mechanical Pencils with a 0.5 lead. Fabulous for making tiny, feathery lines in detailed work. I also use them for precise sketching. I've been using these for years and thoroughly recommend them.

It's also worth trying **Carpenter's pencils**. The wide lead is fabulous for making thick marks and great for rapidly shading large areas; also brilliant for quick sketching, when details aren't necessary.

PAPER

Here's what I use. Try them all out and have a play; see what works for you.

Photocopy paper is great for general sketching work and for finished line art. It's inexpensive, too. Go for the good quality stuff, though.

Illustration board is very smooth—not so great for sketching but ideal for detailed pen and ink work. It's more expensive than cartridge paper.

Rough watercolour paper is fabulous for quick, loose sketches.

Hot pressed watercolour paper is ideal for gallery-quality drawings, and takes ink well, too.

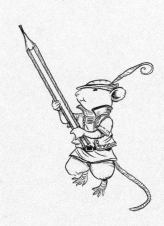

TOP TIPS
(And/Or, Things I wish I'd known Sooner)

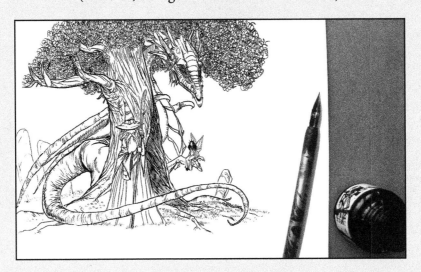

* It's important to spend time 'looking.' Keep your eyes well and truly open; you'll be surprised what the mind takes in.

* Visualise! Before you begin a new piece of work, spend a minute or so 'seeing' the image in your mind in as much detail as you can muster.

* If you want to be an artist, a musician, or a brain surgeon, you have to *want* to be one. It's all down to the effort you put in. Half-hearted attempts do not guarantee results.

* Strive to put 'soul' into your work, dig deeper, don't rely solely upon technique; find YOUR unique voice, what makes you, you.

* Artist blocks are imaginary, plain and simple. If you find yourself 'down-in-the-dumps,' the root cause is sure to be something other than your art. If you go around saying, 'I have a block,' as sure as eggs is eggs, you'll create one. The masterpiece you're working on isn't happening? That's OK, go off and sketch something! Loosen up and come back when you're feeling more refreshed.

* Nobody, understand... *NOBODY* is a) 'Blessed' or b) 'Gifted' when it comes to art. Sure, people may have been born a certain type of person, more inclined to lean a certain way maybe. Finding ways to express yourself is a skill you have to learn, and being an artist is something you need to spend time working at. It doesn't just happen, Sit and learn, study all you can, then study some more—*you can never learn too much.*

* Practice! Practice! It's important to keep at it. There are no shortcuts to be had, it's *all* about mental dexterity, soul AND technique.

* Not happening with that medium you're using? Try another one!

* Sketch!!! In front of the telly, on that train, out in nature. It can only strengthen your work.

* Be confident. Can't do it yet? You will. Know this.

* Inject 'life' into your work. This can come from many sources, but it ultimately comes from your mind. Want to make that scene more interesting? More exciting? Vary the strokes, 'be' your character, add props that help the movement around the image, play with camera angles—Anything that'll put across what you're really trying to say.

* That blank sheet, there, in front of you.... is YOUR playground, anything goes!

*To keep your mind from stagnating or wandering whilst you work, I thoroughly recommend playing a selection of your favourite music. Music is a 'mood' thing. Choose appropriately, i.e.: meditative music for dreamy images, or good rock stuff for more 'aggressive' pieces. I have a massive music database and often find myself reaching for certain bands or albums to help me into the right mood.

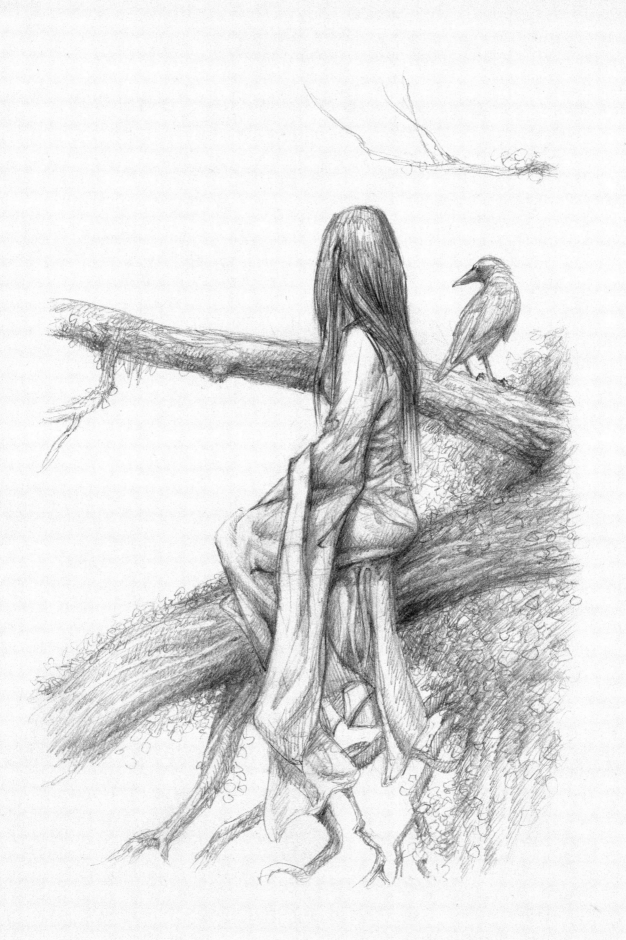

DRAWING—A THREE-STEP PROCESS

Simplify, simplify... I'll be saying that a lot throughout this book. It's my goal to show you just how easy things are when you break them down to their simplest form. Much of what I'll be teaching will rely on what I call a 'Three-Step Process.'

Here it is:

1) Think of the idea.
2) Visualise it.
3) Bring it to life.

When we get down to the actual drawing, there's another Three-Step Process, which you'll find easy to follow.

DRAWING USING THE THREE-STEP PROCESS

1) Rough in the basic shape.
2) Gesture secondary elements.
3) Add details.

It's that simple! Remember, I'm here to show you how easy it is; you will be challenged from time to time, but I guarantee that if you follow these simple formulas, you'll make a great amount of progress in a short amount of time.

What are you waiting for? Grab your pencil and some paper!

Remember: Rome *wasn't* built in a day... But a good drawing can be!

THE IMPORTANCE OF SKETCHBOOKS

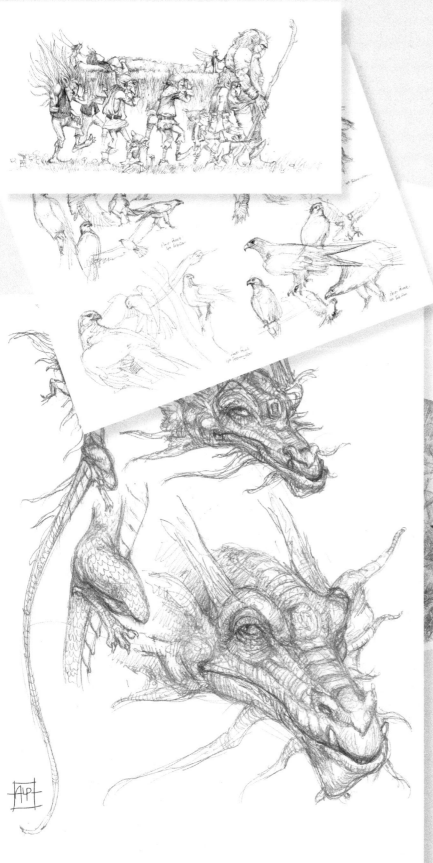

Sketchbooks are your playground. Anything goes! Develop, explore, work out those tricky areas of your drawings, learn how animals move.
In short:
sketch! sketch! sketch!

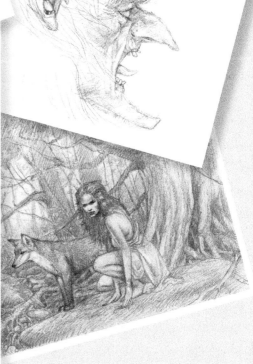

You'll be surprised at just how often sketches you made in that old sketchbook can inspire new works. Sketchbooks are also a fabulous way of measuring your artistic progress—which is very important.

I take great delight in looking over my old work as it shows just how much I've improved, AND what I still need to work on.

REFERENCE PHOTOS

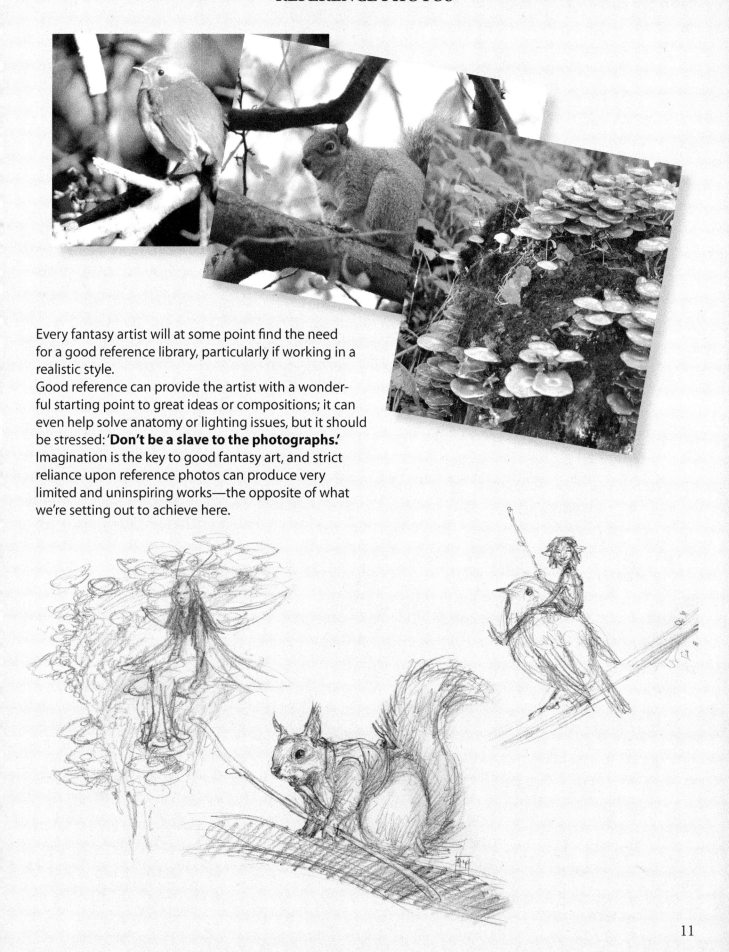

Every fantasy artist will at some point find the need for a good reference library, particularly if working in a realistic style.

Good reference can provide the artist with a wonderful starting point to great ideas or compositions; it can even help solve anatomy or lighting issues, but it should be stressed: '**Don't be a slave to the photographs.**' Imagination is the key to good fantasy art, and strict reliance upon reference photos can produce very limited and uninspiring works—the opposite of what we're setting out to achieve here.

FROM A LIZARD TO A DRAGON

The following example should hopefully give you a good idea as to the importance of keeping a database of reference photos. I took this shot (along with many others) on a recent trip to a rainforest with my son. It's a good thing to always have a camera handy; you never know when the perfect photo opportunity will present itself!

So, what we're going to look at with this exercise is how to use a photograph from our files and turn it into a fantasy illustration.

Well, that's the plan.

Let's have a go, shall we?

Firstly, I recommend acquainting yourself with the creature. So a quick sketch or two to get to know it should help us to warp its features from a Lizard to a Dragon.

Also, it might be worth mentioning that we could just as easily have used a crocodile or another type of lizard.

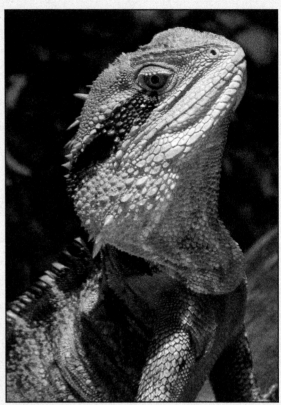

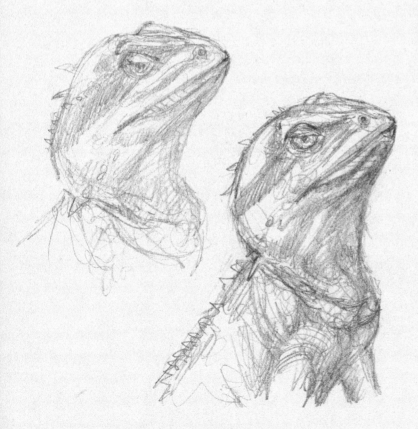

So, now we've made a couple of sketches. Not worrying too much about a likeness here, and rather than working on a portrait of the lizard, we're more interested in bottling up some of that 'reptile' vibe, to carry it over into our dragon drawing.

Having sketched it, I'm really excited about exaggerating the curve of its neck and the way its chest is puffed out proudly. At this point, I know exactly how I expect my dragon to look; the next part is to get that out onto paper.

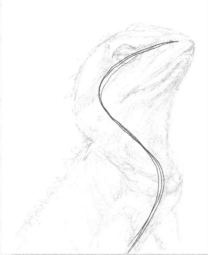

Here's what I'm talking about. The 'S' curve here is what I'm hoping to work with; I'll be exaggerating this a great deal. I still want to maintain that 'regal' bearing, but it needs to look like a dragon, not a lizard. How do we achieve that? The steps below should illustrate how I get from A to B.

So, this is what I came up with after a bit of a play with the designs: Four quite different-looking dragons based on the reference photo. Note the difference in width of the neck and the ear shapes. The face has stayed true to the photo; we've also kept that satisfying 'S'-shaped neck. Pick a favourite.

Mine's the last one.

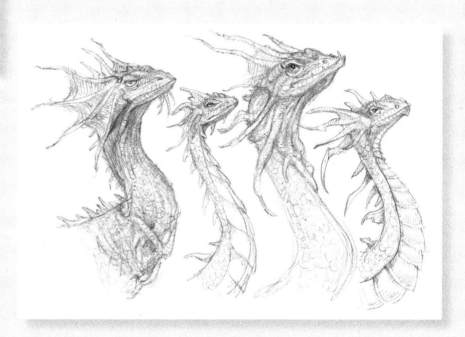

DRAWING DRAGONS

Here's how we get from A to B.

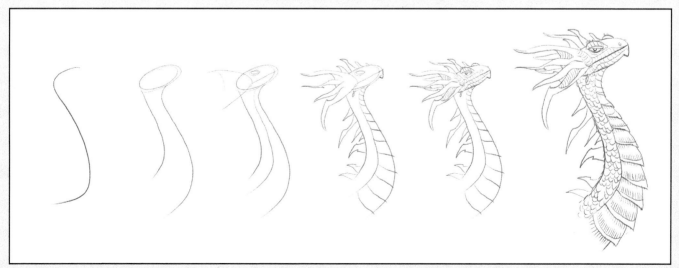

DRAWING TREES

Trees feature prominently in my art. I can't remember a time in my life when I wasn't in awe of these incredible beings.

Drawing trees is largely a process of only a few steps. Once you have these steps down pat, you'll be drawing them confidently and with gusto.

A tree can serve wonderfully as a backdrop in your compositions or, with a little imagination, as a character in its own right. Every tree has a story to tell; take advantage of this! Fantasy art is ALL about telling stories.

From slim, bendy trees that sway in the breeze to great, gnarly wizened old sentinels who stand for hundreds (even thousands) of years... Give them life and let them breathe on the page.

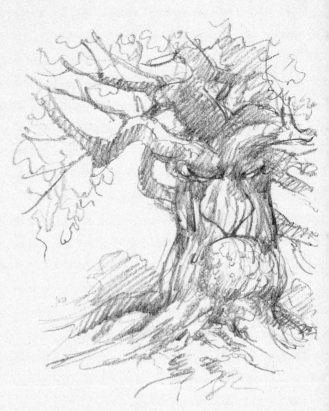

FOUR VERY SIMPLE STEPS

STEP 1
Begin by gesturing the direction and the angle you intend your tree to lean.

STEP 2
Add branches and roots. **KEEP IT SIMPLE FOR NOW.**

STEP 3
Gesture in more branches and roots. Loosely introduce areas of foliage.

STEP 4
Move ahead with the details.

NOTE
Details *ALWAYS* come last.

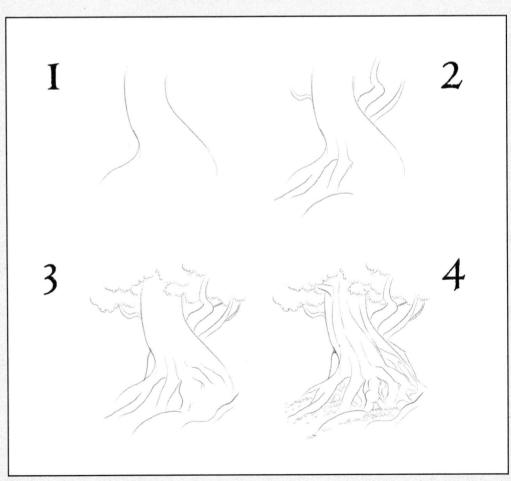

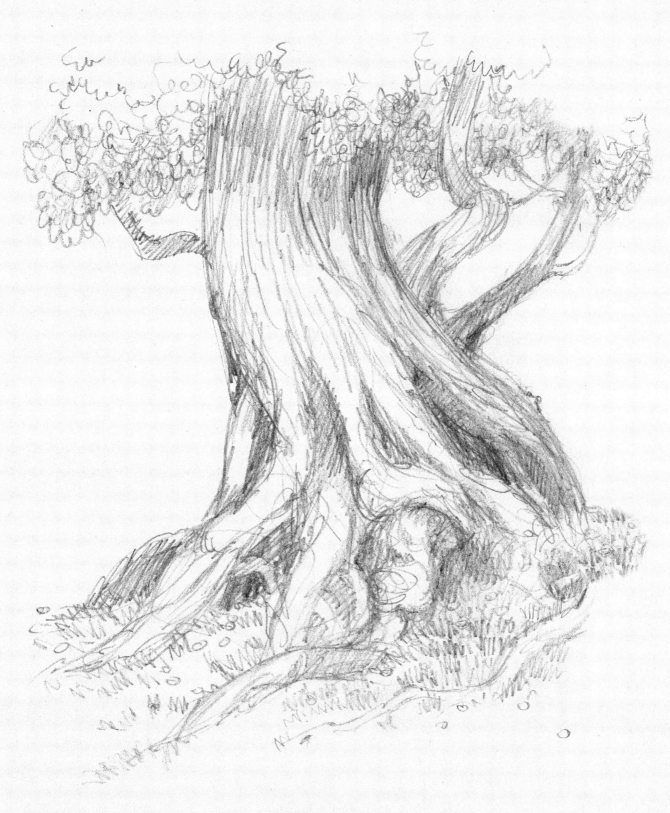

The Finished Sketch

Be sure to pay attention to the way you 'ground' your tree. A large tree like this should give the impression of being rooted in the earth—solid, able to stand against the elements. A tree such as this would surely have a thousand tales to tell; its strength is never in question.

TREE TYPES

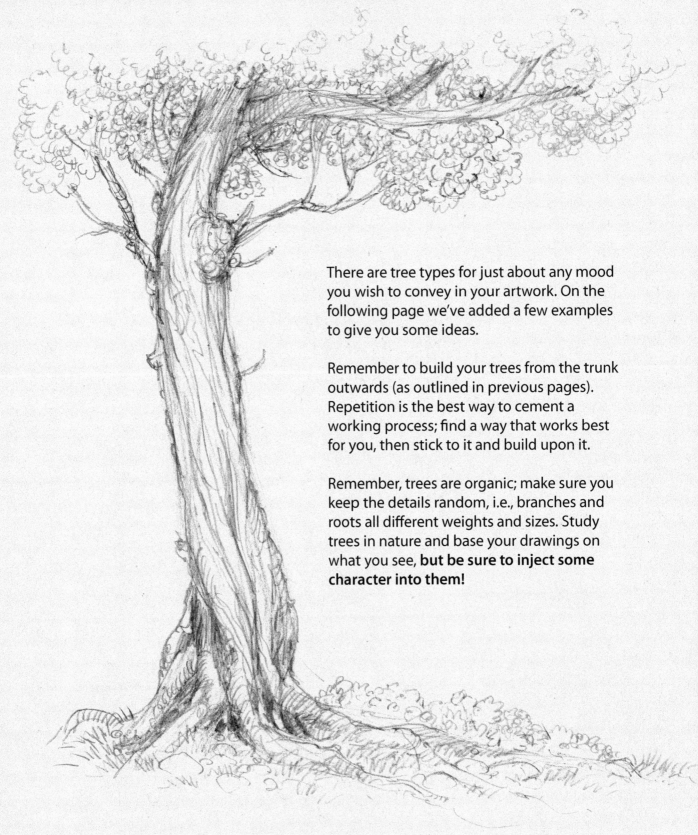

There are tree types for just about any mood you wish to convey in your artwork. On the following page we've added a few examples to give you some ideas.

Remember to build your trees from the trunk outwards (as outlined in previous pages). Repetition is the best way to cement a working process; find a way that works best for you, then stick to it and build upon it.

Remember, trees are organic; make sure you keep the details random, i.e., branches and roots all different weights and sizes. Study trees in nature and base your drawings on what you see, **but be sure to inject some character into them!**

COMPOSITIONAL DEVICES

See how the tree above surrounds the text? Trees can be used effectively to frame important elements within your images—for example, imagine a castle in place of the text, or a hero, or heroine.

BY THE WATERSIDE

This is the kind of tree you'd find by the water's edge. The limbs are strong and grow outwards and upwards. Strong roots grow to help stabilise the tree as it grips into the moist soil. These trees are great fun to draw as long as you've studied how they grow.

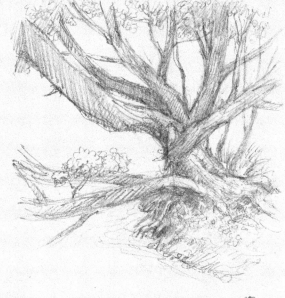

SPOOKY

A spooky tree, devoid of leaves and feeling very sorry for itself. The limbs hang downwards, giving a melancholy feeling. It has also been manipulated to give a vague humanoid shape, and a subtle hint of a face adds to the experience. This guy has 'issues'.

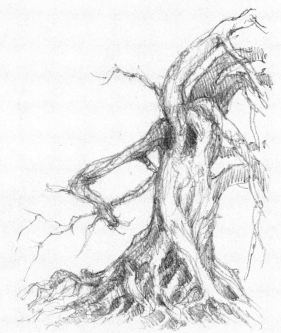

VERSATILE FANTASY TREE

This tree belongs in just about any fantasy setting. Varied limbs and a good collection of roots would ensure it was happy in anything from an Elven forest to a spooky wood.

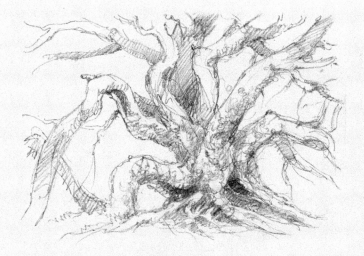

DRAWING FOLIAGE

Here's a good example of different ways to draw foliage within a single illustration. Note how the details of the leaves are silhouetted in the background and become more detailed as they reach the foreground. It's best to choose the appropriate strokes early on.

Remember, good planning reaps good results!

A HANDFUL OF WAYS TO DRAW FOLIAGE

Even if you take a stylised approach to drawing, the marks you make to convey foliage will keep your viewers interested.

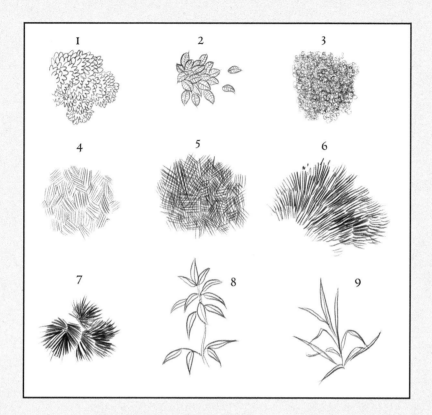

fig. 1 This is a favourite of mine. A good multi-purpose gestural stroke. Easy to lay down over large areas and can be used in background and middle-ground sections of a drawing.

fig. 2 (See illustration.) Another effective way to convey groups of leaves. Definitely for mid and foreground subjects. You'd drive yourself nuts drawing millions of little leaves in the background.

fig. 3 Another favourite. Great for backgrounds with no heavy blacks present.

fig. 4 A classic multi-purpose way to render darks. This is a little more stylised and the image should support marks such as these.

fig. 5 Cross-hatching—One of the most used area fillers in the whole of pen and ink illustration land.

fig. 6 Directional strokes here. Another effective line style, great for backgrounds and grassy areas.

fig. 7 Definitely one for spiky, long foliage.

fig. 8 Simple marks to convey leaf shapes. Also great for cartoon or comic-style artwork.

fig 9 (Handled much the same way as fig. 8) Good for long foreground grass subjects or flowers.

THE IMPORTANCE OF ANIMALS IN FANTASY ART

What *IS* a dragon? Some would argue that it's an over-sized lizard, with wings of a bat. What about a Minotaur? Yes, it's a rather large man with the head of a bull. Could you draw Medusa without knowing how to draw a snake? Could you draw a mermaid without being able to visualise and render a fish tail?

These next few pages will show you just how important it is that you get some experience with drawing animals if you're to progress as a fantasy artist.

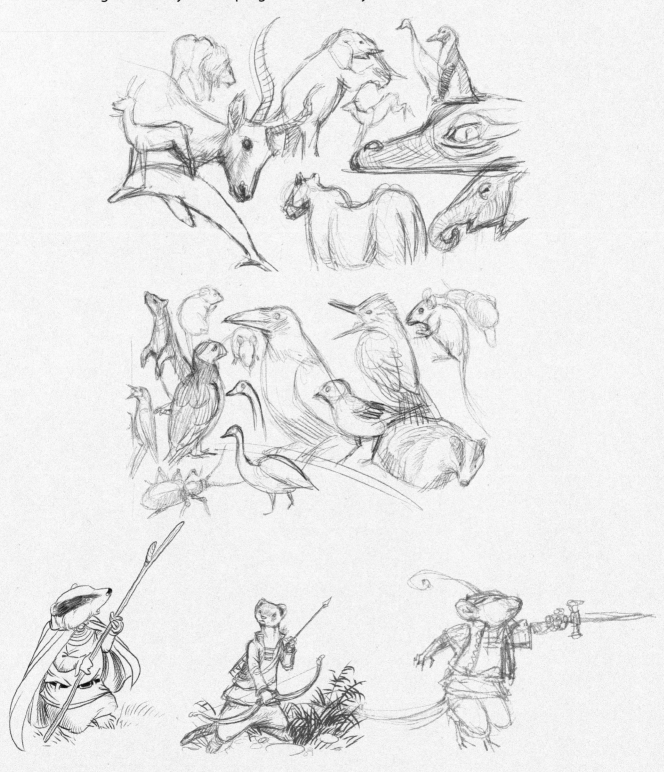

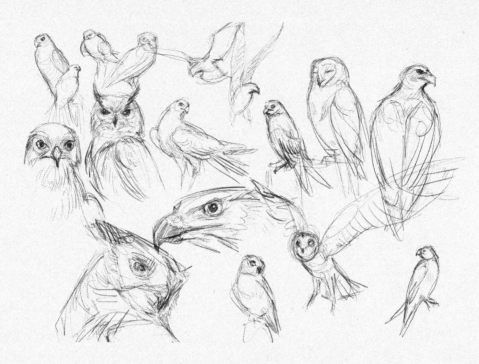

The examples above (and opposite) are sketches from my sketchbooks. I have page after page of drawings like these; not only are they useful as warming-up drawings, they're also perfect for understanding animal anatomy. Without the knowledge gained from these pages, the illustrations (see below, and following pages) wouldn't be anywhere near as accomplished. It's very important to try and retain as much of the animal's 'essence' as you can to be able to animate them convincingly with human characteristics.

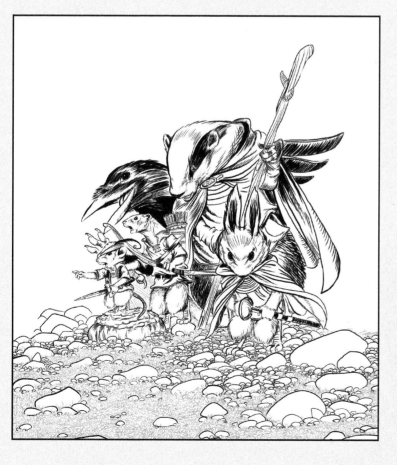

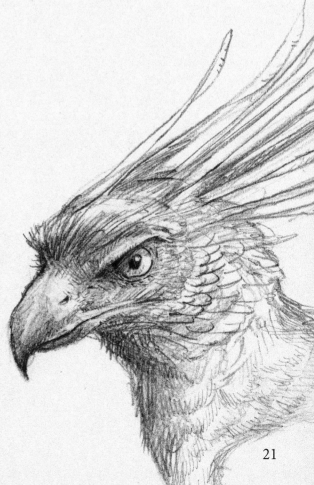

VALIANT

One of my personal projects (and one that's very dear to me) is a graphic novel idea I'm working on called VALIANT. It follows the exploits of a mouse called Finn MacNiall and his pals. The story has no humans in it... at all.

Learning to draw mice (and the other animal characters in the story) was a must. I made sketch after sketch after sketch to find a satisfactory design for Finn, and even now, he's still a work in progress. With each page, however, he's looking more like he should.

Taking the time to get to know your characters is very important. Even if it doesn't come out anywhere in the story, a back history must be well thought out; character traits should also be highly developed. Flesh your characters out as best you can; you'll be surprised at just how much easier it then becomes to draw them, and to tell their story.

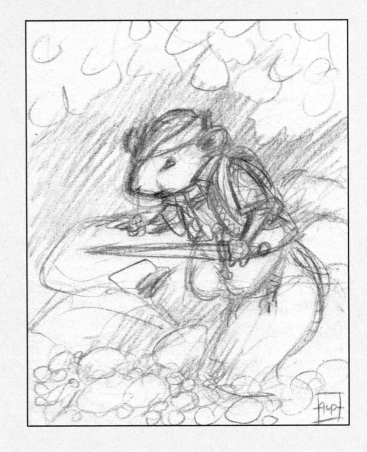

There are no shortcuts. To make your animal characters convincing, you have to understand that particular animal, really get into the nuts and bolts of it. This guy's a mouse, which is, in reality, completely at odds with a brave, even 'regal' character. It's important to think from all angles, and equally important to come at your designs from every angle possible. Your work can only benefit from this.

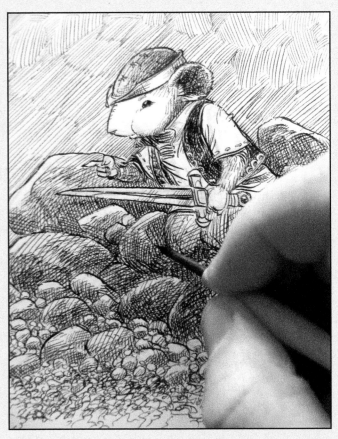

SUPPORTING CHARACTERS

Everything that was said on the previous page applies to your supporting characters. They require as much fleshing out as you can manage. Lifeless, two-dimensional characters will only serve to hold your work back. Push yourself, strive to do the very best you can. Here are a few more characters from the story.

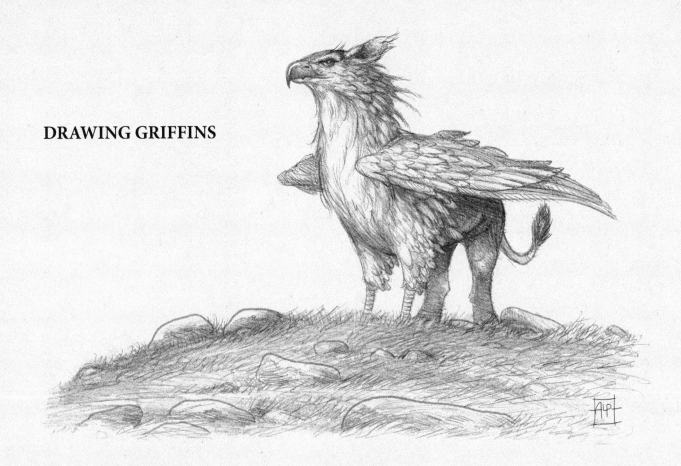

DRAWING GRIFFINS

Griffins have the back end of a lion and the front end of a bird of prey (usually an eagle). One of the best things about fantasy art is that YOU have complete control over what you're creating. When you're drawing subjects such as these, it's a very good idea to take the natural world into consideration, study how a lion moves—what do an eagle's wings look like—then ask yourself: "How do I put two very different creatures together?"

Let's take a look at those elements now.

Lions and eagles are both proud and regal creatures by nature; this should be echoed in your creation. Study a lion's legs, and the way it carries itself. Make sketches; then when you're done making sketches, make some more. I have sketchbooks full of animal studies; there is no better way to aid you in creating believable creatures.

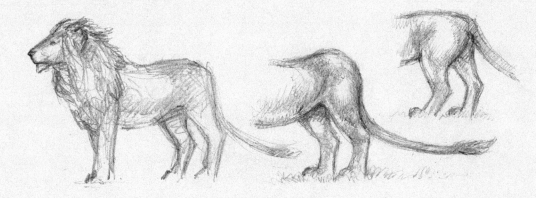

WING STUDY

Remember,
keep it simple.

fig. 1
Gesture in the
overall shape

fig. 2
Mark down a few
directional strokes as
a guide.

fig. 3
More guide lines,
working out the
feathers here.

fig. 4
Adding in smaller
feathers.

fig. 5
Add shadows and finer
details last.

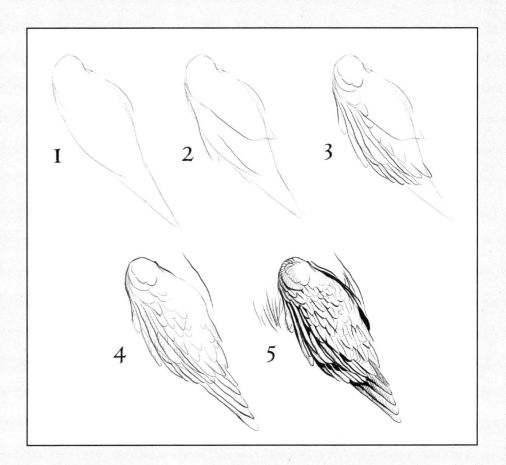

HEAD STUDY

Here, we're exaggerating the features of an eagle. Making the beak longer, larger, more deadly looking; adding ears helps to create a unique creature. We're essentially taking nature and working *with* it.
See how the feathers have been enhanced also? These give the impression of wind blowing through them.

Take advantage of the eyes of your creatures too—wild creatures should have wild eyes.

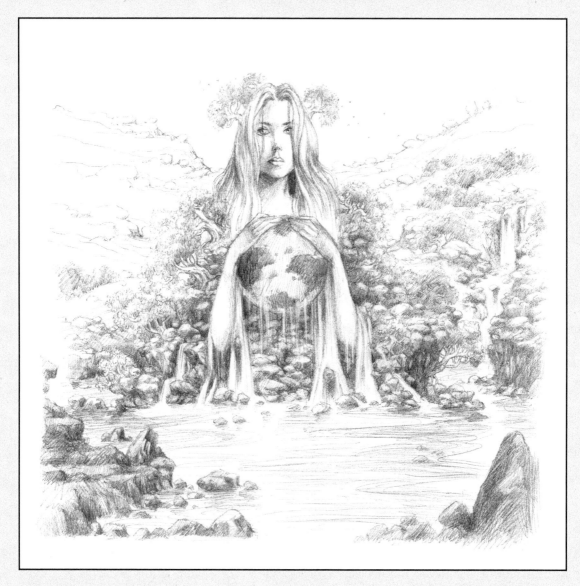

In this section, we're going to be taking a detailed look at this drawing (entitled 'Earthmother') as I believe it contains many of the necessary ingredients that go to make up a good fantasy drawing.

Let's take a look at what makes this image work.

DEPTH OF FIELD

Starting with the background, see how the strokes have been kept to a minimum? This is a fabulous way to achieve 'depth of field'—which is a term photographers use when they refer to the way they achieve a sense of distance in their images.

As we move through the middle ground, notice how the detail has filled out; we're still keeping the pencil strokes light, striving to achieve more focus as we move into the foreground, where the details become far more apparent and the pencil strokes take on a darker tone.

So, let's break the drawing down into a series of elements, crucial to its success:

COMPOSING THE SCENE

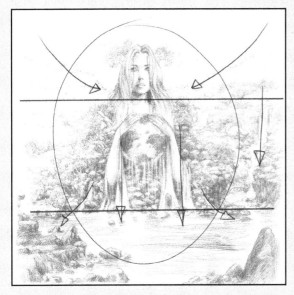

Notice how...

a) The 'rule of thirds' principle has been used here. (The image has been divided into three equal parts.)

b) Directional lines lead your eye through the drawing (see top).

c) Water elements in the middle ground lead your eyes downward.

d) The rocks in the foreground serve to halt the 'flow' and perpetuate the circular motion of the main elements.

DRAWING THE WATERFALL

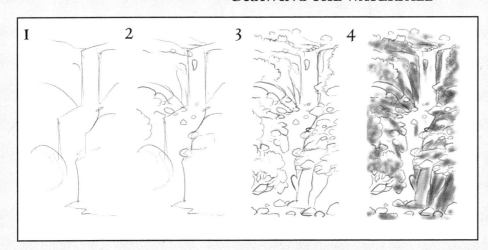

fig. 1 Gesture in basic shapes.

fig. 2 Begin adding secondary elements.

fig. 3 Move forward with the details.

fig. 4 Lay in tonal areas.

DRAWING ROCKY AREAS

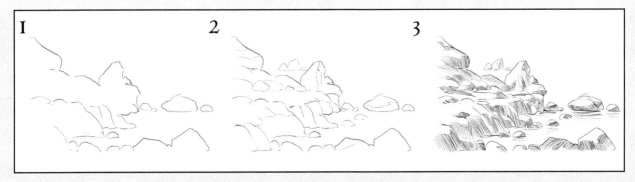

fig. 1 Gesture in outlines. *fig. 2* Add secondary (smaller) rocks. *fig. 3* Work into the rocks tonally. (Be sure to vary strokes for visual interest, paying attention to the light source.)

COMPOSING A SCENE

The following illustration was originally created for the cover of this book. Instead, it became an exclusive print for those who backed the first edition of this project. I thought it'd make a good example of how to get from a conceptual idea to a finished illustration.

BRAINSTORMING

Okay—so I wanted an illustration that not only had the right ingredients to represent a book about Fantasy Art; it also had to represent me, as an artist, and showcase my style. Easy, right? Actually, no. You'd be surprised at how the seemingly simple things become more difficult when they begin to involve too much thinking.

DECIDING UPON A ROUGH

Having exhausted idea after idea, I settled on the one with the wizard, the fairy and the dragon. And what self-respecting illustration, drawn by me, would be complete without a tree? That was enough to keep me happy. So off I went, setting about making some thumbnails based on that idea.

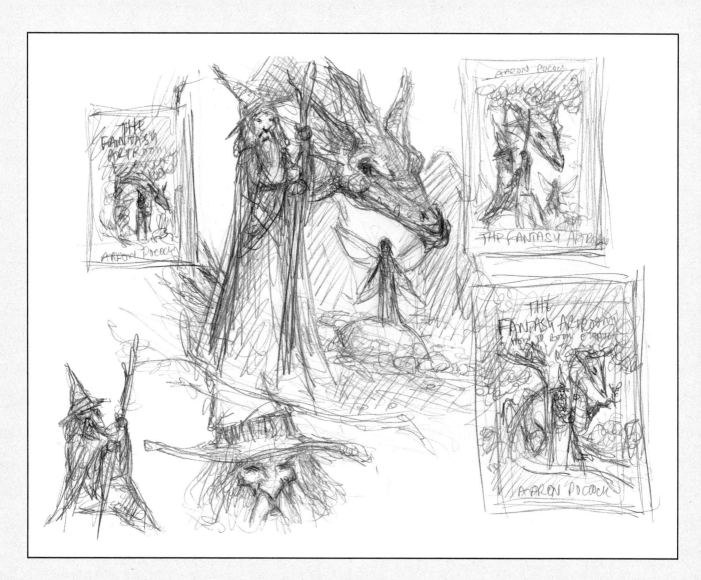

Next, we draw up the version we've settled upon (see sketch at bottom right of opposite page).

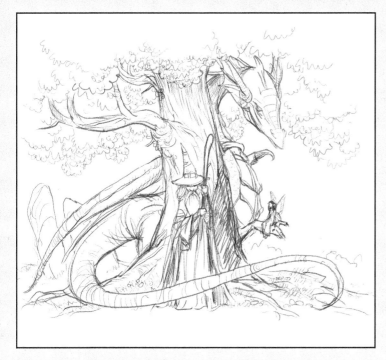

Having tightened up the drawing to this level, the next step is to think about the way we'll be rendering it. Do we want it to be an elaborate pen and ink drawing? Will we be adding colour? Those questions will be instrumental in determining the final 'look' of the illustration so it's important we make that decision before we begin.

I chose to keep it as a line drawing, staying true to my own style and also, more importantly, staying true to the contents of the book.

Compositionally, the scene is balanced satisfactorily. The dark areas at the top and bottom sandwich a light area in the centre, working with the 'rule of thirds'.

The 'C' shape (starting from the dragon's head, running down its wing, through to the end of its tail) frames the tree trunk and the wizard rather well, creating a lovely 'centre of interest'.

The finished drawing:

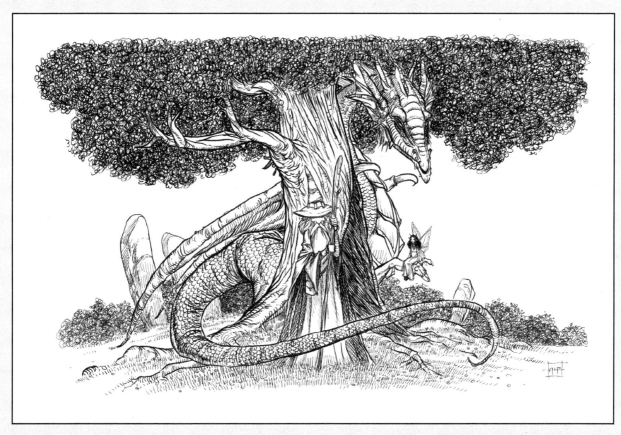

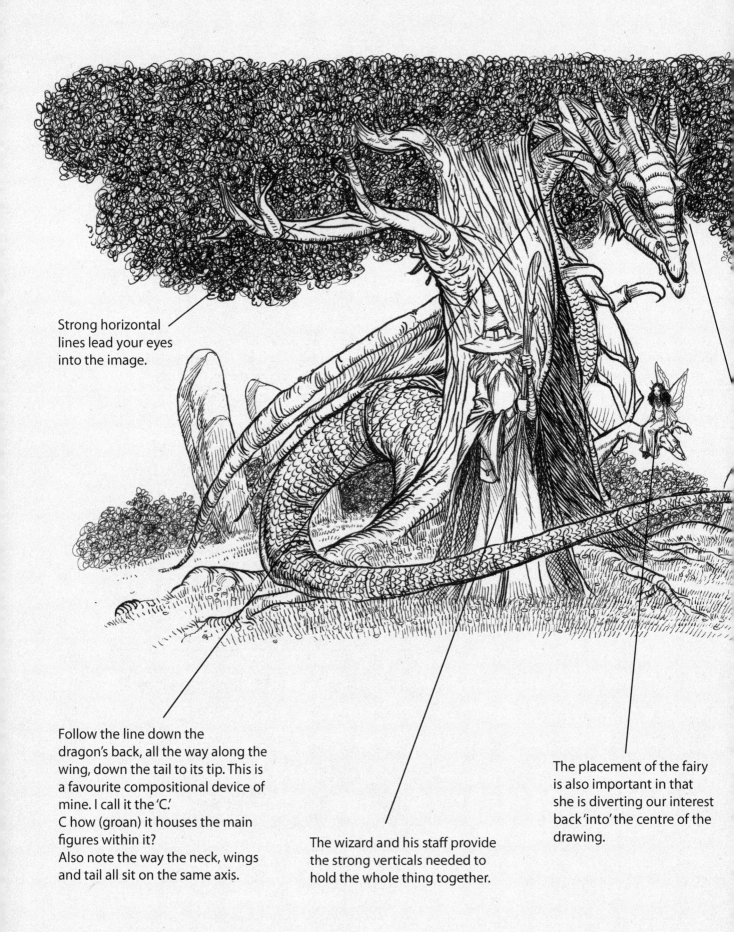

Strong horizontal lines lead your eyes into the image.

Follow the line down the dragon's back, all the way along the wing, down the tail to its tip. This is a favourite compositional device of mine. I call it the 'C.'
C how (groan) it houses the main figures within it?
Also note the way the neck, wings and tail all sit on the same axis.

The wizard and his staff provide the strong verticals needed to hold the whole thing together.

The placement of the fairy is also important in that she is diverting our interest back 'into' the centre of the drawing.

RULE

OF

THIRDS

The angle of the standing stones also echoes other elements within the drawing.

See how the illustration has been broken down into three main sections? This is called 'The Rule Of Thirds'—A compositional device artists and photographers use to break their images up into areas of interest. Typically a horizon line will be placed in the upper or lower third of a composition, as sitting in the centre is about as bland as a composition can get.

The example here is a good example of a textbook 'Rule of Thirds' whereby the top third is dark, the middle third is mostly light and the bottom third is, again, mostly dark—the centre has been 'sandwiched' most satisfactorily.
See tonal map (below)

The tilt of the dragon's head also serves to lead your eye into the image. It wouldn't be the same if he was looking over across to the right.

TONAL MAP

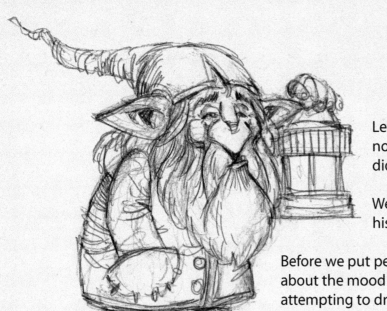

CREATING CHARACTERS

DWARF

Let's have some fun, shall we? For me, there's nothing better than creating something that didn't exist before I sat down to draw it.

We'll begin by drawing this old guy and his lamp.

Before we put pencil to paper, it's a good idea to have a think about the mood and bearing of the character you're attempting to draw.

Here, I've chosen a jovial little fellow in an almost cartoon-like style. What's his story?

Remember... It's ALL about the storytelling.

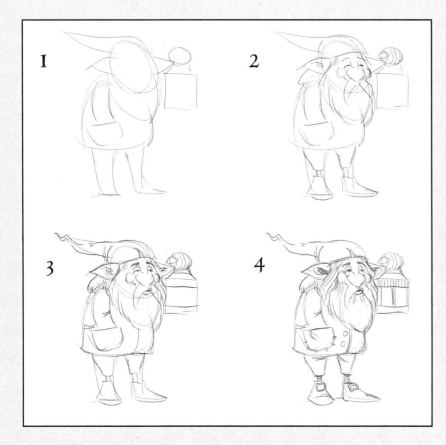

fig. 1 Begin by working out the pose (on a separate sheet if necessary). Gesture in the figure (always starting with the head), paying attention to the body language.

fig. 2 Adding face and boots, refining as we go.

fig. 3 Paying more attention to the face and his expression here. The character is beginning to come to life.

fig. 4 Adding final details and refining all elements within the drawing.

NOTE
Details ALWAYS come last. Get used to hearing this.

WITCH

Folks, meet Beryl. I caught her with this look (lucky I had my sketchbook handy at the time) as she was glaring at a shopper who took the last tin of baked beans from the shelf at the supermarket just before she managed to reach it.

'Eye of newt' (etc).

Ummm... Actually I made that whole story up, but that's the point, isn't it? And it's just as well really; can you imagine what she would have done to that poor shopper?

Anyway... In the tradition of the previous page, we'll be focusing again on following a few simple steps.

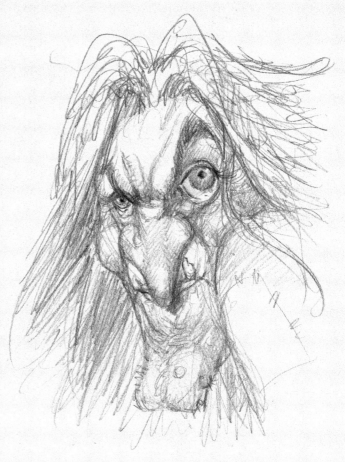

fig. 1 Yes, you start with an egg. I know, I know...

fig. 2 Rough in the placement of the eyes, nose and mouth, using gestural lines as guides.

fig. 3 Tightening up the facial features and working a little more on her expression.

fig. 4 Add the final details; pay attention to her hair, keeping the strands loose and flowing—directional lines are important! Also, remember to erase all unwanted lines as you go.

NOTE
It's **ALL** in the eyes!

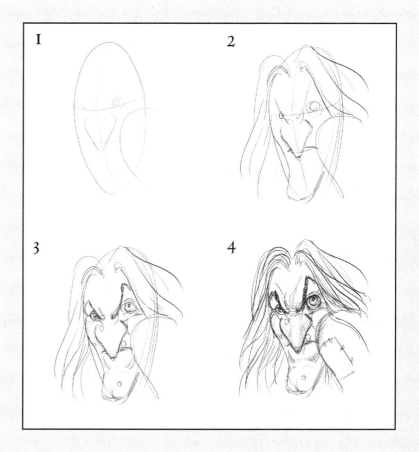

A DRAGON RIDER

Let's take another drawing from beginning to end, shall we?

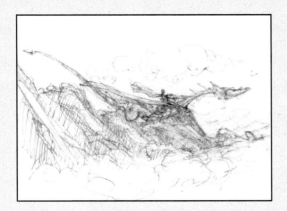

STEP ONE

As always, we start with a rough sketch. I chose this one over the others I drew as it had a little something more about it, it somehow contained a little more of that 'falling' feeling I was after. Keep your sketches fast and loose, say all you need to say without labouring the point. Remember, though, to work on a few and pick the one that speaks to you the most.

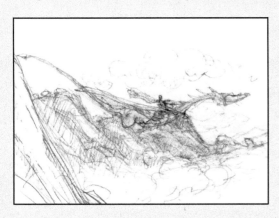

STEP TWO

Upon further reflection, the sketch felt unbalanced and didn't give much by way of distance. The inclusion of the cliff face to the left finished the composition off nicely. Far more balanced! And now, we're ready to move onto the finished drawing.

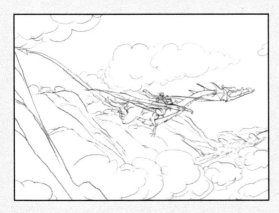

STEP THREE

Using a sheet of tracing paper and a 2B pencil, trace the sketch, tidying the lines up as you go. This is an important step and a great way to iron out the flaws of the original sketch. To find out if there are any areas within the drawing that look 'off', simply turn the sheet over; they'll become apparent, if they aren't too glaringly obvious, and you should only need to make a few minor alterations.

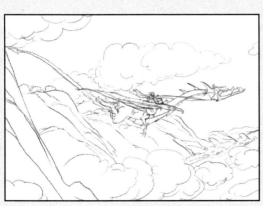

STEP FOUR

Transfer the traced outline onto your chosen surface. Try not to press too hard as you transfer it, or it'll leave indentations and make it hard for smooth drawing as you progress, softly, softly...

WHAT YOU'LL NEED

sheet-quality cartridge paper
HB, 2B and 0.5 mechanical pencils

STEP FIVE

Using an HB solid graphite pencil, work into the tonal areas of the mountains and give form to the clouds. Again, build up in soft layers rather than pressing too hard and having to erase. (HB is a good grade of pencil to work with—neither too hard nor too soft). Keeping control to a maximum is a must at this stage.

STEP SIX

Work up the clouds using gentle, circular strokes. Next, change to an HB (0.5) mechanical pencil and begin adding details to the dragon and rider, all the while keeping the tonal work around the whole drawing nice and even. Remember, details will recede as you move from foreground to background.

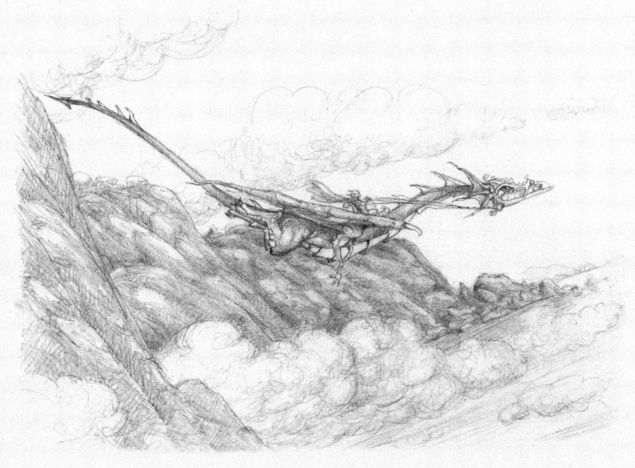

EXAGGERATING FACIAL FEATURES

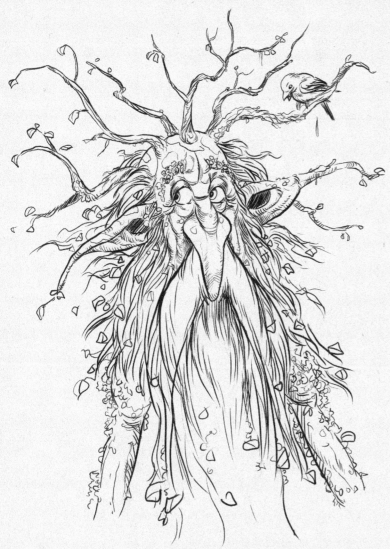

As a fantasy artist, it's your job to record all those stories that didn't happen. How boring would it be if all the heroes and heroines from those stories were human beings?

Creating cool creatures and designing fantasy characters is all well and good, but without the ability to manipulate certain facial features, your work will fall short...

I've added a few characters over these next couple of pages; see how they're vaguely human in origin? But with a little coaxing, they've taken on that 'fantasy', or 'fairytale' quality—it's your job to find a balance, to make magic from the mundane.

Let's go through and take a look, shall we?

ECCENTRIC

This old character (see left): is he a tree shaped like a human? or a human with tree-like qualities?

In order to make him appear even older...

1) The ears have been stretched and pulled, and are not sitting evenly, or straight.
2) The beard has leaves growing out of it.
3) His nose is abnormally long.
4) We've exaggerated his crows' feet and the bags under his eyes.

OTHERWORLDLY

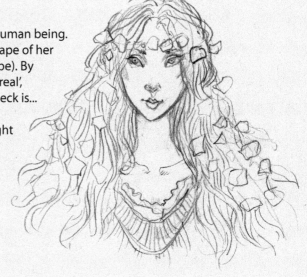

This beautiful Fae Princess is clearly no run-of-the-mill human being. Here, we've placed our attention on her eyes and the shape of her face (which is very much a 'reverse teardrop' kind of shape). By giving her slanted eyes, she immediately becomes 'ethereal', 'otherworldly'. Also note how slender and graceful her neck is...

Take the time to study people and you'll gain great insight into how best to manipulate those facial elements, and, in turn, create great fantasy characters!

NOTE
The eyes truly are the 'windows of the soul'—which is where the stories live. Bear that in mind as you create.

INTELLIGENCE

This character (see right) has a hint of mischief about him, a sort of wizened cheekiness—again, the eyes tell the story here. What is he thinking? His beard and his ears both sit at the same angle, accentuating his clever and forward-thinking manner. The glasses add even more of a clue to his obvious intelligence and his bulbous nose also helps to convey his age, definitely a Dwarven librarian, this guy...

TO RECAP...

1) Pay attention to the eyes.

2) Ears are a great way to convey age and also wonderful to articulate the personality of a character; play with them and find what looks 'right'.

3) Choose the right type of beard to suit your 'bearded' characters. Should it be long? short? bushy or closely cropped?

4) Noses are just plain old fun to play with! You mustn't forget to have fun!!!

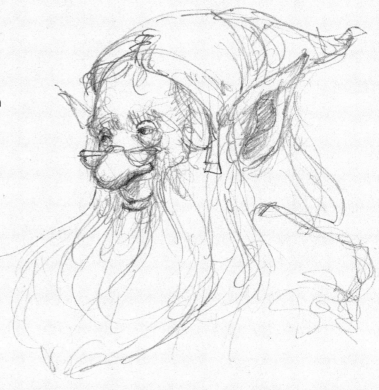

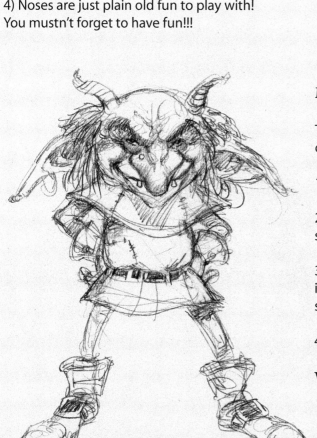

MISCHIEVOUS

This little guy is just downright naughty. There are plenty of clues here—we'll start from the top of his head, shall we?

1) He has horns. Enough said.

2) The brow/eye area—we can tell he's up to something, scheming, calculating...

3) His ears, note the angle here... They don't give the impression of good intent, do they? The downward slant surely gives clues as to his state of mind...

4) That smile—not a welcoming one, is it?

Would you trust this bloke?

DRAWING A CENTAUR

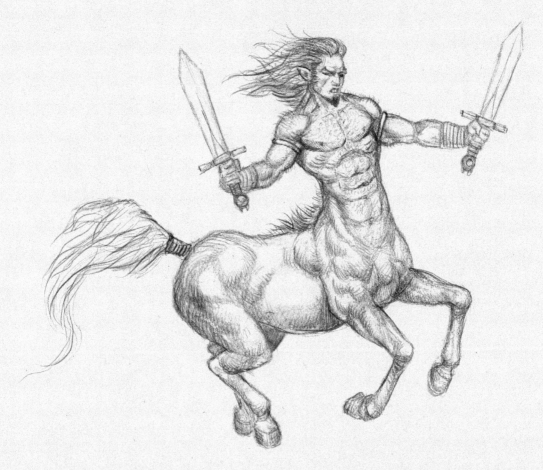

A centaur is a very interesting creature to draw, with the upper half of a human being and the legs of a horse. Another mix of animals that shouldn't work, but somehow does. The design success of your centaur will largely depend upon how you join the two animals together. Let's take a closer look...

In this example (see right), note how the graceful 'S'-shaped line runs from the top of the Centaur's head, right down to the front foot (the one on the ground). It's a natural-looking join, the 'shoulder' of the horse's front leg almost sitting where the buttocks of a human would be placed.

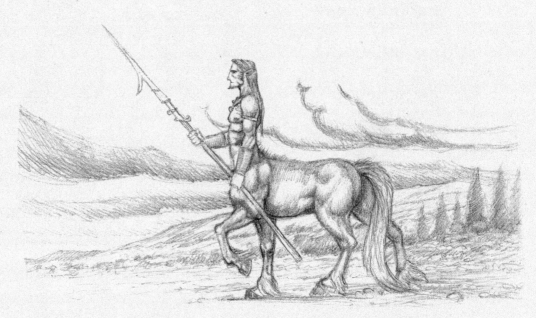

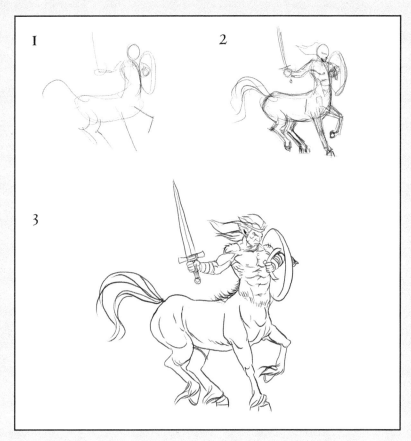

SKETCHING A CENTAUR

fig. 1
Gesture in basic pose. Keep things nice and loose, and simple.

fig. 2
Work on the body shape, paying close attention to the muscles and proportions. Add details, but don't overdo it!

fig. 3
Erase all excess lines and rework any stray ones. We want to convey power with this pose; keep your lines confident!

PRACTICE DRAWING HORSES

Here's how I fill my sketchbooks up... You know, even though I'm a professional artist/illustrator, I still find it hard, even after all this time, to draw certain things. Horses are way up there on the top of my 'these things are still hard to draw' list.

A good rule of thumb... If you find it hard, keep drawing it!

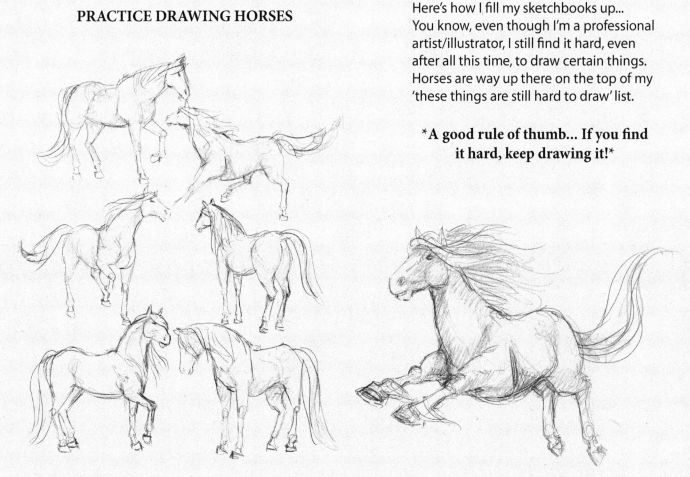

Everybody has an idea of what a unicorn looks like. Most people see it as a white horse with a horn; modern myths have helped this vison along as unicorns in movies and books all look like this. Waaaay back, unicorns were depicted somewhat differently, looking only vaguely 'horse-like' with a slimmer head and more elegant body. In the example (see right), I've merged the two ideals.

I'd like, at this point, to point out the three-step rule again:

1) Shape.
2) Gesture in the secondary elements.
3) Details last.

Trust me, you can't fail if you follow these three steps!

I

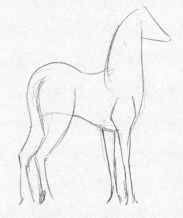

Gesture the shape first.

2

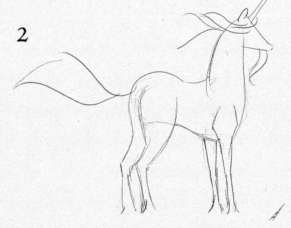

Begin adding horn, mane, tail.

3

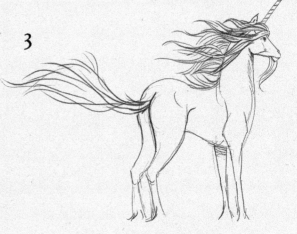

Details come last. ALWAYS.

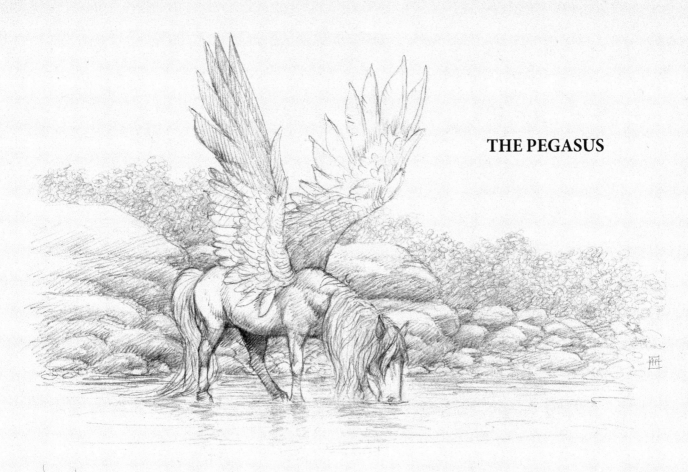

THE PEGASUS

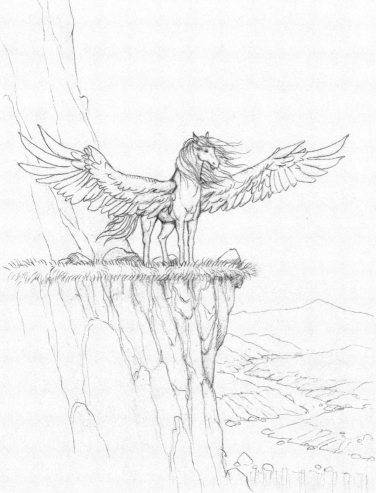

I love drawing the Pegasus. Adding wings to something as large as a horse fills me with great satisfaction—it shouldn't work, but somehow it does!

The placement of the wings is all important... The best place to put them is up above the shoulders, below where the neck joins the spine.

Again, some exaggeration can help your designs... The mane and the tail are perfect tools for adding drama to your illustrations. Always think creatively about the marks you make—happy accidents are all well and good, but if you're relying on them, well, you know...

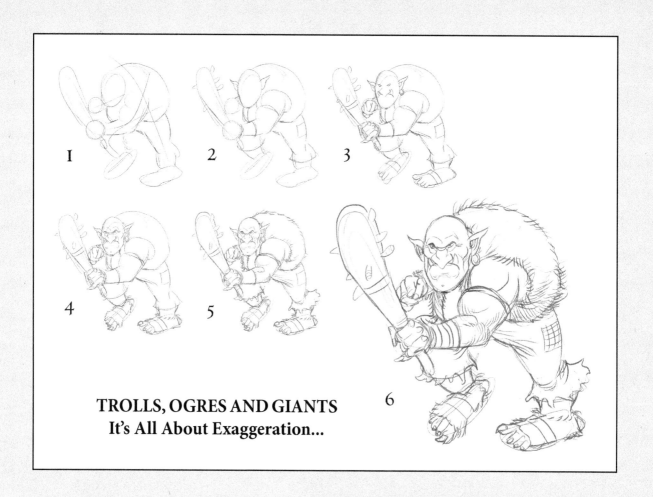

TROLLS, OGRES AND GIANTS
It's All About Exaggeration...

fig. 1 Gesture the basic body shape.

fig. 2 Work into the body, adding elements of clothing.

fig. 3 Begin working on the Troll's club, face, feet and hands. Still keeping details down to a minimum. Patience is a virtue...

fig. 4 More work on his face, concentrating on his expression.

fig. 5 Pay attention to the finer details now. Moving around the whole figure to keep everything in line, no one area is more rendered than another.

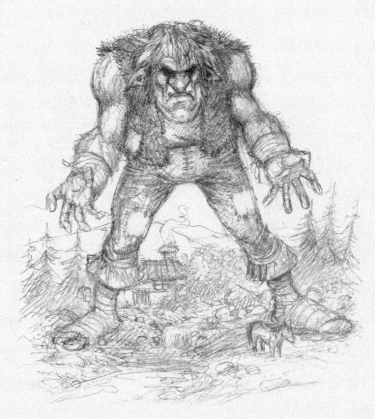

Your sketchbooks are a place for you to play.
Have fun... CREATE!

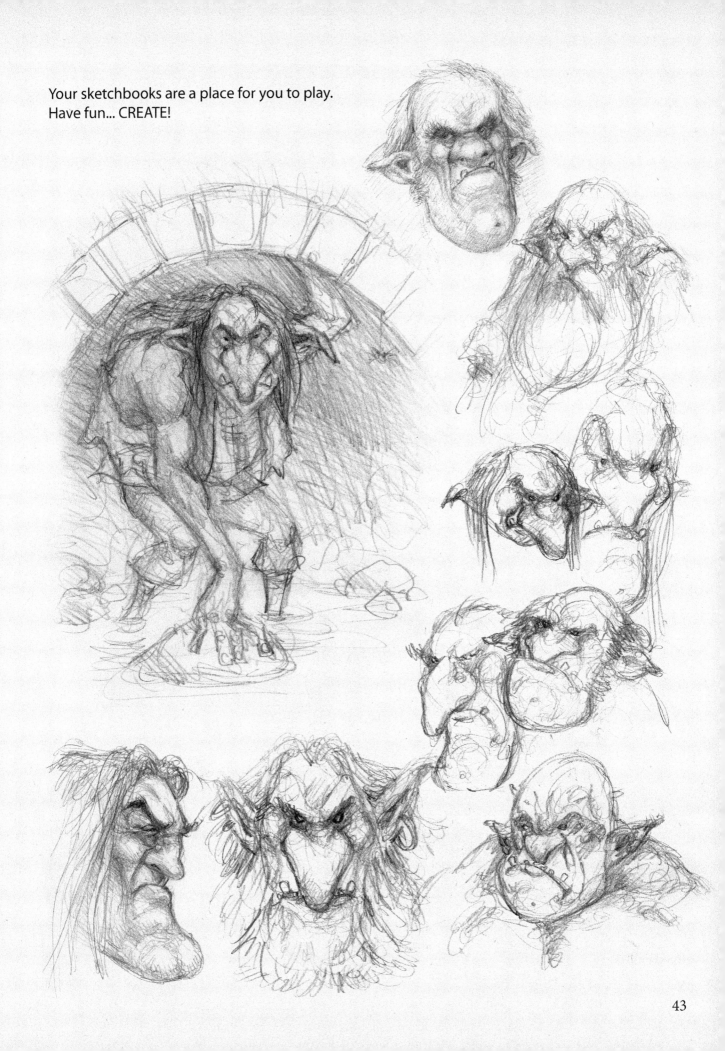

DRAWING A GIANT'S FACE

Drawing Giants is fun... In fact, Fantasy Art, in general, is fun. Taking what's already there and building upon it is a large part of getting from A to B. Though I can't stress this enough—study from life, from nature, look and understand what works and what doesn't. By getting to grips with what you see, you'll be able to create from your imagination. This is one of the key steps to being able to transfer what you see in your mind onto the paper in front of you.

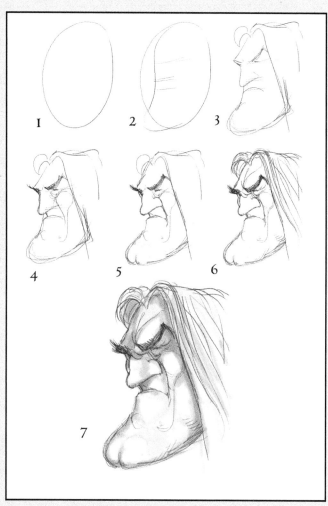

fig. 1 Begin with an oval to gesture the shape of the Giant's head.

fig. 2 Add placement lines for eyes, nose and mouth.

fig. 3 Start at the top of the head, laying in the hairline, working downwards sketching in the eyebrows, nose and mouth, rounding the chin off also.

fig. 4 Add the eyes and the cheekbones.

fig. 5 Tidy up the lines as you go, erasing any guide lines you may have acquired along the way.

fig. 6 Work on the hair, keeping the strands long and flowy, rather than scribbly and scratchy. **Always strive for graceful lines.**

fig. 7 Finish off here, with some tonal work to make the drawing appear 'realistic' as opposed to 'cartoony'. This stage really depends upon what you're trying to achieve from the drawing; for example, you could quite happily leave it at fig. 6 if you were going to colour it with watercolours.

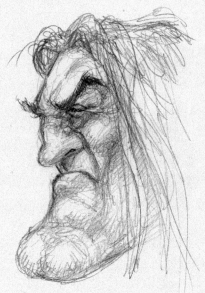

NOTE

Keep it simple!

Wouldn't it be great to know what you're doing every time you sit down to draw? A good working process is a key ingredient to making great art upon command. Following the simple steps outlined within the pages of this book will have you well on your way.

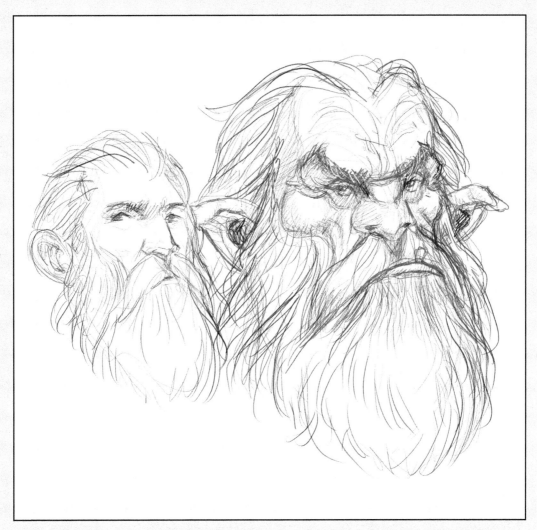

In this example (above), we've compared the head of an average bearded human to that of a giant. The angle of the head is the same, they both have eyes, a nose, a mouth (etc.), but see how, by taking those human features (left) and distorting and manipulating them, we end up with the Giant (right).

By paying attention to areas such as the brow, tilting the eyes, emphasising the cheekbones, giving the guy an underbite, warping his ears and poking that tooth out, we arrive just where we want to be. If you stole this fellow's golden harp and saw him coming after you, you'd run... Wouldn't you?

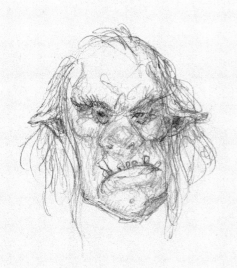 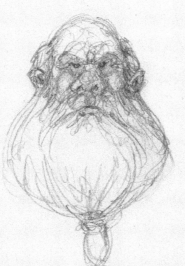 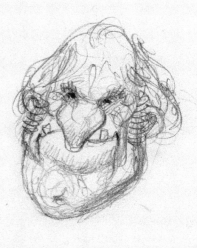

MORE ON STORYTELLING

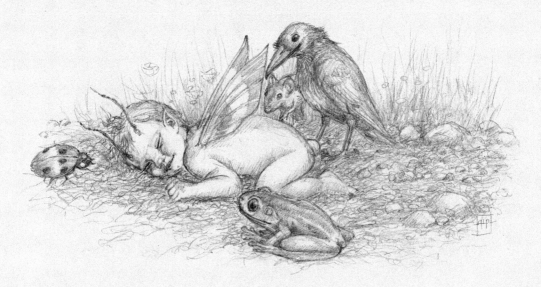

I've heard it said that illustration is a lower form of art than supposed 'fine art'. I disagree. I mean, I **really** disagree. Anyone who studies 'fine art' would do well to study illustration and integrate it into their own work. Storytelling is of the utmost importance to a work of art, be it 'fine art' or a lowly illustration. In fact, I'd send anyone who draws or paints to look at some of those cartoonists or comic artists to see how they tell stories.

In this section, I'd just like to give you a few things to think about regarding how best to put across a story in your artwork.

1) ENVIRONMENT

That's an easy one, right? You'd be surprised how often it goes overlooked. In their haste to draw great characters, students of art often forget to include environments to support the character and help to tell their story. It's good practice to learn how to draw landscapes and rooms and buildings, too. (Unless you intend to become a character artist for an animation studio [wink wink]).

2) CONSIDER THE BACK HISTORY OF YOUR CHARACTER

Another easy one, of course... But again, you'd be surprised how effective this can be. Imagine some-one just getting up from a fight; what would they look like after it? You might consider adding rips in their clothing, a drip of blood, dishevelled hair, a split eyelid... Of course! Consider a figure walking alone through the dark, silhouetted against the moon. What's HIS story (his-story, 'history'). The pose will tell everything. He might be slouching due to poor luck, or standing straight and determined, etc... Get inside the minds of your characters and you'll have a wealth of information to create better and more engaging art; after all, it's ALL about engaging with your viewer... Use your imagination!

3) COMPOSITION

Composition is a very important part of the way you tell your story through your art... Let's take apart a drawing and see just what makes it tick and, more importantly, why.

Strong composition is largely a matter of planning as well as intuition. Placement of objects can help your composition stand, or fall.

The image below is a sketch based on a classic 'Dragon and Hoard' theme. The first thing we notice are the strong horizontal lines; beginning from the rear of the drawing, we have the horizon line, followed by the dragon's neck, then its tail. Secondary horizon lines include the mounds of gold and the dragon's forearm.

To 'house' the composition there are the verticals made by the spears and swords. Also echoing these are the spikes along the dragon's back, head and tail. If you look closely, both sides of the image have subtle angular elements that lead your eyes in and keep them there.

Lastly, we have the head—see how it's set at a kind of an 'intersection' point? Almost the centre of a large 'X'. There are many things to take into consideration when you plan your compositions; just bear in mind that random placement most often leads to random results. Reduce this risk and plan your compositions carefully.

See diagram (right) for directional lines used within the composition.

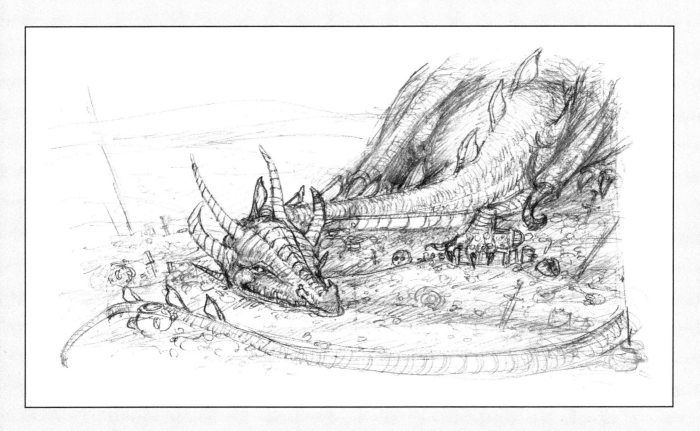

USING TEXTURES IN YOUR ART—MOSSY STONE

Although we're interested in producing 'Fantasy art', it's still a good idea to base your drawings and paintings in reality; they'll be far more convincing. I've chosen to demonstrate mossy stone and bark, but by no means limit yourself to those. Keep your eyes open and pay attention to the textures around you; including them, where appropriate, will give your art more depth.

WHAT YOU'LL NEED

HB pencil
sheet cartridge paper
sharpener

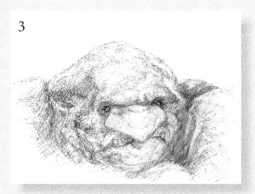

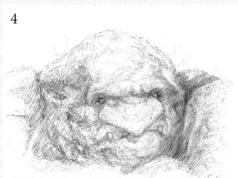

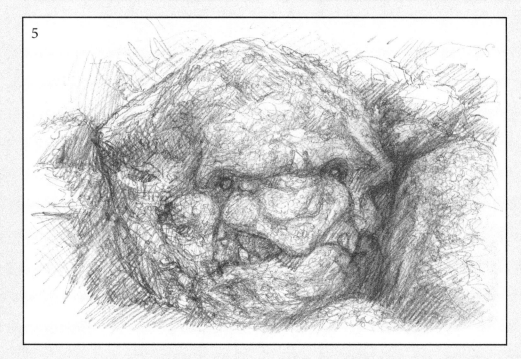

fig. 1
Sketch in the outline of the rock formation. The central rock is our focus here.

fig. 2
Gesture in contours and details, keeping your lines lively and interesting; these add to the texture (as you'll see).

fig. 3
Thinking more in 'tonal' terms here, bearing in mind where the light comes from, and where the shadows fall. Things start to come alive as soon as the light and shade are established. Also, vary your strokes to hint at the moss on the rocks.

fig. 4
It's coming together now. We're working around the whole drawing and filling out more details. We want this dude to appear old and weather beaten. Paying more attention to pock marks, moss and contours of the rock.

fig. 5
THE FINISHED DRAWING

The old fellow is looking just as we'd like him to... weather beaten, grumpy, ancient...

Note The emphasis paid to certain areas of the drawing (his eyes, mouth, shadows bordering him)—although care should be taken not to emphasise these areas to the exclusion of all others.

BARK

There's a knack to drawing realistic bark textures. The following steps will give you a quick and easy route from A to B.

fig. 1
The downwards strokes here will give you an idea as to which way the bark sits on the trunk of the tree.

fig. 2
Using a blunt HB solid graphite pencil, add tonal marks over your downward lines, varying intensity. Then, randomly rub over the marks gently with your fingers (if they're clean) or a sheet of tissue paper.

fig. 3
With an eraser, go through and pick out highlights; then, having sharpened your HB pencil, strengthen the tonal work in the split wood. Now, gesture in more textural patterns *across* the whole area. Now it's really starting to look like bark...

fig. 4
More of the same...
Move around the whole image, strengthening lines with darker strokes, pulling sections out with an eraser and reworking details into them with the pencil. These kinds of textures are very much an 'adding and taking away' exercise.

FEMALE FACES

Drawing females is really quite different from drawing males. The focus on a male face is to use all the curves and contours and angles to create a masculine look. For a feminine look, the focus is very much on the features themselves. The eyes, the nose, the lips—anything else is peripheral and often unnecessary. In the examples below you'll see great attention placed upon the eyes. The eyes speak volumes about the character and can be tweaked to suit the personality.

Pay great attention to your lines—keep them smooth and graceful, particularly when you render the hair. When drawing fantasy females, it's OK to enhance or exaggerate certain features; e.g., for an Elven lady, tilt the eyes slightly and turn the tip of the nose up a touch; see example (right).

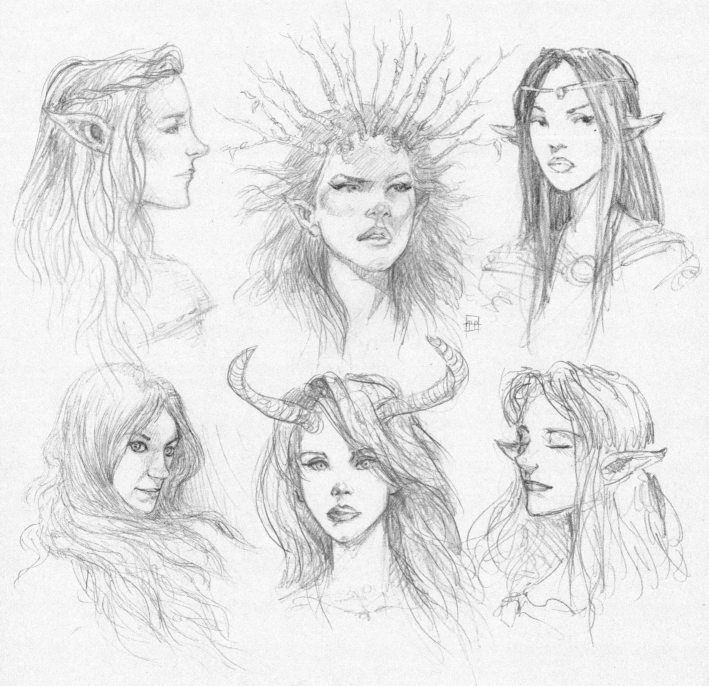

This Wood Elf (below) has all the qualities of an Elven face.

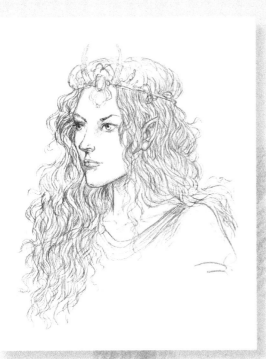

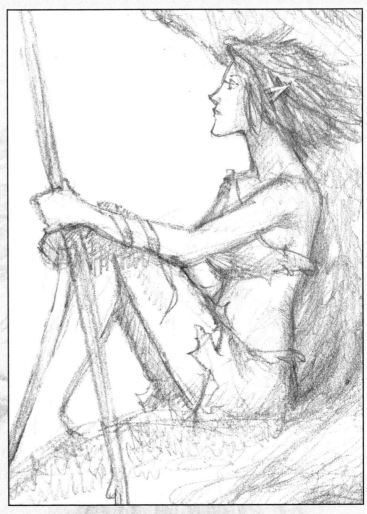

When drawing Elven females, be mindful of the shape of the face. Angles dominate. The angle of the chin, the eyebrows, the eyes, the tilt of the nose, the lips...

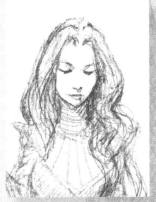

Even with her eyes closed, we can still see she has a tale to tell.

STORYTELLING

It's very important to consider a back story when you draw people. Just a glance can tell a story, but that glance has to be rendered convincingly enough to make it believable. Body language, adornments and countenance will all help to put across the mood, backstory and current circumstances of your characters.

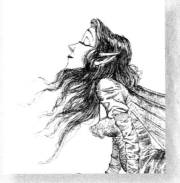

Where's this lady going?

Facial expressions are very important. It's not enough to have perfect features; your characters should also convey a story, or at the very least, a mood. Leave your viewers wanting to know more about them.

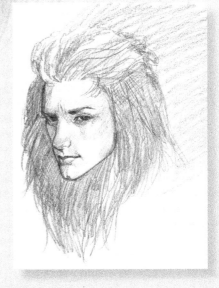

INKING

So, we've looked at drawing in pencil, for sketching and finished drawing purposes, but what if we're looking to make illustrations for publication? Much of what is going on in the publishing world requires art to be rendered in ink. Cue pen and ink section of this book.

In this section, we'll be looking at ways to ink your drawing to suit the mood and detail level required. Drawing pens and dip pens are our tools of choice here.

SO WHY INK YOUR WORK?

Good question. Inked artwork dates back hundreds of years. The Victorian illustrators (in my humble opinion) made the best use of line work. Artists such as Arthur Rackham employed the humble pen to delineate some of his greatest works; the American artist Franklin Booth created superb line work, which, over time, has influenced countless artists.

Good line work can make a huge difference to a drawing. If rendered convincingly, adding ink can make a good drawing even better, stronger.

The benefits of inking your drawings are (and not limited to): it's easier to print/scan; it creates stronger lines for colouring; and it can help to 'stylise' your drawings.

TOOLS OF THE TRADE

Okay, so you've decided to give inking a go—what to use? The choices are threefold, really. Dip pen and ink, brush and ink and drawing pens. By far the most popular choice nowadays is the drawing pen. For this book, however, we'll mainly be focusing on the use of the dip pen, a versatile medium if ever there was one (and my personal favourite).

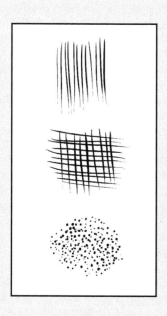

MAKING MARKS

There are three main types of line you'll encounter when rendering in pen and ink:

HATCHING simple lines inked alongside each other.
CROSS HATCHING simple lines that cross over each other.
STIPPLING small dots used to darken an area.
See diagram (left).

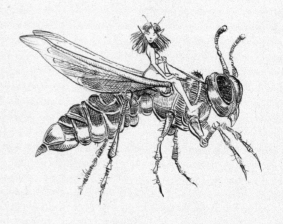

THE IMPORTANCE OF STUDYING THE MASTERS

History has provided the world with great artists who have, in turn, dazzled us with their greatness... and much of that greatness is available to you and me through the availability of the Internet, galleries and museums, and last, but most definitely not least... books.

With that in mind, I urge you to spend a long time studying the works of these great masters. You will be pleased to know that at some point or another, they started out just like you but utilised time and practised dedication in order to become masters of their craft. There's simply no shortcut. The good news, however, is that the masterworks these incredible human beings created are available to you to study, and study them you must.

For me, the best period to study is right back to the 'Golden Age' of illustration. The age of brilliant artwork included greats such as Howard Pyle, Arthur Rackham, John R. Neill, and H.J. Ford (to name but a few). Many of today's illustrators wouldn't hesitate to drop the names of these men as their own influences. The reason I feel it best to go back and study the masters is that many of today's illustrators, despite having killer technique, pale in comparison. The artists of yesteryear had a far more thorough approach due to their more 'in-depth study'. It's also due in part (I believe) to the fact that time nowadays isn't in such large supply as it once was and distractions are certainly more prevalent (TV, social media and the like). Taking the time to look at and absorb great artwork is a fine way to not only understand what constitutes great artwork, but often without knowing it, you'll be absorbing the methods and techniques, which will find their way into your own efforts. Remember, 'looking and seeing' is often as important as 'doing'.

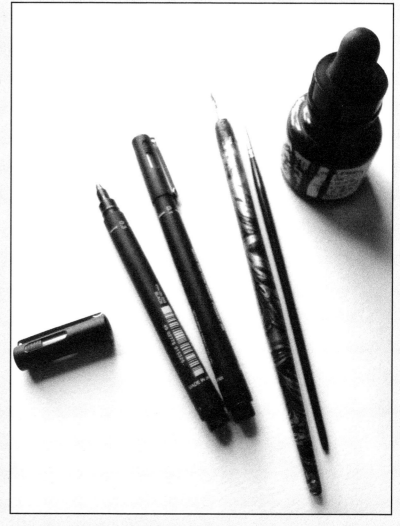

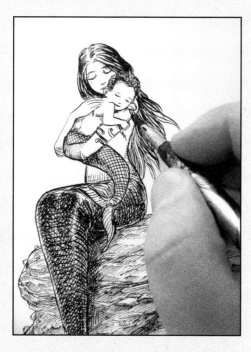

INKING WITH DIP PENS

PAPER TYPES

There are many types of paper that will comfortably take pen and ink. The photo below shows a few, ranging from:

sketchpad paper (all grades)
cheap watercolour pads
heavy cartridge paper
hot pressed watercolour paper
cold pressed watercolour paper

fig. 1 India Ink (shellac-based ink dries to a shiny, satisfying finish).

fig. 2 Dip Pen Holder.

fig. 3 White Gouache (for correcting errors, making highlights, etc).

fig. 4 Nibs.

For the dip pen demonstrations in this book we'll be using a Nikko G-Pen; here are a few examples (below) of the kinds of marks it's capable of. See nibs *fig. 4* (top) and pic (right).

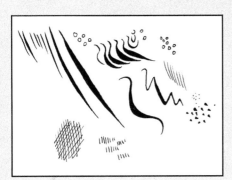

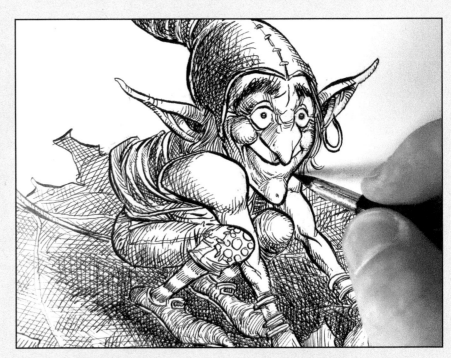

THINGS TO BEAR IN MIND

Always keep a sheet of paper handy, to test your ink levels first; accidents happen and India ink is very messy!

Remember to keep your nibs clean.

Blot off any excess ink with a tissue.

Be careful not to flick the nib. If this happens too often, it's probably due to an incompatibility between you and the nib. The G-Pen, for example, is far more robust than the Hunt or Gillott nibs; see bunny pic left/above (which was inked using a Gillott nib)—this required a far lighter and considerably more gentle touch.

Dip pens make excellent tools for fast and loose sketching.

HERE BE DRAGONS

DEVELOPING A LINE DRAWING

With this example, we're going to go from the initial thumbnail sketch to the final drawing, stopping along the way to pay attention to a few vital steps. Onward! (But beware... These things bite.)

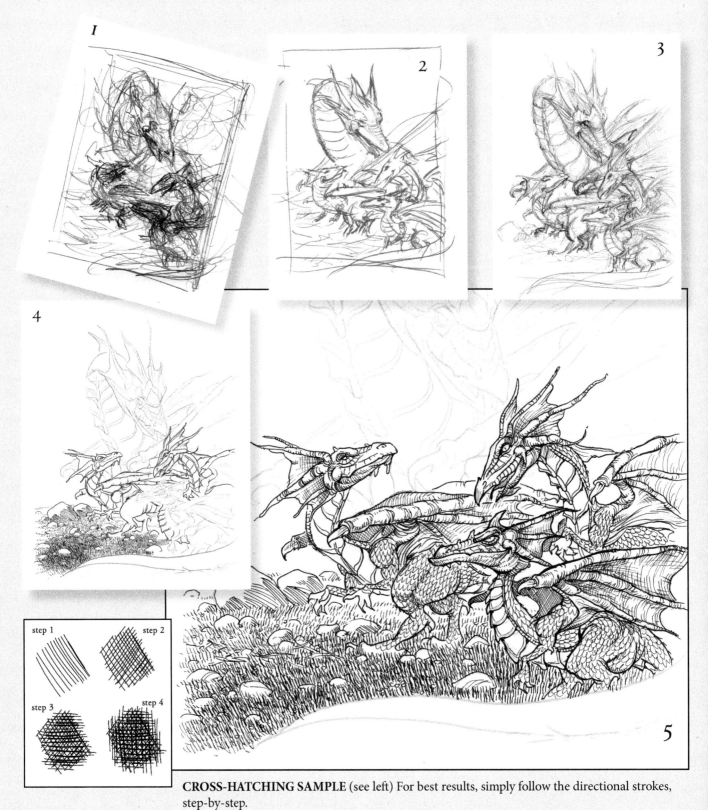

CROSS-HATCHING SAMPLE (see left) For best results, simply follow the directional strokes, step-by-step.

STEPS

fig. 1 Thumbnail drawing. Settled on this one after having worked out a few designs (always good to try a few ideas out...).

fig. 2 Here we've traced over the lines to make a coherent enough reference drawing from the chaos of the thumbnail sketch.

fig. 3 The redrawn, tightened working drawing. This is the stage where everything is worked out, so inking the illustration becomes a much easier process.

fig. 4 Firstly I worked around the dragons using the .1 inking pen, rendering the rocks and grass first, then moved into working on the dragons. I find a good practice to adopt is to draw around the outside of each figurative element (in this case, the dragons) for a couple of reasons.

1) It helps to draw some confidence into your images and...

2) You aren't tempted to over-labour them.

fig. 5 I'd already decided to keep the foreground dragons a lot more detailed than the larger one at the back, so with that in mind, I set out to ink them first, working en masse. It's crucial to keep your lines interesting and varied, following the contours of the object instead of ill-thought-out strokes.

fig. 6 The finished artwork. Note the background cross-hatching.
Hours and hours should be set aside to work on large areas such as these and should be built up methodically for best results; there's really no short cut.
See cross-hatching box (opposite page) for directional strokes.

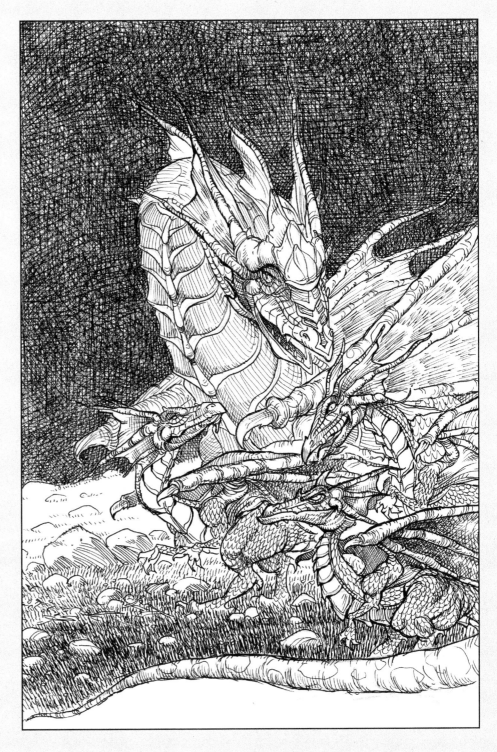

MOON

In this drawing, we're setting out to create a sense of depth, but at the same time, we're going to keep the drawing simple and the details understated.

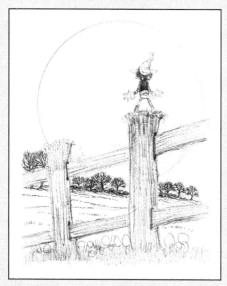

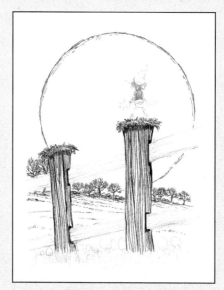

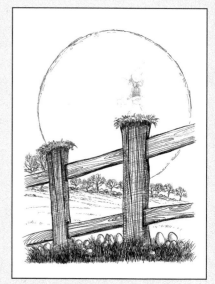

Having settled upon a satisfying composition, begin inking the trees in the background and gesture in grassy areas of the land in back and middle ground, keep your lines nice and thin as you'll need the thicker lines for the foreground.

Next, carefully work around the outline of the moon, taking care not to over-render it. We can build this up in stages. Begin working on the wood grain of the fence in the foreground, using heavier strokes.

Finishing off the fence. Pay particular attention to your directional lines here. Draw in the mushrooms, then surround them with clumpy, grassy areas, again using heavy lines. The darks here are in contrast to the large light areas. As always, we're striving for balance.

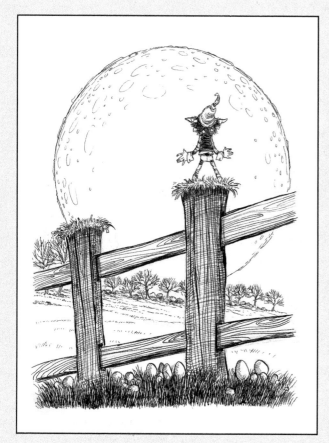

THE FINISHED DRAWING

Moving around the image and tidying up any areas that need work (including adding the craters of the moon). We then pay attention to the figure on the fence post, being careful to vary our lines for visual interest—there's nothing worse than ill-thought-out, boring pen strokes.

****It's often a good idea to save tricky areas for last, (or at least, areas that require a little more technical dexterity). I believe in drawing some confidence into an illustration by working on the easy parts first; that way, by the time you get to those fiddly details, your hand, your eye and your mind are all in sync with each other.****

A CLOSER LOOK

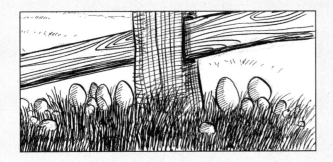

Even though the drawing is a rather small one, we still need to keep the lines as interesting as possible. Varying pen marks for each element within the drawing will add energy and movement throughout, producing a much more visually stimulating piece.

Looking at this close up, you can see that we've given this drawing a very loose approach. It's all well and good to have beautifully rendered drawings, but sometimes fast and loose is the order of the day. Energy is often as important.

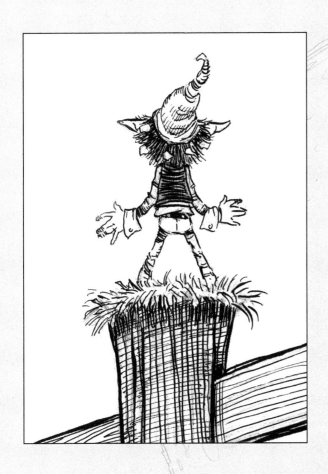

Varying strokes—line widths, directional marks, etc.—is a great way to achieve visual interest in your work. Without the above, drawings can appear flat, lifeless. Each element, although part of the whole image, is instrumental in telling a story. Learning when to stop drawing is another string to your bow. Developing restraint comes easily over time, you'll see...

LEAVES, HAIR AND BERRIES

In this example, I've taken the 'Green Man' and given him my own spin. The interesting thing about this drawing is the textural work that's involved in its rendering. Let's take a look, shall we?

For this, you'll need your Nikko G-Pen nib, Winsor and Newton shellac-based India ink, and a sheet of illustration board.

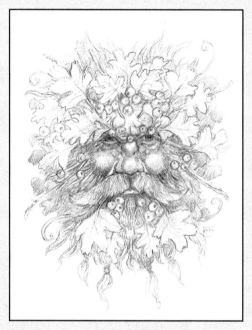

The finished pencil drawing. As you can see, this has been drawn very tightly and is highly detailed, to make inking far easier. Clean lines mean clean inking.

As always, ink some confidence into the drawing, starting with the simple stuff. The leaves and the berries will do just fine to begin with. Remember, take your time...

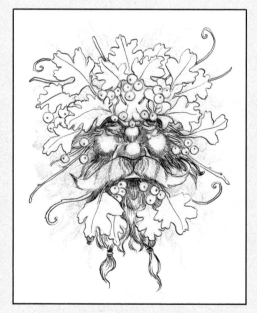

Work your way around the rest of the drawing, following the sketch as closely as possible. Keep your lines smooth and simple and always pay attention to directional strokes.

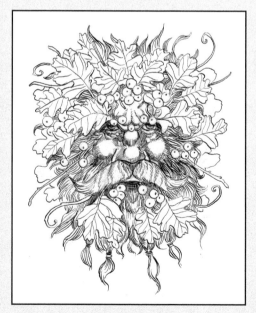

These drawings are very much an exercise in patience. It's easy to become lost in some kind of meditative state once you get into it though. Roll up your sleeves and commit yourself.

THE FINISHED DRAWING

Can you see how this would've been overloaded if I added more detail to the leaves? Plan your approach in as much detail as you can muster; it will show in the resulting image. (Good planning here kept the need for random cross-hatched lines at bay.)

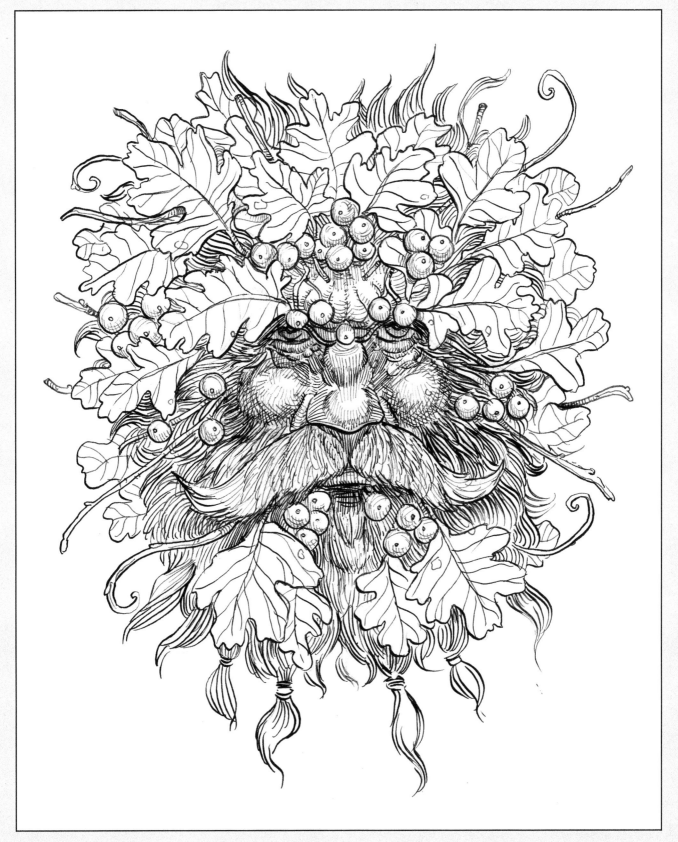

MAKING MARKS: 'Loose but controlled.'

VARIETY

Here, a wide variety of textural marks helps to keep the image lively and interesting. A balanced mix of cross-hatching and clean lines guide the eyes around the drawing. Instead of labouring over each and every line, the scales, for example, have been applied loosely.

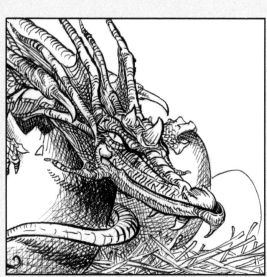

LEADING THE VIEWER

It's the little things that often go unnoticed that make all the difference. The heavy line around the dragon's eye leads your eye right there. His gaze is very important to this drawing.

VARY YOUR LINE WIDTHS

Make sure you use wider and more elaborate lines for the objects closer to the viewer. This will naturally help the eye to rest on the foreground elements, keeping the background secondary.

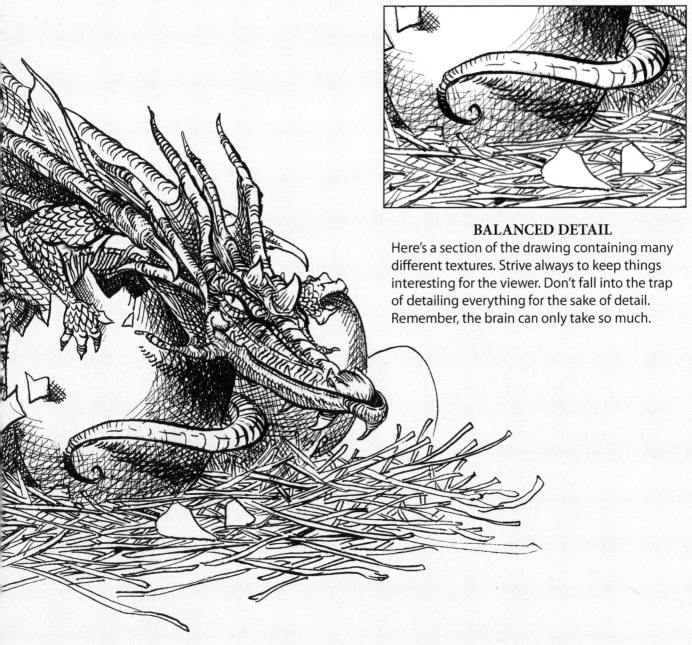

BALANCED DETAIL

Here's a section of the drawing containing many different textures. Strive always to keep things interesting for the viewer. Don't fall into the trap of detailing everything for the sake of detail. Remember, the brain can only take so much.

INKING A FLOWER FAIRY

It helps to have a good balance of styles and genres in your portfolio if you hope to make it as a fantasy artist. Both light and dark are necessary to show off your range. With that in mind, let's try something a little softer...

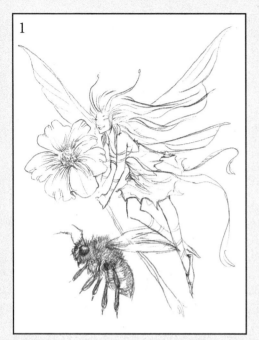

fig. 1 Here's the working drawing, having taken the rough and tightened it up. Before you reach this point, make sure that you're happy with it; once you begin inking, it is usually too late to make changes. See how we've echoed the flower theme through the image via the dress, and the antennae belonging to the fairy repeats the theme set by the bee. Repetition and well-thought-out concepts will not only enhance the visual but will also make it more authentic. We're drawing nature here; nature should be well represented.

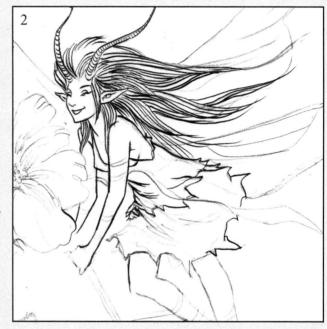

fig. 2 With your G-Pen, as always, begin by rendering the outline of the figure, not lingering too long on the details, which come later. At this point, we're far more interested in a good, confident start and a setting up of line weights and form.

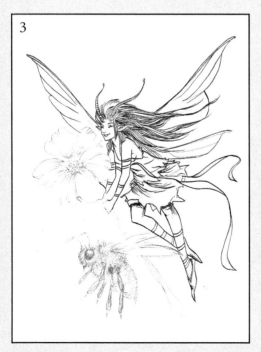

fig. 3 Still working around the image—making sure your lines are clean and fluid; don't labour too long on each stroke to ensure you avoid your drawings looking stiff, which results in blandness. It's often worth having a separate sheet of paper to scratch away at to get you used to things before you begin. That way, you go into each piece with more confidence than you otherwise might have had.

Many people have issues rendering hair; the trick is to keep things simple and make sure your lines are graceful and flowing (especially when drawing long hair).

fig. 4 So now we've reached a point where the details are beginning to emerge. The flower, the bee and the details are all given equal treatment. Remember, no one area should be more detailed than another and always strive to keep the light even throughout.

fig. 5 To finish off, put on your cross-hatching head and go through the image adding darks via cross-hatched lines where the shadows fall. Tighten up any loose areas you might have left and look through the drawing to see if you can improve any areas; there are always areas that can be improved upon. I thoroughly recommend leaving the work for a while and then coming back to it, and checking with new eyes to see if there's anything you might have missed.

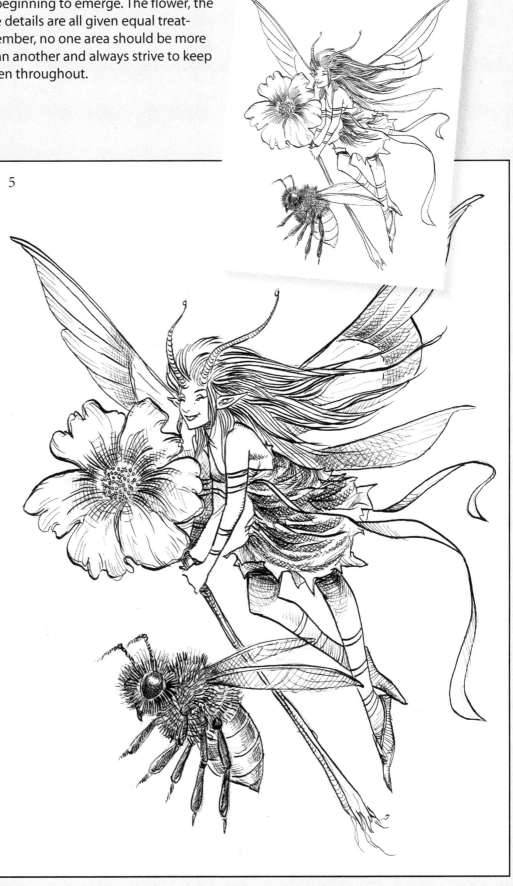

TOP TIP

'A sexy lady with wings stuck to her back does not a Fairy make...'

DRAWING PENS OR DIP PENS?

So... You've made a sketch and you're going to ink it. What tools will you use for the job?

You might think that inking is just, well... inking, and of course you'd be right, but the tools you use add a different flavour to your lines. If you don't like peanut butter, you might like jam—you spread them both on your toast, don't you? I'd suggest having a play with both drawing pens and dip pens and see what suits you best. I often find myself using both of them within a drawing as they both offer a variety of unique strokes. Then of course there are different types of drawing pens and different types of dip pens... Experimentation is the key.

Here are a couple of examples for us to pick apart.

INKING WITH A DRAWING PEN

A good indicator if something has been inked with a drawing pen or not is that the line widths usually aren't varied at all. Having one or two different pen widths can help counter this. My usual sizes of choice are .01 and .03, and sometimes a .05. There's enough of a width difference to make the lines varied for interest (and it is of course very important to keep those lines interesting...)

I make a practice of beginning the inking process with the thinner pen and going around and reinforcing the lines that need it with a thicker one.

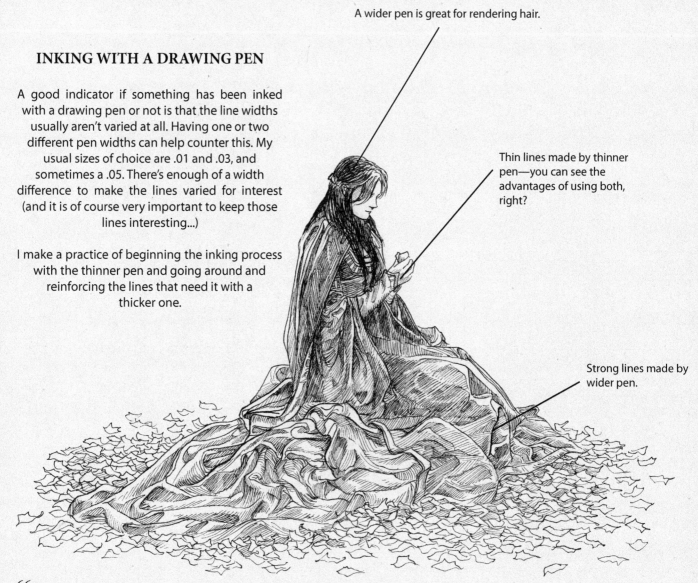

A wider pen is great for rendering hair.

Thin lines made by thinner pen—you can see the advantages of using both, right?

Strong lines made by wider pen.

INKING WITH DIP PENS

There's a reason dip pens are still around, largely unchanged after 100s of years: What could be simpler than a pot of india ink and a holder with a metal nib at the end of it? I love using dip pens; I find the whole thing very therapeutic and the sound it makes as it scratches over the paper is simply music to my ears.

As I mentioned on the previous page, drawing pens AND dip pens both have their place; they're both quick and easy to use and are both very versatile.

Let's take a look at this drawing on the right. Having studied the linework, you'll have noticed immediately that the lines are varied throughout each section, almost 'random' in many respects. Great effort is taken to maintain control over the pen but random lines are often a by-product of a shift in attention, hand pressure, variations in ink flow, etc. So maybe the fun of using a dip pen is the challenge of trying to control it?

A dip pen has a natural tendency to lead into and out of the line itself, causing the start of the line to be thinner, the middle to be thicker and the end to taper off thinner again; if handled correctly, this can look great. There's a reason most of the line art in this book has been rendered with a dip pen.

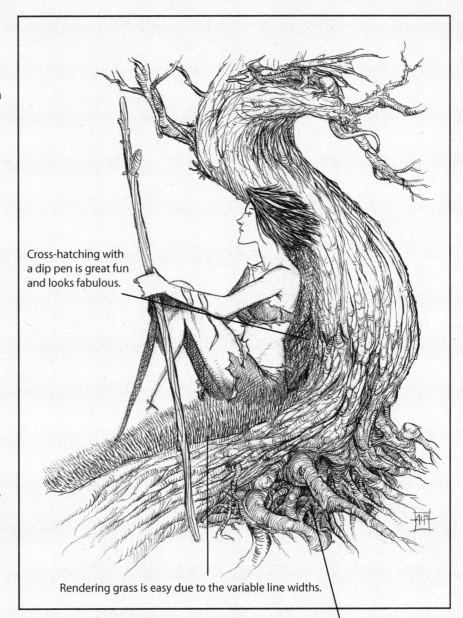

Cross-hatching with a dip pen is great fun and looks fabulous.

Rendering grass is easy due to the variable line widths.

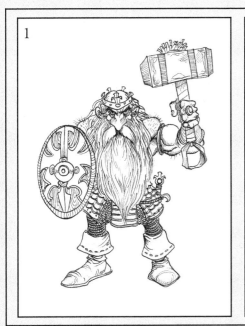

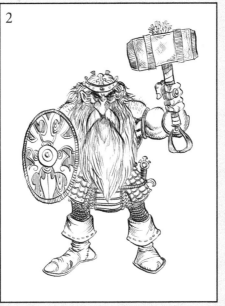

In my opinion, these curved marks are the kind of marks that really put the dip pen in another league entirely...

fig. 1 Drawing pen sample.

fig. 2 Dip pen sample.

Here, I've inked the same drawing twice, to demonstrate how different the same image can look when it's been rendered with both mediums. Do you have a preference?

INKING LANDSCAPES: CASTLE ON THE HILL

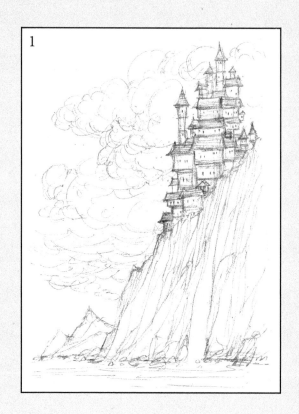

WHAT YOU'LL NEED

A4 sheet illustration board
Nikko G-Pen nib
Winsor and Newton shellac-based India ink

For this demonstration, we'll be looking at inking a landscape. I took this sketch from one of my old sketchbooks and thought it'd make a nice example to ink. As with everything else in this book, we'll focus on keeping things down to a few simple steps. Read on...

fig.1 The sketch has been drawn rather loosely and we're hoping to keep as much of that quality in the inked art as we can. There's a time and a place for highly rendered, tightly inked work, but we don't want that for this particular drawing.

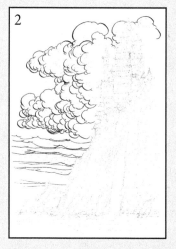

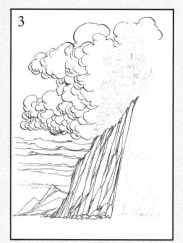

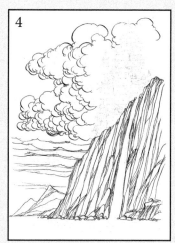

fig. 2 We'll begin with the clouds. As mentioned previously, keep your lines nice and loose, don't over-tighten; we don't want them all stiff-looking. Keep the lines thinner on the horizon and wider as they move towards the foreground. It would also pay to vary line widths and strokes for added visual interest.

fig. 3 Next we'll focus our attention upon the mountains. Ink the rear mountains with thinner lines and again, make them wider as they appear closer to us. This creates depth within the drawing. If you always bear this rule in mind, you'll never have an isssue. Remember... thinner lines at the rear, thicker lines in the foreground...

fig. 4 At this point, we've pretty much decided that this might make a nice piece to add some paint to. So making sure you don't over-work them, keep adding inks to the foreground mountains, again, keeping the lines nice and loose.

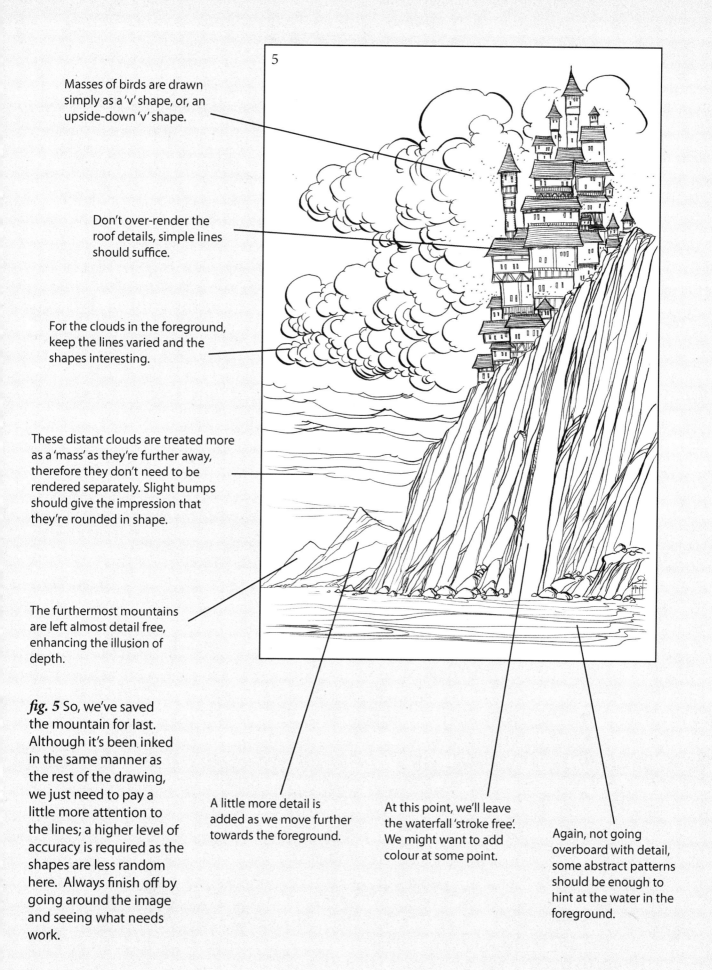

Masses of birds are drawn simply as a 'v' shape, or, an upside-down 'v' shape.

Don't over-render the roof details, simple lines should suffice.

For the clouds in the foreground, keep the lines varied and the shapes interesting.

These distant clouds are treated more as a 'mass' as they're further away, therefore they don't need to be rendered separately. Slight bumps should give the impression that they're rounded in shape.

The furthermost mountains are left almost detail free, enhancing the illusion of depth.

fig. 5 So, we've saved the mountain for last. Although it's been inked in the same manner as the rest of the drawing, we just need to pay a little more attention to the lines; a higher level of accuracy is required as the shapes are less random here. Always finish off by going around the image and seeing what needs work.

A little more detail is added as we move further towards the foreground.

At this point, we'll leave the waterfall 'stroke free'. We might want to add colour at some point.

Again, not going overboard with detail, some abstract patterns should be enough to hint at the water in the foreground.

TAKING IT FURTHER...

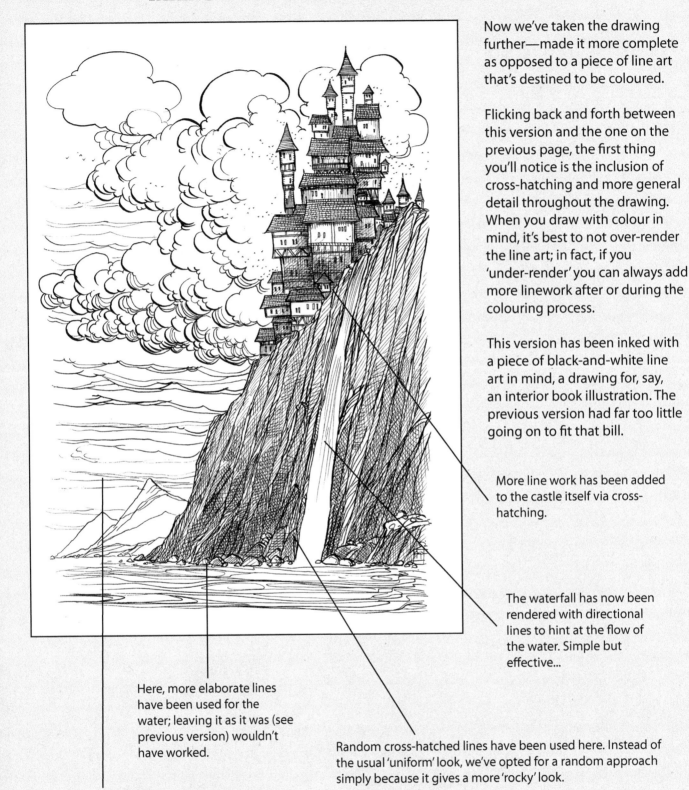

Now we've taken the drawing further—made it more complete as opposed to a piece of line art that's destined to be coloured.

Flicking back and forth between this version and the one on the previous page, the first thing you'll notice is the inclusion of cross-hatching and more general detail throughout the drawing. When you draw with colour in mind, it's best to not over-render the line art; in fact, if you 'under-render' you can always add more linework after or during the colouring process.

This version has been inked with a piece of black-and-white line art in mind, a drawing for, say, an interior book illustration. The previous version had far too little going on to fit that bill.

More line work has been added to the castle itself via cross-hatching.

The waterfall has now been rendered with directional lines to hint at the flow of the water. Simple but effective...

Here, more elaborate lines have been used for the water; leaving it as it was (see previous version) wouldn't have worked.

Random cross-hatched lines have been used here. Instead of the usual 'uniform' look, we've opted for a random approach simply because it gives a more 'rocky' look.

The sky has been given a little more treatment to bring it up to scratch as a piece of line art. Also, in order for the foreground to stand out, it's important we don't go too over-the-top with the sky area.

REMEMBER... 'BALANCE'.

MOVEMENT

A good piece of art is much the same as a story—it should have a beginning, a middle and an end. The most effective way to grab the attention of viewers is to have all your elements placed in such a way as to lead them *through* the story. The illustration below should serve as an example.

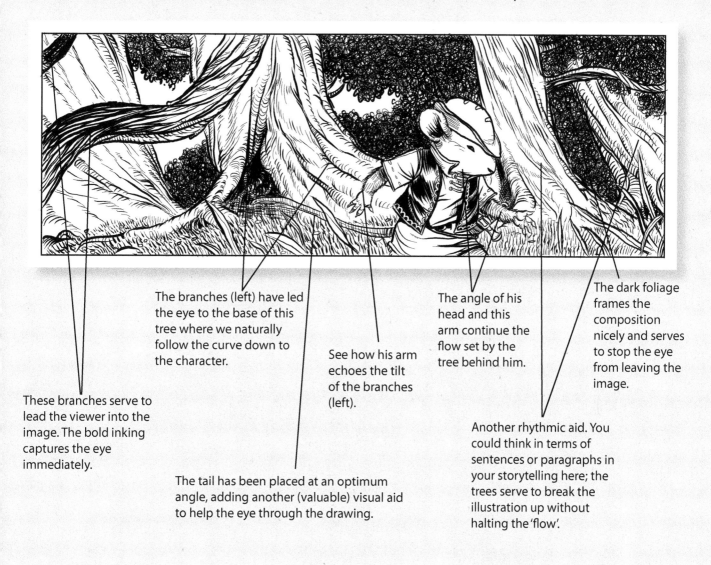

The branches (left) have led the eye to the base of this tree where we naturally follow the curve down to the character.

See how his arm echoes the tilt of the branches (left).

The angle of his head and this arm continue the flow set by the tree behind him.

The dark foliage frames the composition nicely and serves to stop the eye from leaving the image.

These branches serve to lead the viewer into the image. The bold inking captures the eye immediately.

The tail has been placed at an optimum angle, adding another (valuable) visual aid to help the eye through the drawing.

Another rhythmic aid. You could think in terms of sentences or paragraphs in your storytelling here; the trees serve to break the illustration up without halting the 'flow'.

Hopefully this has shown the importance of placing the elements of the composition in anything but a random order. Everything in the image should be singing the same song.

RHYTHM

Here's another example, considerably more complex than the previous one but still built on the same principles...

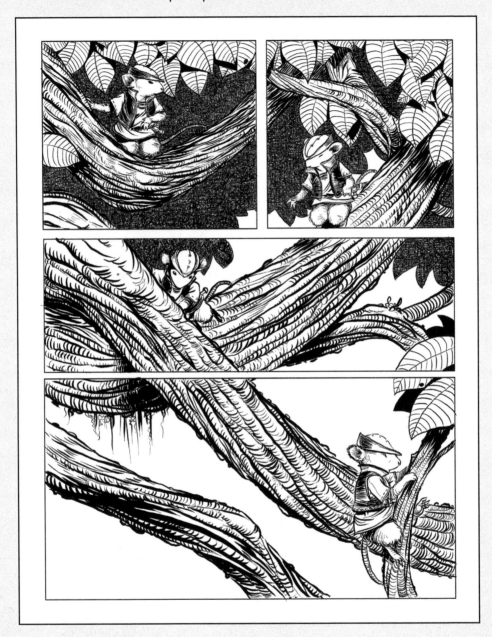

As the teacher, I feel it's my place to explain all the concepts in this book, but with this one, having taken all you've learned so far, I think it only fair that I get to set you some homework. What I'd like you to do is study the way the panels are all interconnected. What makes this comic page a success? What do the elements within it do to aid its success? What elements help your eye 'through' from panel to panel? And just as importantly, Why? Is there a beginning, a middle and an end to this page? If so, where? Follow the lines through from panel to panel—can you feel the rhythm?

Here's an idea... Study just about every piece of artwork you deem 'successful' for a little longer than you normally would, working out in your mind why the image is successful. You'll be learning far more than you realise and it'll eventually work its way into (and out of) your own artwork.

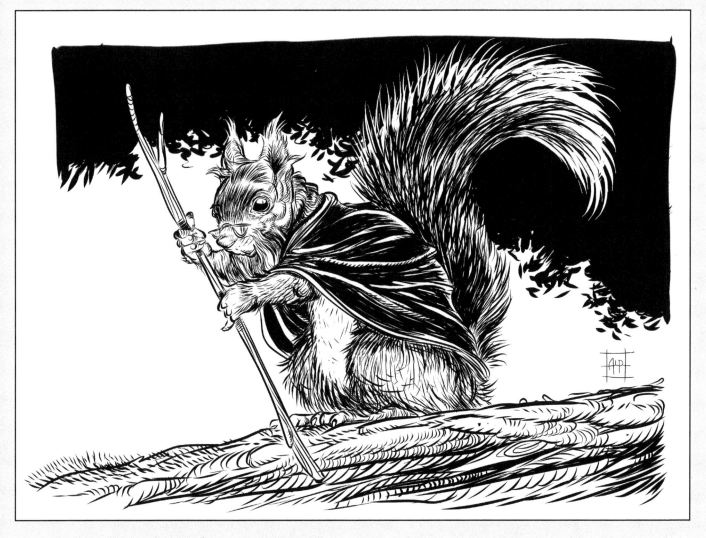

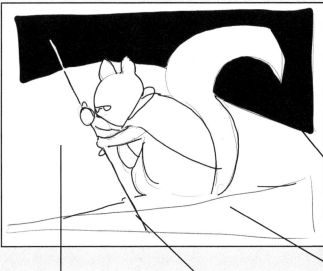

This old Squirrel has received a fair amount of interest and I believe, in part, that it's due to the actual composition employed here. Having a look at the image (above) first, the eye isn't too overwhelmed with details; the composition has been well-balanced with light, dark and mid-tones. If you take a look at the tonal map (left), you'll see that great care has been taken to keep the main focus upon the Squirrel himself, whilst framing the artwork using subtle compositional techniques. Let's take a look...

This pure black area is what 'squeezes' your gaze down into the image. It's so stark, with nothing at all happening, that your eyes are literally forced to look down and through the rest of the drawing.

The white 'negative' space here has been placed within a definite shape; this shape 'houses' the Squirrel.

The staff brings your eye to a halt, again, containing the Squirrel within that definite negative space.

This mid-toned area serves as a platform for the Squirrel to stand on; it also helps frame the composition nicely.

RENDERING TEXTURES IN PEN AND INK

WATER

White gouache has been carefully added here with a size 0 round brush. Be careful not to overdo it.

Here, the paper has been left blank. The spray stands out so well because the area around it is dark.

The dark rocks are in direct contrast to the white of the spray.

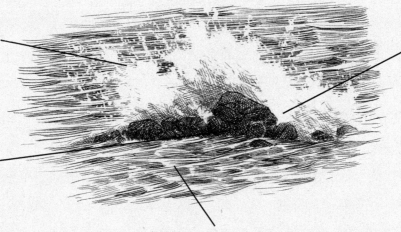

In this example, it's easy to see which way the water is flowing due to the directional strokes and the direction of the spray. Bear these things in mind before you begin inking, to avoid mistakes...

DRAWING WATER—TIPS

I'll admit, drawing water is tricky. But there are ways to handle this seemingly difficult element. The best way (as always) is to break things down into bite-sized pieces, tackling each stage at a time. The demonstration below will help. Remember... SIMPLIFY!

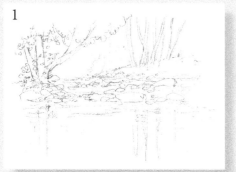

fig. 1 The working drawing. Even though it's been drawn minimally, the drawing contains enough detail for us to begin inking.

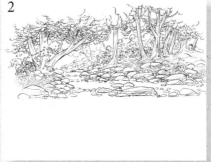

fig. 2 Work around the elements within the drawing, keeping your lines clean and sure. Not going overboard with details, work on the background—the water can wait.

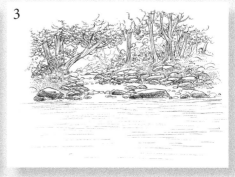

fig. 3 Making ripple marks for the water via broken horizontal lines, we'll build it up as we go. Gently at first...

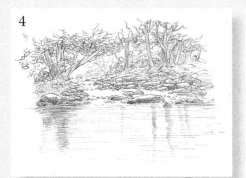

fig. 4 Working on the reflections. This is where we begin to pull the whole thing together. Keep to the theme of horizontal lines, it helps the rhythm... (*note* It pays to *actually* study the way water behaves.)

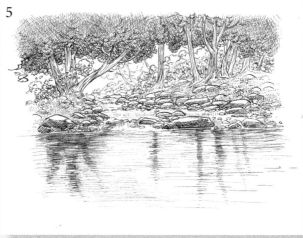

fig. 5 Still focusing on the water, go through from the background to the foreground, paying particular attention to the directional strokes—where the water cascades downwards, use downward strokes. To finish off, go through the entire image and work on the tonal aspects of the drawing, making sure the light and shade is balanced and the reflections are suitably represented.

THE ANATOMY OF A DRAWING: 'A MOTHER'S LOVE'

This drawing has a nice balance of dark and light tonal work, and heavy and intricate line work. What makes it work so well?

Always plan the hair well. It's easy to render well-thought-out hair—elegant, flowing lines are the key.

Here, I've given the baby large scales on his tail—I feel it adds the illusion of being young, much the same as a young child will have toy building bricks far larger than those of an older child.

Lines drawn at a slight angle help to lead our eyes down and inwards. The rocks could have been inked using a lot more detail, but holding back helps keep the focus on the main elements of the drawing— namely, the figures.

The drawing needed a darker area for interest—the heavy cross hatching here balances things nicely.

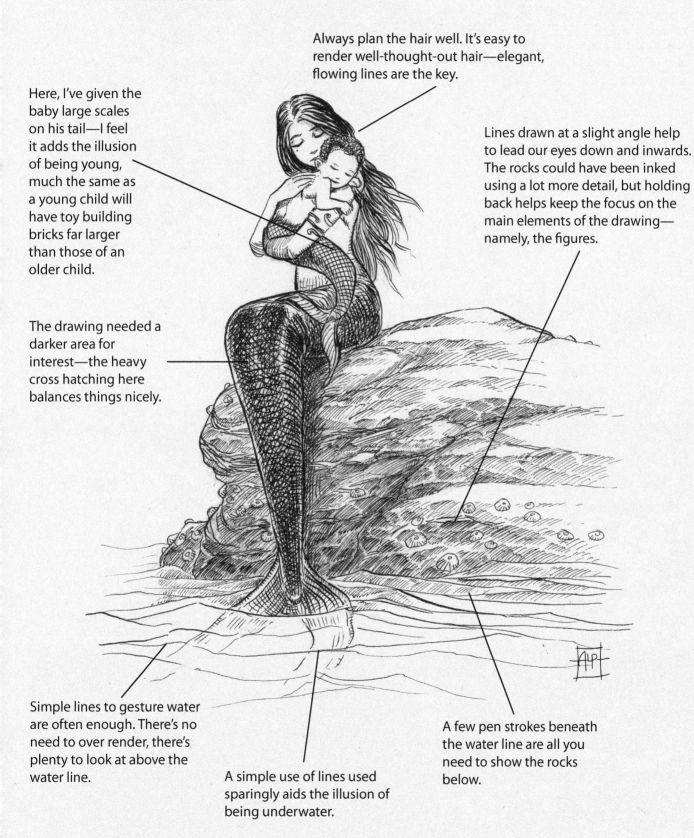

Simple lines to gesture water are often enough. There's no need to over render, there's plenty to look at above the water line.

A simple use of lines used sparingly aids the illusion of being underwater.

A few pen strokes beneath the water line are all you need to show the rocks below.

DRAWING SILHOUETTES

Simplify, simplify, simplify. That's the key to creating silhouettes. You have to break everything down to the bare basics, letting only the very important elements do the talking. You're also required to somehow flip the image into negative mode, but with a little practise, this will all become easy. Like everything you've come across in this book, it's ALL about practise.

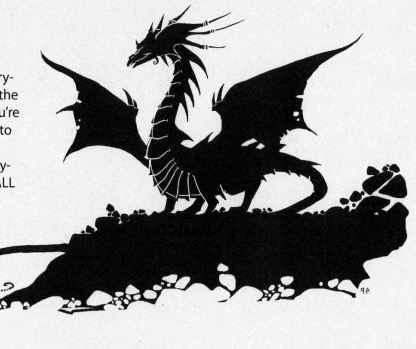

When tackling silhouettes, it's often as important to know and understand what to leave out as it is to include...

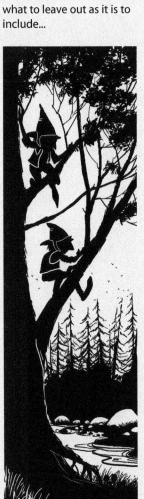

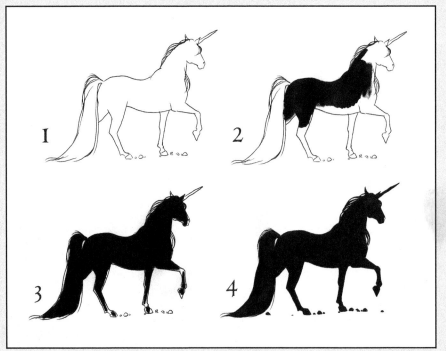

fig. 1 Once you're happy with your drawing, tighten it up, ready for inking. Carefully draw around the outside with your G-Pen nib and Winsor and Newton ink.

fig. 2 Block in some heavy black with a brush, avoiding the edges unless you are super-confident.

fig. 3 Work through the entire drawing with the brush, still avoiding the edges. Keep your hand steady.

fig. 4 There will be areas that the brush hasn't quite reached. If you're confident, reach for the size 0 round detail brush; then tidy up the fine detail lines with your G-Pen nib. VOILA!

76

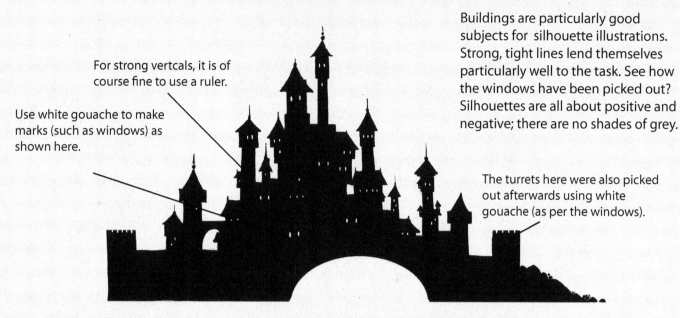

For strong vertcals, it is of course fine to use a ruler.

Use white gouache to make marks (such as windows) as shown here.

Buildings are particularly good subjects for silhouette illustrations. Strong, tight lines lend themselves particularly well to the task. See how the windows have been picked out? Silhouettes are all about positive and negative; there are no shades of grey.

The turrets here were also picked out afterwards using white gouache (as per the windows).

The Dragon (below) was an absolute joy to work on. One of my first successful attempts, as it happens (and probably the most successful commercially, having been featured in a rather good book about Dragons). It did however, come with a few technical challenges, largely due to the fact that it contained many different textures.

Pulling this off convincingly meant that each and every one of them needed the utmost care whilst rendering; no one area of the drawing (particularly when drawing silhouettes) should overpower another.

The Dragon is obviously hiding; therefore, his body language should echo that. You'll find that the more you draw silhouettes, the more you'll begin to realise just how important it is to have strong body language to carry the story.

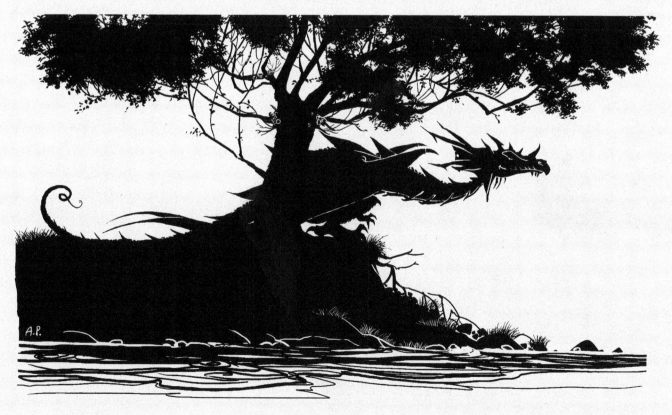

TACKLING COMPLEX TEXTURES IN INK

Even a humble onion has a place in fantasy artwork. Like most effective illustrations, it's made up of many different textures involving thoughtful pen marks. The example (bottom) takes a stylised approach with a nod at realism. I know, I know... this is a book about fantasy art. An onion? Let's take a look anyway...

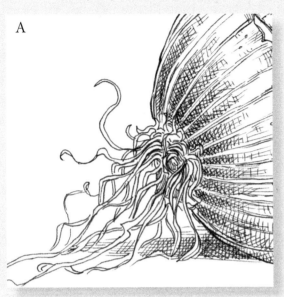

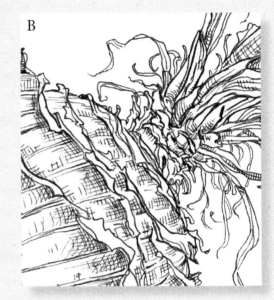

Fig. A
Here's a close-up of the bottom of the onion. Care has been taken to make each one of those stringy strands as coherent as possible. Cross-hatching has been used to good effect here, representing the shadows tapering off as it moves towards the light.

Fig. B
In this example, things are substantially more complicated. Good planning is the key. A well-thought-out underdrawing is the most important thing.

By the time you come to adding your inked lines, everything should be worked out for you.

THE FINAL DRAWING
Overall, the illustration looks far more complicated than it *actually* is.

Remember, detail is just a by-product of 'application', of patience...

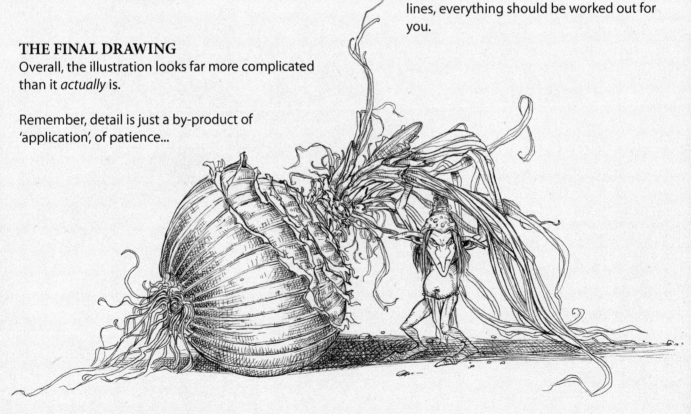

MULTIPLE TEXTURES WITHIN A DRAWING

Keep it simple, keep it tasteful...

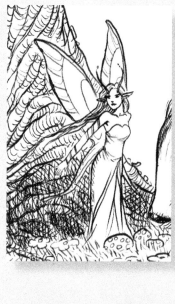

The ink work on the Fairy has been kept deliberately simple, so she shows up against all that detail around her. In fact, take a look at the white of the Badger's head and the white of the Fairy and you'll understand why your eyes are drawn here...

This network of tangled roots has been created using many directional strokes, avoiding the use of cross-hatching until you get into the very darkest of areas.

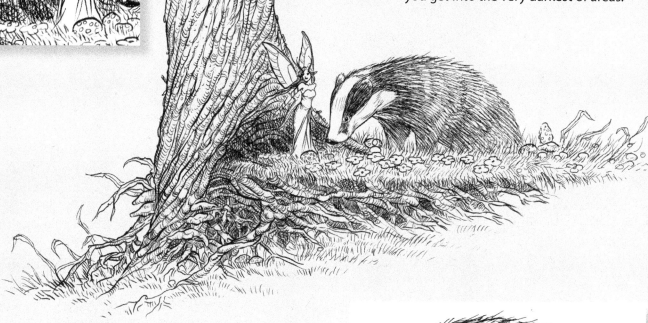

The hair on the Badger has been rendered 'deliberately' also. Starting from the tip of the nose, the lines run along the same angle as the body, helping your eyes along the body and off at the tail. Pen marks such as these force the eyes to look, and to follow...

Here, great care and attention has been paid to the grass and the things growing from the ground. Notice how the grass is growing off at different angles (to add interest); the flowers are all unique, not drawn like some cut-out and stamped on the artwork.

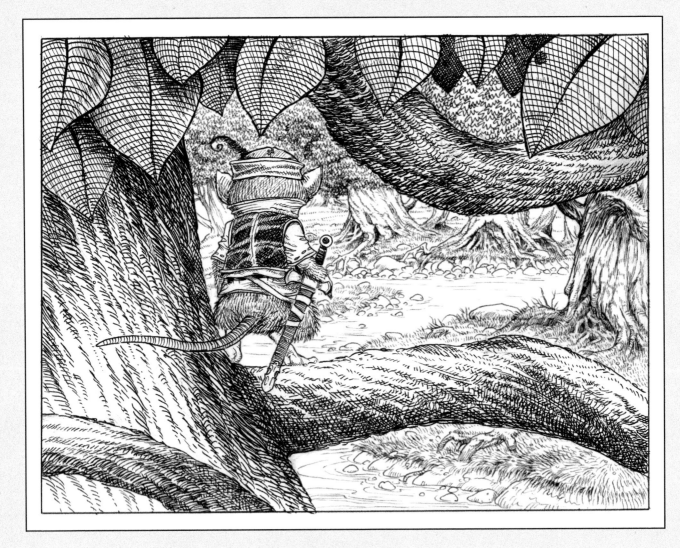

MAKING A MARK

A good illustration will house many tricks, techniques and strokes that will hopefully encourage viewers to move around it and have enough visual interest to hold their gaze a while longer than they otherwise might have. Let's take a closer look at this illustration and break things down.

TOP TIP

Vary your line widths:
Thinner marks for backgrounds,
thicker marks for foreground, result in
INSTANT DEPTH OF FIELD.

Darker strokes in the foreground aid the illusion of an object being closer to the viewer.

Less detail and thinner strokes in the background help the foreground stand out.

Although the trees and grass are still fairly detailed, thinner lines have been used to achieve this.

This area, although devoid of detail, is obviously water. It's very good practice to try and avoid over-rendering your line work.

Light cross-hatching adds a shady effect to the foreground without becoming overbearing.
Remember Subtlety is the key.

The use of angular lines here gives the illusion of form. Carefully thought out marks make a huge difference; always go into an illustration bearing the shape **and form** of an object in mind.

81

ROOTS AND BRANCHES

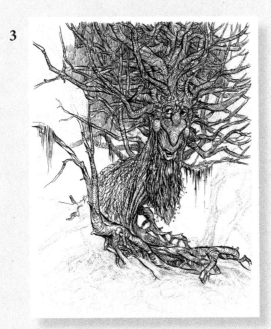

fig. 1 The pencil sketch. I based this drawing on an old sketch from my files. It's handy (particularly when inspiration isn't exactly forthcoming) to go through old work and see if anything still speaks to you. I always liked this one... Immediate inspiration! (Remember, you can find inspiration just about anywhere—*'Seek and you shall find'.)*

fig. 2 Trace and transfer the drawing to your illustration board or sheet of cartridge paper (whatever you use, make sure it will withstand a lot of work). As always, draw some confidence by going around the outside of the image. We're going to tackle things a little differently here by getting into the detail a little earlier than normal. This is largely due to the need for an 'organic' feel. Grow your drawing from the 'inside-out', keeping your lines lively, loose and above all... interesting.

fig. 3 It's important to be aware of the fact that the tree branches are rounded; this look is obtained by using 'round' as opposed to 'straight' strokes with the pen (I know it sounds obvious).

fig. 4 Go through using vertical lines in between the branches; this is where we'll begin to make tonal adjustments throughout. Right now, it looks a bit of a mess, bear with it...

82

5

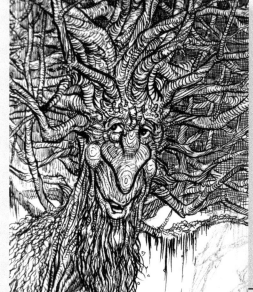

For cross-hatching tips, refer to the diagram on page 56.

fig. 5 Let the cross-hatching commence! Using horizontal lines, keeping your strokes nice and thin, hatch across the verticals in between the branches. What we're trying to achieve here is some depth—we want this area to be dark—very dark—in order to stand out against the branches.

It's important to pay attention to the line weights of the branches and not overpower them; otherwise we'll need to go back in and strengthen them again. The idea is to allow the foreground to stand out against the background elements. Try and keep your lines approximately the same width throughout this portion of the drawing.

6

fig. 6 So now we've established our darks via the cross-hatching of the foliage; it's time to go through the rest of the drawing and equalise all the areas in shadow for unity.

The grassy areas have been handled with angular directional strokes, purposely leading the viewer's eyes from the ground up. The strong verticals and horizontals of the foreground branches (via the heavier lines) have framed the face of the tree, nicely putting the focus, quite rightly, upon his expression.

That area of white at the back, due to its lack of detail, allows the rest of the drawing to shine.

Remember... Balance!

WHAT YOU'LL NEED

1 x Nikko G-Pen
1 x pot Winsor and Newton shellac-based India ink
sheet A4 illustration board
(or quality cartridge paper)

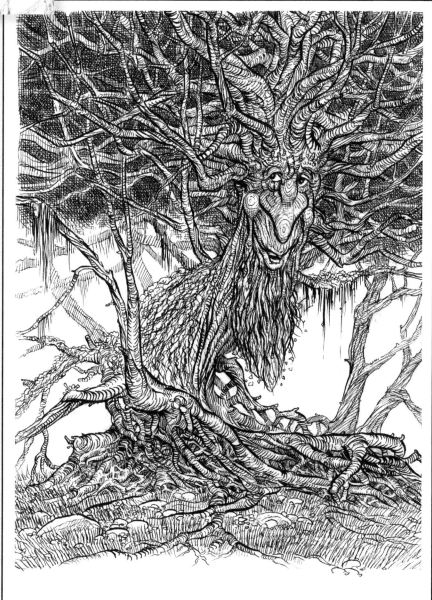

NIGHTFLIGHT

For this demonstration, I've chosen to ink a version of one of my most popular paintings. It was great to pick this apart and work on it in this manner to see and understand what makes the image 'work', all over again.

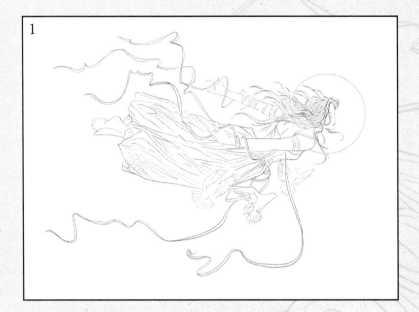

fig. 1 The sketch has been transferred and simplified. Keep the under-drawing simple and don't smudge the pencil lines too much; the mess can make the inking process really quite difficult.

Great care and attention has been paid to the overall composition—we want our eyes drawn to the lady's face and to the moon surounding it. The ribbons, the hair, the 'line' of her body all help the drawing flow to the main area—her face.

fig. 2 Beginning with the head area, each strand is carefully rendered —don't rush, keep your hand steady and your lines flowing... scratchy, bitty lines will ruin this drawing. We're after 'grace' and 'beauty' here.

From the head, work your way down the rest of her body, paying very special attention to the ribbons—they must be rendered using flowy, unbroken lines...

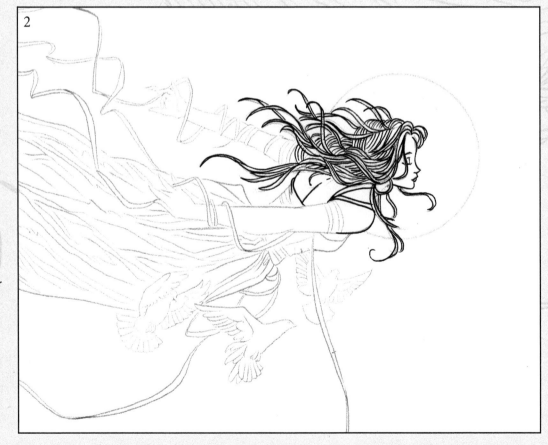

fig. 3 Now we've worked our way through the drawing, The lines are unbroken, everything works, there's nothing to distract the eye. It's important to bear in mind that the inked lines should be consistent throughout the drawing until we begin our cross-hatching.

For the dress at this point, we're only interested in laying in straight lines; the hatching will begin once the whole area has been covered with these directional lines. See how they follow (almost) the same angle through the whole dress? Repetition. It doesn't distract the eye...
For the doves, keep your lines simple.

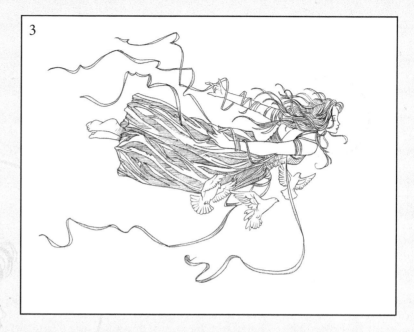

fig. 4 Finishing up... Carefully draw around the moon using 'freehand' strokes if you're feeling confident. If not, use a compass or draw around something round that's approximately the right size.
Go through the dress and add the secondary cross-hatched lines throughout. Leaving the white areas will ensure we keep the natural look of the material. Always go through and tidy any areas that look 'off'.

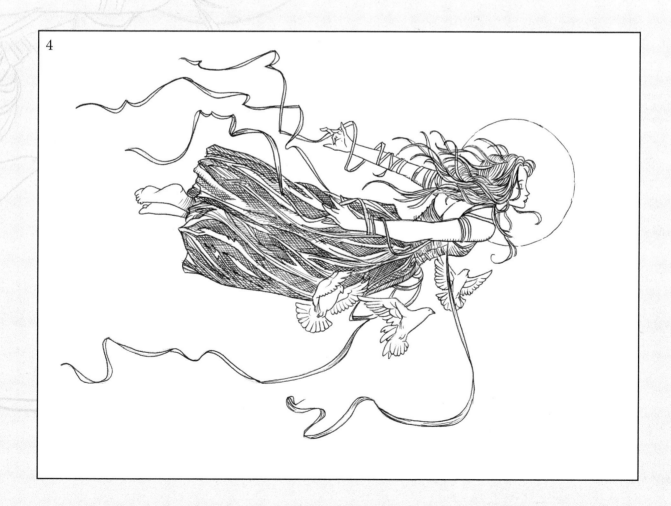

A NOBLE STEED

I've always been fond of this drawing. It seems to be popular wherever it's shown. Bearing that in mind, I decided to ink it and record the steps taken for this book. To me, it's a good example of handling a tricky textural subject and pulling it off convincingly. Read on...

WHAT YOU'LL NEED

Sheet of good-quality cartridge paper

0.1 drawing pen (waterproof ink)

Plenty of patience.

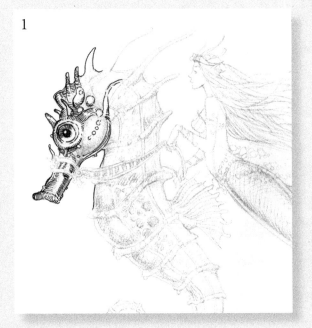

fig. 1
Having transferred the drawing, we begin working on the head of the seahorse. We'll start here, then move down the rest of the body. Remember to keep it simple for now. We can always add more details as we move along through the drawing...

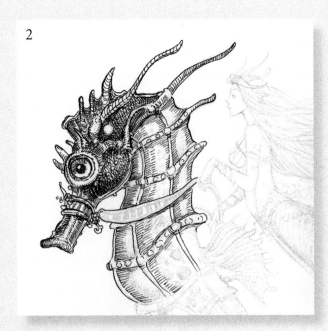

fig. 2
Work from the outside in—begin inking around the outline as if it were a simple cartoon drawing, then increase the amount of detail slowly, building it up as you go.

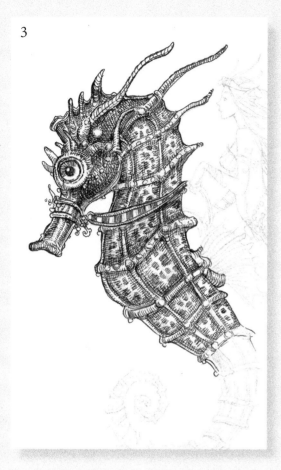

3

fig. 3
Strive to keep the level of detail even and under-render rather than over-render. Pen and ink is a very unforgiving medium to try and correct mistakes you may have made.

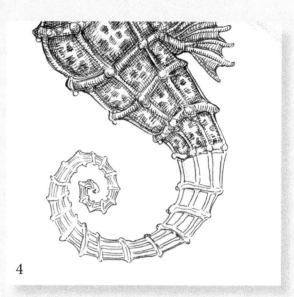

4

fig. 4
Here's a good example of what I was saying in fig. 2. Working from the outline, work your way down from the top to the tip of the tail. Try and develop a working practice for yourself— a set of steps to follow is a great way to make sure you always know what you're doing; the rest is then just a matter of applying yourself.

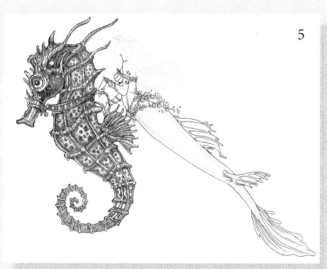

5

fig. 5
That's the seahorse completed. Now we'll focus our attention upon the mermaid. From the word 'go' we'll be bearing in mind that the seahorse is dark enough and if we render the mermaid the same way, it'll end up as a big black mass. Moderation is the key here. Begin with the outline as always, keeping your lines nice and tidy. Strive for elegance.

6

fig. 6
Working our way down the tail here. Building up the cross-hatching gradually, leaving it almost bare along the central line of the tail to show where the light hits.
(See page 56 for cross-hatching demo).

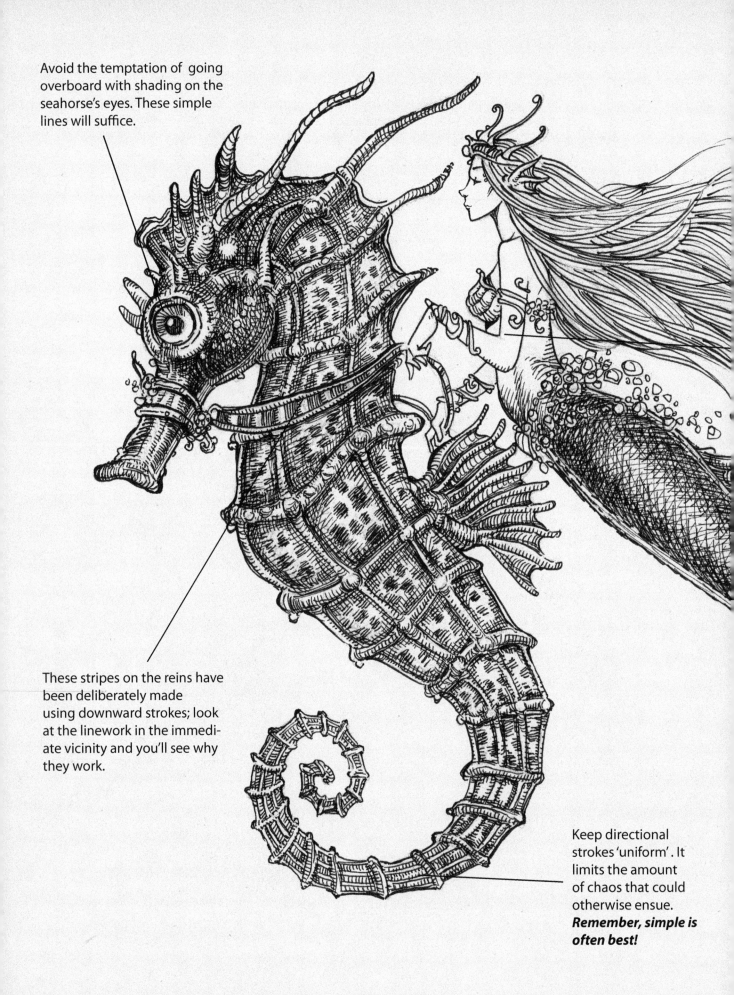

Avoid the temptation of going overboard with shading on the seahorse's eyes. These simple lines will suffice.

These stripes on the reins have been deliberately made using downward strokes; look at the linework in the immediate vicinity and you'll see why they work.

Keep directional strokes 'uniform'. It limits the amount of chaos that could otherwise ensue. **Remember, simple is often best!**

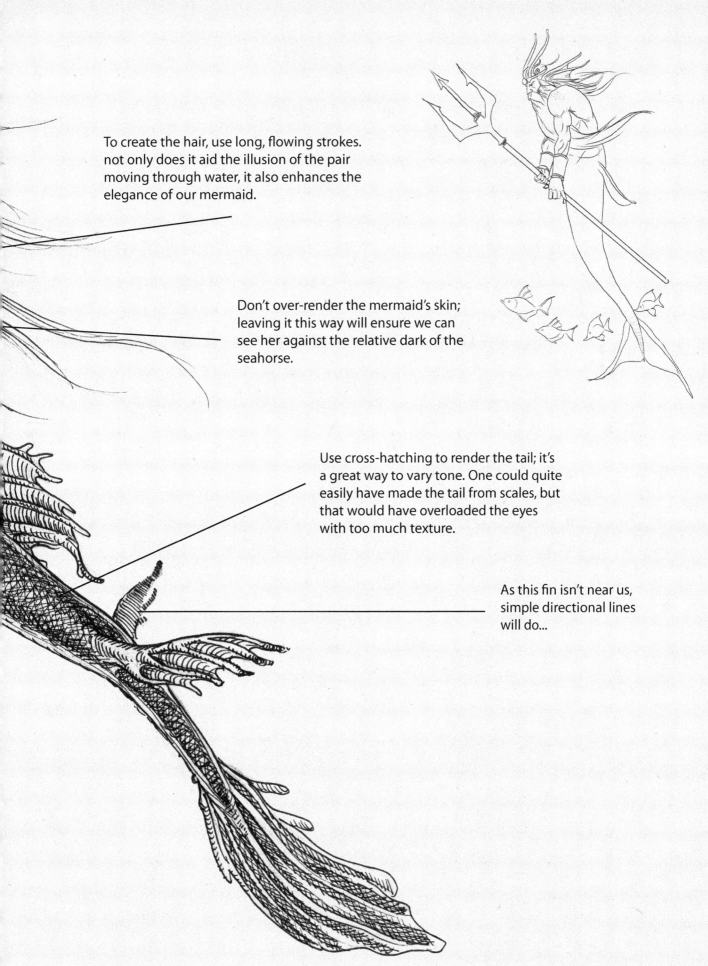

To create the hair, use long, flowing strokes. not only does it aid the illusion of the pair moving through water, it also enhances the elegance of our mermaid.

Don't over-render the mermaid's skin; leaving it this way will ensure we can see her against the relative dark of the seahorse.

Use cross-hatching to render the tail; it's a great way to vary tone. One could quite easily have made the tail from scales, but that would have overloaded the eyes with too much texture.

As this fin isn't near us, simple directional lines will do...

RIP IT UP AND START AGAIN?

We *ALL* experience frustration with a piece of artwork from time to time. It doesn't matter how long one has been an artist, the dreaded 'This-just-isn't happening' boogeyman rears his ugly head and there's no getting away from him. What to do?

SUGGESTIONS

1) Leave your work, go and do something else, then return to it with fresh eyes.

2) Turn it upside down, reverse it in Photoshop—does it look right 'mirrored'?

3) Ask somebody for an opinion (if your ego is ready to hear it).

4) Chant "OM" for an hour.

If none of the above have salvaged the artwork, there's a very good chance you need to start again. And remember, there's no shame in starting over... Think of all you learned from the piece you abandoned. There's NEVER a 100% success rate and the sooner you understand this, the sooner the frustration factor lessens, making way for more great art! Don't let a perceived failure doom future efforts.

...IF IT'S NOT GOING YOUR WAY, IT'S OFTEN A GOOD IDEA
TO JUST SIT AND WAIT FOR THE RIGHT MOMENT...

MEDUSA

Not many characters have set their legend in stone (insert groan here) to quite the same extent as this lovely lady. I've always found her extremely interesting to draw. Let's go through and see how it's done...

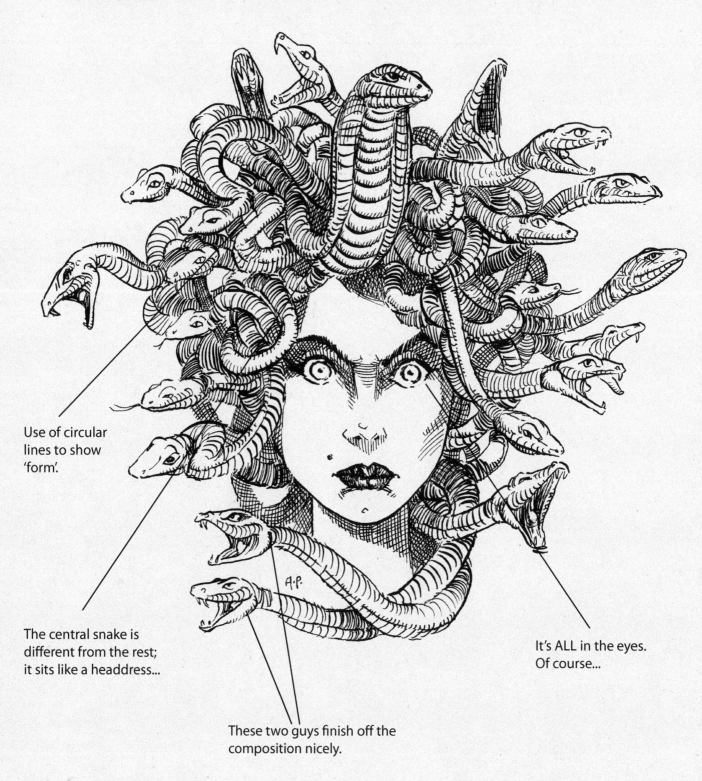

Use of circular lines to show 'form'.

The central snake is different from the rest; it sits like a headdress...

These two guys finish off the composition nicely.

It's ALL in the eyes. Of course...

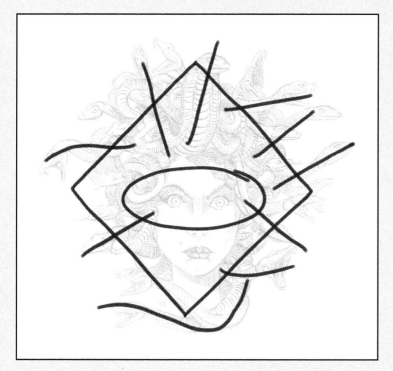

Here we see the compositional approach I took to achieve the image. I always had a 'frame' in mind; the focus needed to be on Medusa's eyes, so the snakes were arranged in such a way as to draw attention to them. If you study the diagram on the left you'll see how many of the snakes point 'in' to her face; these aren't randomly placed however, much thought has been given to their placement.

Never leave your compositions to fate—try and control as much as you can without eliminating the chance of a 'happy accident'.

Notice how the stark white of her face stands out against the chaos of snakes surrounding her? This is another thing that draws our attention to her face. Not to mention her eyes themselves...

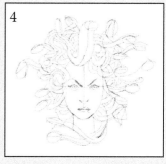

fig.1 Begin with the basic shape of the face. (See, I refrained from saying: "Start with an egg"...)

fig. 2 Squiggly lines and circles to gesture in the snakes. Easy peasy...

fig. 3 Once the gestural lines have been laid down, go around each of them and give them form, paying particular attention to the way they intertwine. Next, begin working on the face, again laying in gestural lines to help guide you.

fig. 4 The rest of the process is largely a 'fleshing out' process. See the finished image (above) for compositional tips.

INKING TRICKY TEXTURES—FABRIC

These two drawings are really an exercise in light, and, bearing that in mind, I set about using directional lines to add rhythm and energy throughout. The goal was always to show the beauty of the lady and the grace of her pose as she slept, keeping the focus upon the top half of her body. The directional strokes were purposely chosen to draw the viewer's eyes to the lightest portion of the drawing, hence the lack of pen marks. Pay particular attention to your line weights, and try to avoid overly cross-hatching, using it only in passing to add depth to certain areas.

Overall, harmony has been achieved by constantly monitoring the balance of light and dark, being careful not to go too heavy with either. If you look at both of these drawings, you'll see that the head area has been left lighter in comparison to the rest of the drawing; the hair acts as a 'halter' forcing your eyes to rest here. This has, in effect, led your eyes to the main portion of each drawing, allowing your gaze to settle upon the face of our sleeping beauty.

The natural 'S' composition, made by the dress and the pose of the lady is of great help also...

Minor cross-hatching for added depth. Careful not to overdo it...

'A Sleeping Beauty'. 2010 (pen and ink)

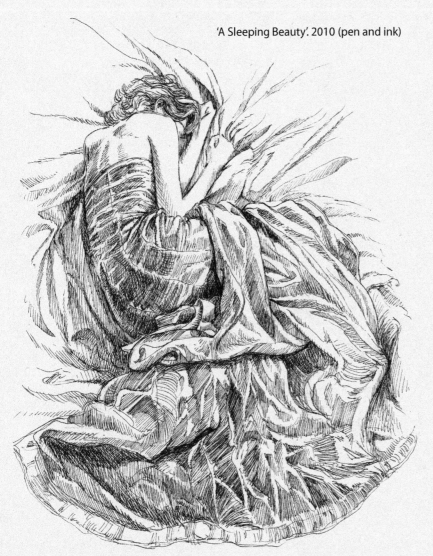

94

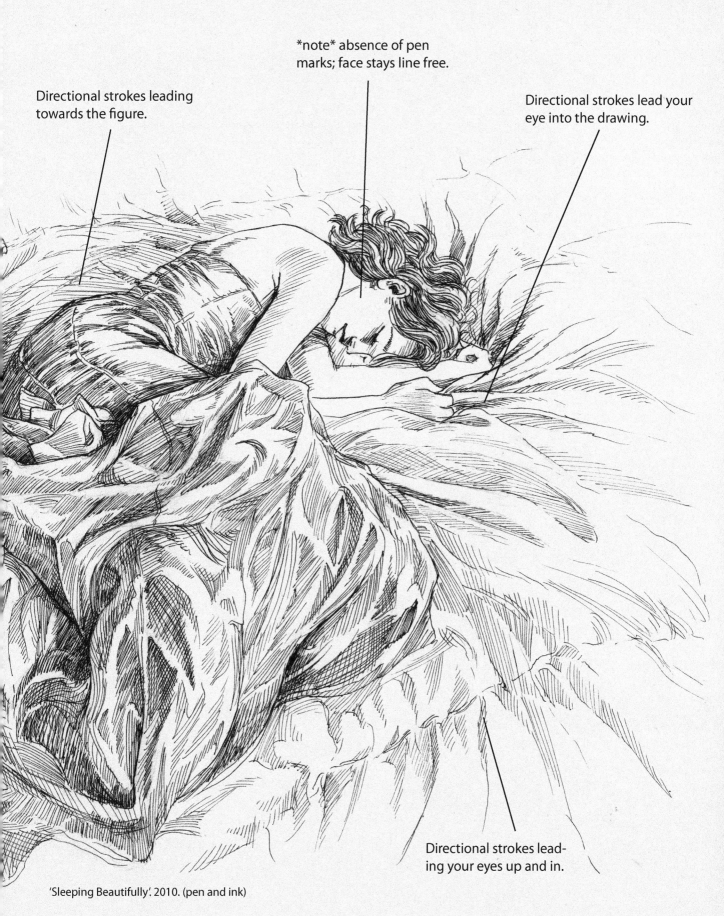

note absence of pen
marks; face stays line free.

Directional strokes leading
towards the figure.

Directional strokes lead your
eye into the drawing.

Directional strokes lead-
ing your eyes up and in.

'Sleeping Beautifully'. 2010. (pen and ink)

WATERCOLOURS

'Still life' 2001. Watercrolour on Saunders Waterford 300 gsm Hot Pressed paper.

Water, and some colour! What could be simpler?

Watercolour is far more versatile than most would think, and even more importantly, it's a great medium to work with! It can be used in a wide variety of styles and techniques, mixed with other mediums. It still retains an element of unpredictability that I haven't found with anything else and, if you're anything like me, the 'thrill of the chase' will excite you enough to pursue it as far as you can go. I intend to spend the rest of my life attempting to master watercolours, but for now, let's have a look and see what we can learn...

It's a good idea to start out with a set of pan colours (always artist's grade paints, by the way) and make sure you have a few tube colours too (at the very least, the 'primary' colours, red, yellow and blue). Contrary to popular belief, you only need a few brushes. I'd recommend a large mop, a round wash brush, a detail brush, and an old brush for scrubbing in/lifting out purposes.

The paper you use is largely dependent upon the style of painting you wish to pursue. For highly detailed work, it's a good idea to use Hot Pressed paper (Arches being my favourite). For more 'washy' paintings, I'd recommend either Cold Pressed or Rough paper. They all have their place and you'll find your own preference in time. Please allow yourself space to experiment—it's the fun, no pressure stuff that'll often reap the best results.

Try and follow the steps, tips and techniques documented here as best you can; there's plenty here to give you a good head start. Enjoy yourself!

Get to know your medium. The only way you'll learn how to control watercolours is to use them. Try out different styles, different papers, different brands of paint. Vary your colour schemes and subject matter. You may stumble across subject matter and techniques you otherwise might never have thought of. Work from life, photographs, your imagination... Look at the work of others. Always be open to inspiration.

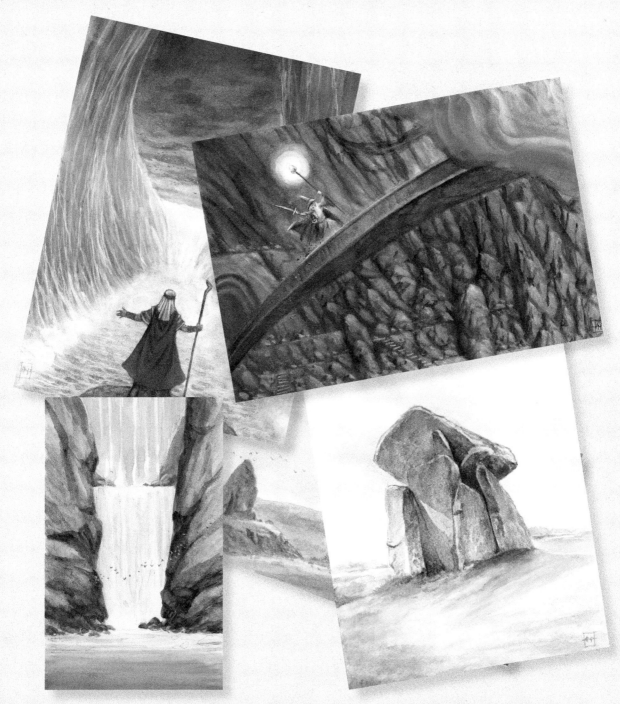

I'll let you into a little secret... Watercolours used to scare the wits out of me. I worked in an art store/framing shop and used to gaze in awe at the watercolour work of others, wishing I could do it too. Day after day I heard the paints on the stand calling me until I finally gave in and bought myself a set... I'm glad I did.

Watercolour is a very rewarding medium. Give it the time and dedication it requires, then sit back and enjoy it—you'll be glad you did.

WATERCOLOUR—SHORT DEMONSTRATIONS

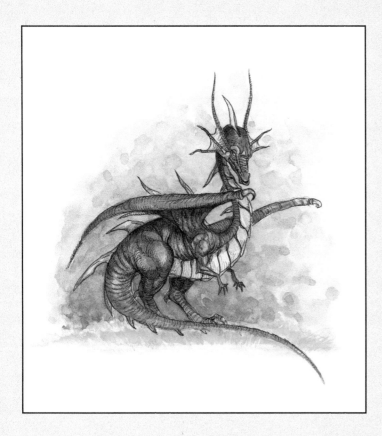

Watercolour is a very tricky medium when you first start out. As you are holding this book in your hands, I'll take it that you've had a tinker already and would like to learn how to do a bit more with them... As there are plenty of books already out there in the world that deal with the history of watercolours, and give a detailed breakdown of the ingredients, we'll save this precious space for some practical stuff. I don't know about you but I far prefer a more 'hands on' approach.

In this section, we'll be looking at a few short demonstrations looking at the best (and often the quickest) way of getting from A to B. Of course, watercolours can be used for lightning-quick sketches, but they are also capable of producing highly detailed images as well.
Let's take a look...

In this demonstration, using a tree as an example, we're looking at the stages of getting from A to B.

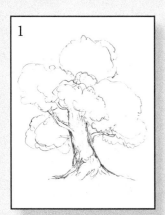 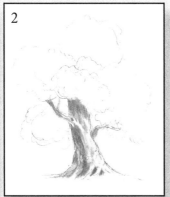 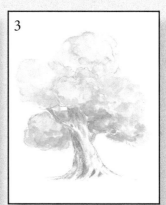 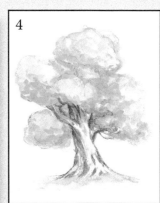

fig. 1 As you can see from this, we don't over-detail the drawing; we want the paint to do the talking without the pencil lines showing through.

fig. 2 Using a size 1 round brush, lay in a light wash of blue, not going too over-board with the details at this point, softly at first, to set the tone.

fig. 3 With clear water, wet the whole leaf section of the tree and lay in washes of Cadmium Yellow and Leaf Green; it's fine to allow them to blend with each other. Remember that the shadows will fall at the bottom, especially as they reach the centre of the tree, near the trunk.

fig. 4 To finish up, work your way around the whole tree, tightening up the foliage with a slightly darker green, paying a little more attention to the form. For the trunk, use a darker colour to add a little more detail.

PAINTING FOLIAGE

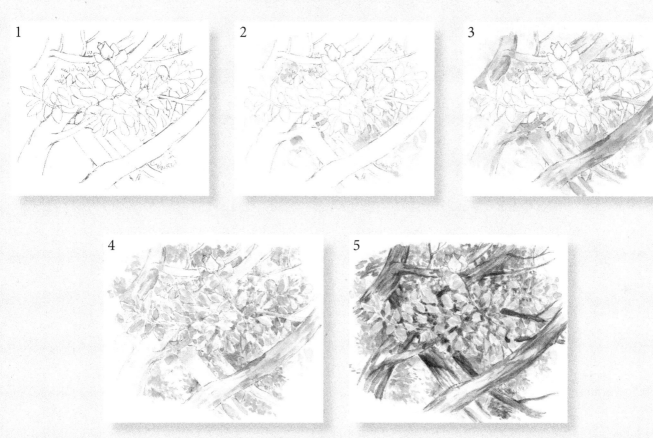

fig. 1 The working sketch. This is quite a detailed drawing, but note the absence of shading.

fig. 2 Wet the areas in between the leaves with some clear water, then drop in some Cadmium Yellow and Leaf Green, allowing them to blend with each other (in fact, this is to be encouraged with background elements).

fig. 3 Using Phthalo Blue and a little Payne's Grey, paint in the branches, adding a small amount of detail only. Work in between the foreground foliage some more with the Leaf Green mix.

fig. 4 Pay attention to the foreground leaves now, varying the shades of green by adding more or less yellow into the mix.

fig. 5 Thinking more in terms of light and shade and paying attention to the details, mix up some Phthalo Blue and Burnt Sienna to create a warmer dark colour and apply it to the branches and in between the leaves. This will separate the leaves and give the painting some depth.

MORE THINGS TO BEAR IN MIND

Different paper types will reap varied results. Try similar paintings using hot press, cold press and rough paper. You'll likely find you develop a preference for one type over another.

All the examples in this book have been completed using artist's quality paints. If you can afford them, I would suggest you do the same. Start as you mean to carry on.

SKETCHING AN ELVEN ARCHER WITH WATERCOLOURS

So, a client has asked you to design an Elven Archer. Here's one way you might be able to bring him to life. Watercolour provides a quick, easy solution.

 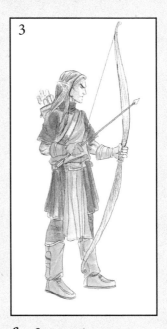 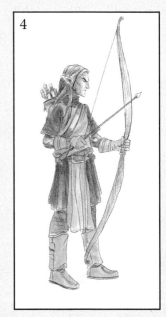

fig. 1 Having sketched the figure, tighten it up, trace it and transfer it to your watercolour paper. For this example, we use 300 gsm cold press (medium) paper.

fig. 2 Make your colour choices, then lay in flat washes of colour. Keep things light here, we can always darken as we go. We're just interested in flat washes at this point.

fig. 3 Using the same colours, (but not so watered down this time) go through and lay in the details. Pay attention to his face, to the straps, and the fabric of his clothing. Again, always bear in mind the fact that watercolours are best left to dry before adding more layers.

fig. 4 Working our way through the whole image, dropping in a little 'cool' colour for the shadows on the shirt. Next, go around the skin and darken the tones up a touch. Then check all the areas that need shadows. When it feels complete, it is complete.

PAINTING A FANTASY LANDSCAPE—'The Seven Sisters'

For this demonstration, we're going to be focusing on a Fantasy/Sci-Fi landscape, incorporating a few different techniques— transparent, opaque and drybrushing. Images of this kind require a fair amount of work, so I hope you've come well-prepared. We'll begin on the following page.

fig. 1 Transfer the drawing, stretch the paper and once it's dry, lay down a wash of clear water with your mop brush and drop in the colours above; allow them to blend together and 'do their thing'. Paint through the floating rocks—we don't want hard edges in the painting.

fig. 2 Having allowed the paint to dry, begin working on the background using your size '6' round brush. Remember, the mountains in the distance will appear less distinct than the mountains in the foreground. Bear 'depth of field' in mind at all times when working on landscapes.

fig. 3 Next, add the details using a size '0' round detail brush. Think of the hills as 'broken by cracks'. That will help you separate them from each other. Although they appear far away, we still want to see all the contours of the land. Everything is painted using transparent watercolours here.

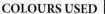

COLOURS USED

Violet
Ultramarine Blue
Leaf Green
Cadmium Yellow
Phthalo Blue
Burnt Sienna
White Gouache

BRUSHES

Size '6' Round brush

Size '0' Round Detail brush

PAPER

300gsm Arches Hot Press

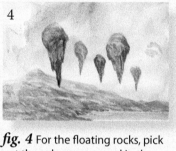

fig. 4 For the floating rocks, pick out the colours you used in the background but apply them more opaquely—we want them to appear sharper as they're closer to us. For the rocks in the distance, use more blue/violet and for the rocks closest to us, use more earthy colours; this separates the distance between the rocks nicely.

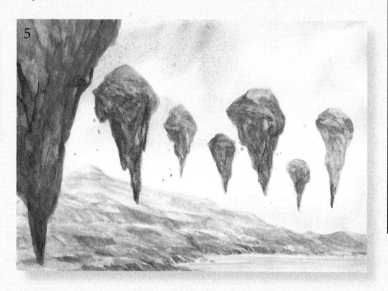

fig. 5 Paint in the details on the rest of the rocks, making sure they're darker as they get closer to the viewer.

For the large rock in the front (left) use a heavy mix of Ultramarine, Phthalo Blue and Violet. This will make it stand out, but still keep the painting balanced. Paint in some falling rocks to show movement.

fig. 6 Go through the painting and add details to the hills and mountains in the background, using more green in the mix for the hills closest to us. Tone down the floating rocks at rear with white gouache, this will help to separate the distance.

Finally, go through the rest of the painting and tidy up any loose or weak areas.

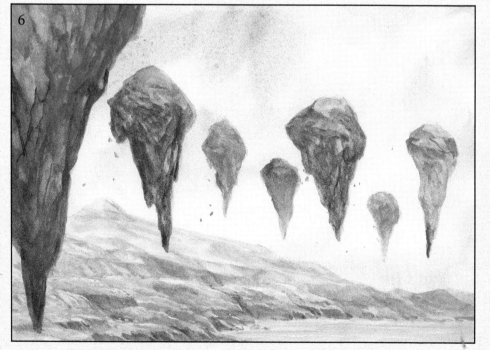

SKETCHING A DRAGON'S HEAD IN WATERCOLOUR

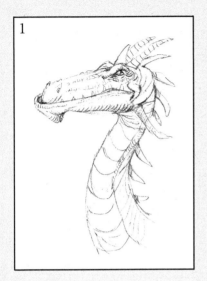

For this demonstration, we'll be focusing on the application of paint. Many people make the mistake of being too 'precious' about making a perfect painting every time. Splashing the paint around in a fun manner can be liberating, too. We've chosen a dragon's head for the subject here.

fig. 1 Having worked out the pose for your drawing, transfer it to your watercolour paper and tighten up any loose areas as you go.

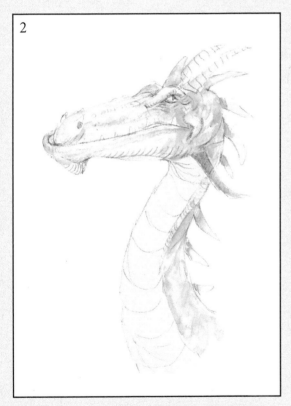

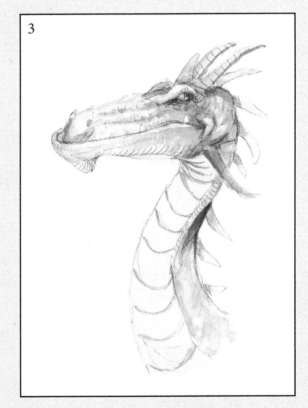

fig. 2 Once you're happy with the drawing, lay in the first washes of colour with your size '6' round brush. First, lay in a flat wash of Cadmium Yellow on the underside of the neck area and for the rest of the head/neck area, lay down a wash of clear water drop in Cadmium Yellow and Leaf Green in the appropriate areas. While it's drying, the paint will spread a little, so you'll need to shape it with your brush if it goes too far astray.

fig. 3 Next, begin adding tonal washes in with Cadmium Red. Here, we're looking to add form to the flat washes we've laid in. We've already established that the shadows fall at the back of the dragon's neck, so bear in mind the way the light will fall at all times from here on in.

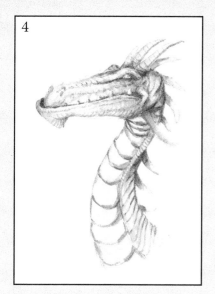

4

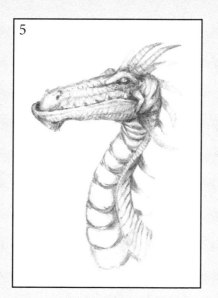

5

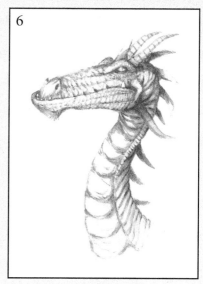

6

fig. 4 Moving around the image now... For the underside of the neck, mix some Cadmium Red and Cadmium Yellow together to create an orange for rounding off the neck plates. Add shadows to the rest of the head/ back of the neck instead of adding any more green. We're looking to add depth now—red will always add depth.

fig. 5 Add details gently, all the while striking a balance between the red and the green paint. We're looking to achieve a 'realistic' feel, although not *too* realistic—we definitely don't want a 'cartoony' look.

fig. 6 With your size '6' round brush and Cadmium Red paint, go through the rest of the image, tightening up the details and adding more shadows. It is beginning to look a lot more complete now.

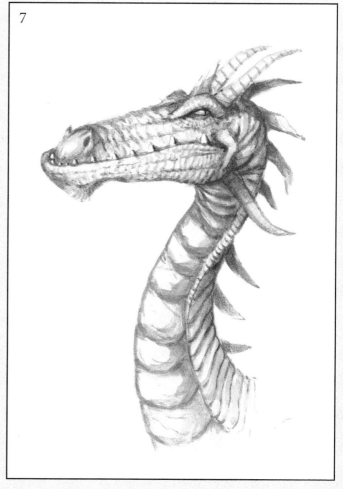

7

fig. 7 The finished sketch. Here we've used white gouache in his eye, for the teeth and touches of diluted gouache/mixed with Cadmium Yellow down the underside of his neck for highlights. As the details become more and more intricate, it's a good idea to use smaller brushes. A size '1' or '2' round detail brush should suffice. Add more Leaf Green to the head and the green areas of the neck, and work your way down the yellow areas of his neck with more Cadmium Red to round the plates off. To finish, go through and tidy everything up, as always.

WHAT YOU'LL NEED
Sheet of A4 Arches hot pressed watercolour paper.
Size '6', size '1' and size '2' round brushes.

COLOURS USED
Cadmium Yellow, Leaf Green, Cadmium Red.
Tube White Gouache

THE ROCK GIANT—Transparent Watercolour Demo

With this demonstration, we'll be focusing upon using watercolours in their transparent form, highlighting application and colour choices.

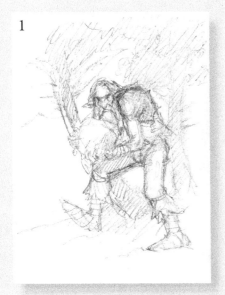

fig. 1 This is the rough sketch I chose for the demonstration, having gone through the handful of thumbnails I made. It's always good to have a few different designs to choose from.

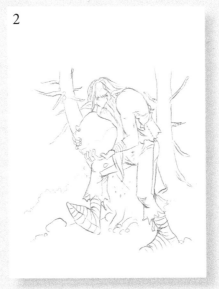

fig. 2 Transfer the finished sketch via tracing paper to your sheet of watercolour paper. Keep the lines simple; we'd like the paint to do the talking with this one. Remember, don't press too hard—we don't want grooves in the paper.

fig. 3 Lay in the first washes with your size '6' round brush, beginning with Phthalo Blue for the bottom of the foliage area.

With a sheet of tissue paper, gently blot out the bottom. Always be aware of the speed hot pressed paper dries at. Leave the edges slightly blurred, we don't want hard edges drying at this point.

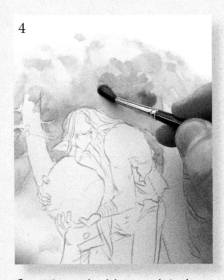

fig. 4 Once the blue wash is dry, add a layer of pure water over the top. While this is still wet, drop in a wash of Leaf Green and another wash of Phthalo Blue.

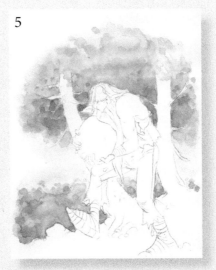

fig. 5 Using the same technique and colours, lay in the bushy area on the ground behind the Giant. Remember to blot the first wash for a soft edge.

WHAT YOU'LL NEED
Sheet of A4
Arches 300gsm hot press watercolour paper
Size '6' round brush
Size '0' round detail brush

COLOURS USED
Phthalo Blue
Phthalo Green
Leaf Green
Cadmium Red
Cadmium Yellow
Yellow Ochre
Burnt Sienna
Sepia

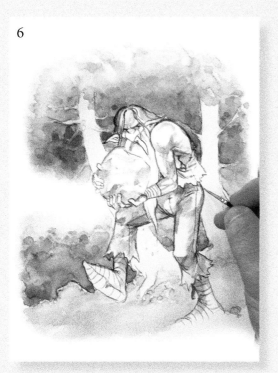

6

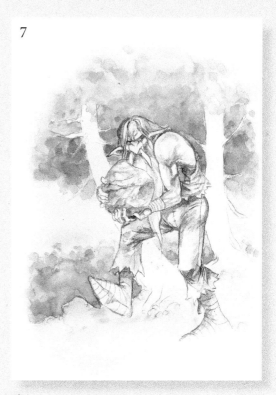

7

fig. 6 Having laid in a light green/blue wash using the size '6' round brush with Leaf Green/Yellow Ochre, we'll begin to turn our attention to the Giant. Using neat Sepia, we'll make an underpainting focusing upon the giant's form, paying particular attention to his musculature and working out where the shadows fall.

fig. 7 The finished underpainting. Great care must be taken here to make sure everything is worked out properly. Musculature, folds in the fabric and shadows should be aptly represented as they will likely 'show through' to some degree.

fig. 8 Now the fun really begins. Here we start to add colour to our giant. Starting with the face, grab your size '0' round detail brush and add tones of Cadmium Red to his nose and skin areas; gently does it, we don't want to have to use the white gouache to tone it down. Moving around the figure, add Leaf Green and Phthalo Blue for his trousers and Cadmium Red for his waistcoat. Remember to lay the colours in with graded washes, allow one wash to dry fully before adding the next one. This process can be quickened with a hair dryer. Next, with graded washes of Phthalo Blue, turn your attention to the trees, adding details as you go, then mix in some Sepia for the dark areas.

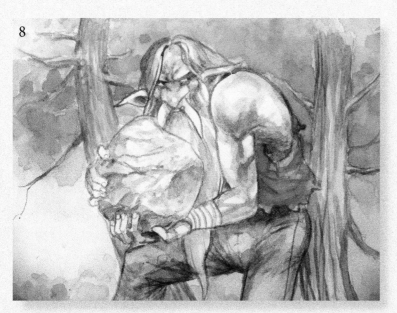

8

fig. 9 Still working your way around the figure, keep your attention on the way the light and shadow fall. We don't want the colours to become flat and lifeless. Don't be too rigid with your application; instead, be mindful of the strength and interest you can create with a 'looser' approach—we want a 'loose but controlled' look here. Lay in a wash of pure water over the trousers and while it's still wet, add a wash of Cadmium Yellow—this will pull the greens together and make them sing. Begin adding details to the rocks and the roots of the trees using your size '0' round detail brush and Phthalo Blue paint. Use Cadmium Yellow, Yellow Ochre and Burnt Sienna for the Giant's hair.

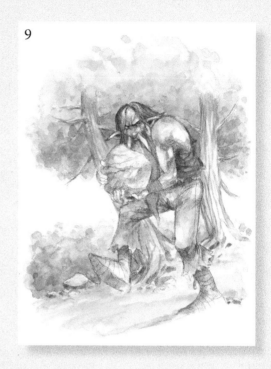

fig. 10 Moving into the shadow areas now, using a Phthalo Blue/Cadmium Red mix to create a warm shadow colour. There are more than enough cool colours throughout this image; by adding more warm areas we begin to balance things out. Also, turn your attention to the boulder he's carrying—a nice mix of warm (Yellow Ochre/Burnt Sienna) and cool (Phthalo Blue/Phthalo Green) colour will do nicely. It's well worth having a look at rock references for authenticity.

fig. 11 Next, pull out your tube of white gouache and with the size '0' round detail brush, begin to add highlights to the giant. First, we'll turn our attention to his face. The highlight on the tip of his nose is a great place to start as it will set the tone for the rest of his face. Working your way around his features, add details and generally tighten things up as you go. Adding that protruding tooth really adds character. Be gentle with the gouache; add the white areas in washes if you must and paint your way into some confidence. As always, it's worth trying these techniques on a separate sheet first.

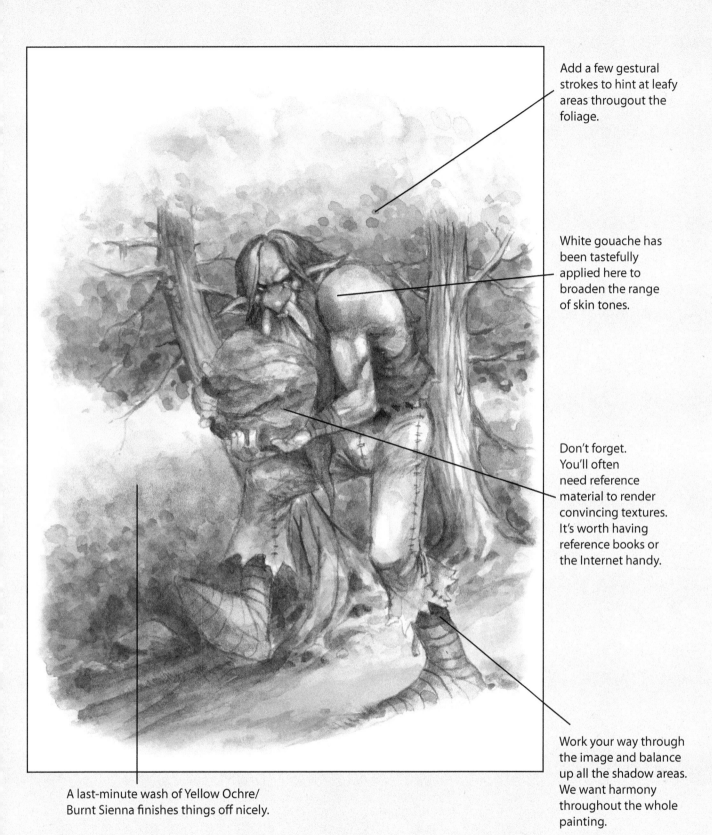

Add a few gestural strokes to hint at leafy areas througout the foliage.

White gouache has been tastefully applied here to broaden the range of skin tones.

Don't forget. You'll often need reference material to render convincing textures. It's worth having reference books or the Internet handy.

Work your way through the image and balance up all the shadow areas. We want harmony throughout the whole painting.

A last-minute wash of Yellow Ochre/ Burnt Sienna finishes things off nicely.

Finishing up

Take a break before you go into the last pass. When you come back, you'll likely notice that the shadows are inconsistent, the highlights need toning down and a whole list of other things may need some attention paid to them.

LINE AND WASH

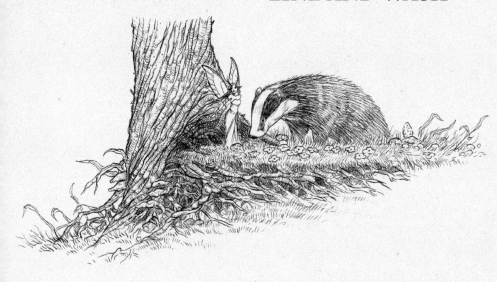

Many of my great artistic heroes (of both yesteryear AND today) employ a line and wash style for rendering their illustrations. I must admit I haven't spent as much time on it as I should, but I intend to rectify that.

For this demonstration, we'll take a drawing I made a while ago and add some colour to it. If I'd had colour in mind from the word 'Go', I might well have drawn it in a more simple manner. That said, let's get on with things.

WHAT YOU'LL NEED
Sheet of Arches 300 gsm cold press paper
Size '6' round brush
Size '0' round detail brush
Tissue paper (for blotting)

COLOURS USED
Leaf Green, Cadmium Yellow, Cadmium Red, Phthalo Blue, Burnt Sienna, Yellow Ochre

fig. 1 Let's begin by laying in a wash of clear water behind the drawing, here's where we'll be painting in the background foliage. While the paper is still wet, drop in some Cadmium Yellow and Leaf Green with your size '6' round brush. Use the rougher paper to its best advantage and let it 'do its thing' as it dries.

1

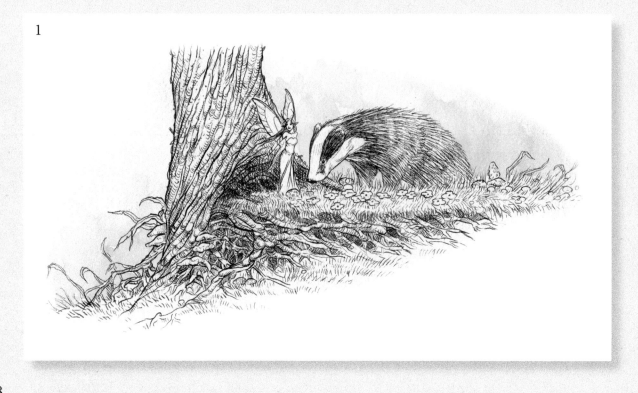

2

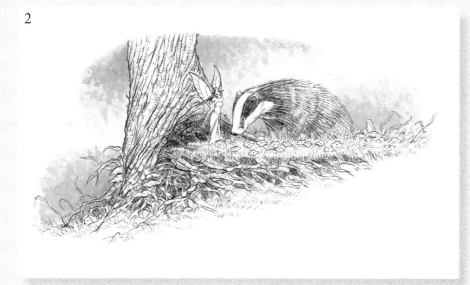

fig. 2 Next, we're working shades of Leaf Green into the background to build up the layers of foliage. Initially, with your size '6' round brush, lay in another wash of clear water and drop in your first green wash, vaguely hinting at leaf details. Repeat this process, making the greens darker and darker as you go. At this point, you should have achieved some depth in your painting—we don't want the background overpowering things here.

fig. 3 This is a technique I use with every watercolour painting I make. I've found tissue paper to be the best material for 'blotting back' areas where you may have gone over the top with water, or too much paint. Always keep a sheet or two handy, (unless you're like me, in which case you'll need the whole roll). It's important to remember not to use sheets that have been used too many times—this can leave unsightly marks or splodges of colour on your painting, which can be difficult to remove.

3

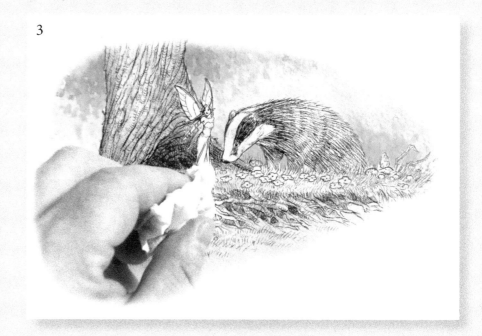

BLOTTING WET WATERCOLOUR

fig. 1 Lay a flat wash of colour into a wet background.

fig. 2 With your tissue paper, blot the colour out while the paper is still wet.

fig. 3 Varied pressure equals varied results.

'Blotting back' is a very handy way to control the amount of paint that you've laid down. It can also be used to create textures (see left). The methods watercolourists adopt are almost as varied as the artists themselves. For 'lifting out' or 'blotting' purposes, some use a sponge, others use cotton wool. I prefer to use tissue paper. And wet tissue paper creates different results again. I recommend you try all three methods and see what works for you. The photos at the left are an extreme example.

4

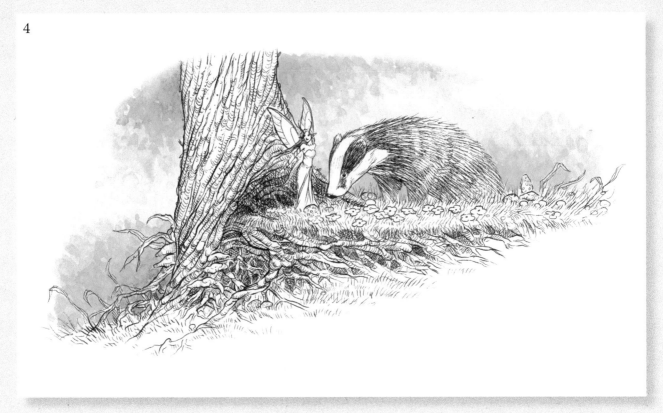

fig. 4 Now we're looking at the rest of the painting, working our way through to the foreground. The yellow and green theme carries through and for the roots and tree trunk we've introduced some Yellow Ochre and Burnt Sienna. Again, these have been dropped into a clear wash of water and have been allowed to blend into each other. Make sure you allow everything to dry before moving into the details and avoid adding too much paint. This can cause the image to become overworked and muddy.

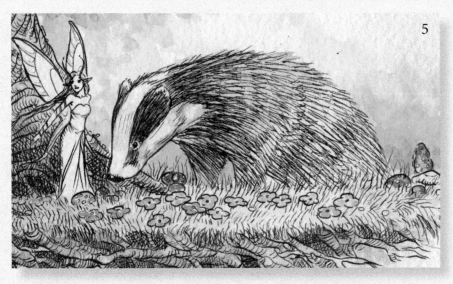

5

fig. 5 Here's a close-up of the story so far. Having worked our way around the foreground figures, we now turn our attention to the figures themselves.

First, let's add some base tones into the badger. Again, lay down a wash of clear water first, then drop in the colours—this will avoid laying down colours that are too dark. We can always darken up the colours in future washes.

Notice how the white has been broken up with Yellow Ochre? It's a good idea to use colours within the painting to do this. White is far too stark to leave as is.

The background is kept deliberately vague, to allow the foreground to stand out.

Simple gestural strokes are enough to make a statement with the foliage here. Again, this allows the foreground to stand out.

Throwing down some cool colour into warm areas is a good way to break the monotony of single colours.

Don't overwork areas such as foliage—allow the lines to do their thing. The colour should compliment the lines (and vice-versa).

Subtle shadows are enough to break up the stark white of the light areas. It's a good idea to pick colours from within the painting as white is a reflective colour.

Avoid the temptation of over painting the flowers and the mushrooms as they aren't that important in the scheme of things. Remember, a little colour can go a long way.

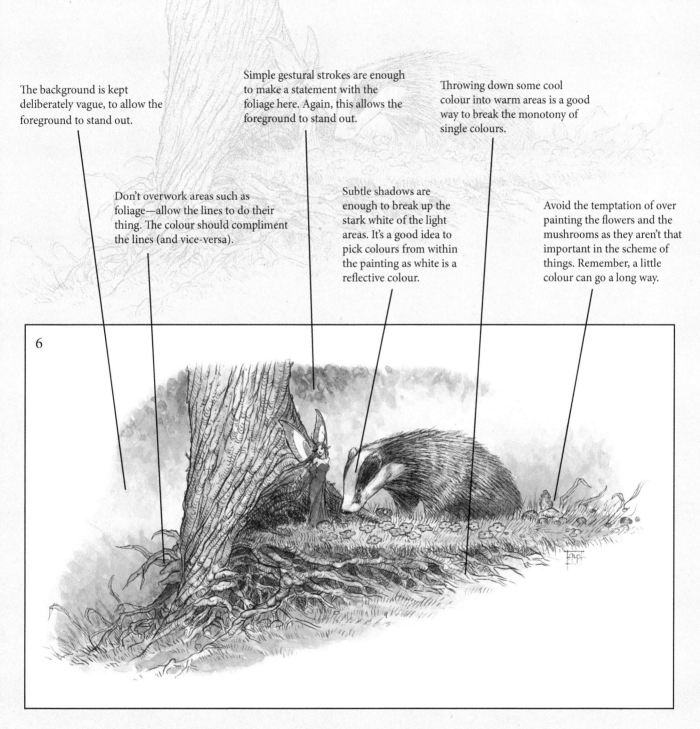

6

fig. 6 As always, finishing up can take a while longer than expected. Having moved through the whole image and made sure everything looks okay tonally, we'll finish up colouring the fairy and the badger. It's a good idea to have a fair amount of the painting completed before you go and add too many shadows to your figures. This will save you from having to update your tonal work again and again. See that little flash of almost 'white' to the right of the Badger's head? That's guiding our eyes into the painting, so let's keep it—another 'happy accident' gratefully utilised.

INK AND WASH

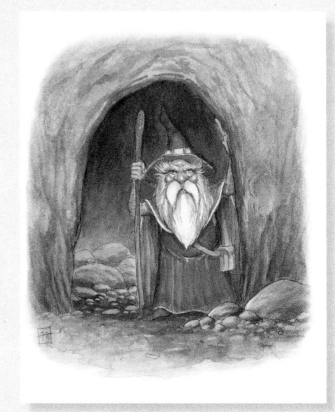

When using watercolours over inked drawings, it's important to bear in mind what you'd like the finished product to look like. It's best not to over-render the line art to allow the paint to sing more. Over-cluttered lines can lead to chaos for the eyes. Keep the drawing clean and simple—you can always add more after the colours have been added, if necessary.

When adding colours to your inked drawing, remember that the ink is there to support the colour, and vice-versa. Allow them both to do their job. Always begin by adding colours lightly, build up in layers until a balance is reached, then stop. It's easy to go overboard. Strive to keep your colours clean and singing out proudly.

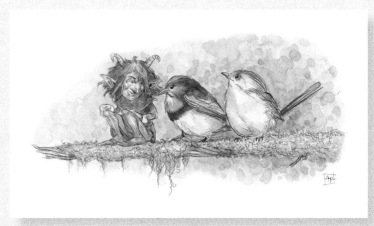

THINGS TO BEAR IN MIND

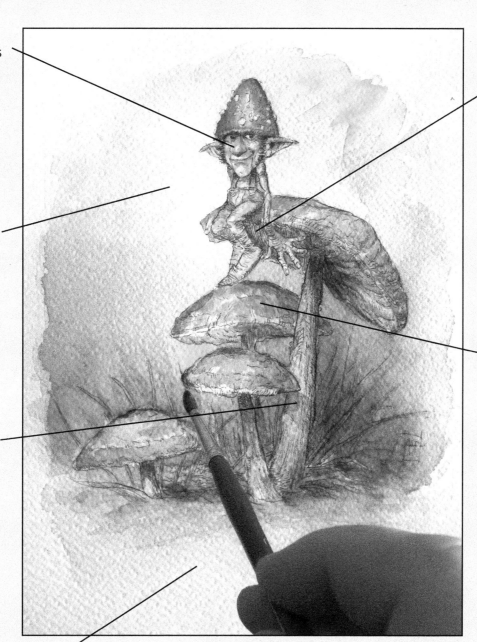

Plan your highlight areas in advance.

Your line work should support your watercolour washes, not overpower them. Think of them as a partnership.

Keep back-ground washes nice and loose to leave the foreground elements sharp and uncluttered.

Strive to keep your brush strokes varied and interesting.

Don't over-render shadows and keep them a neutral colour, as they're part of the whole image; don't allow them to dominate.

Textured (cold pressed or rough) paper is best for loose washes.

A WORD OR TWO ABOUT INKING OVER WATERCOLOURS

Whether the style is loose or tight in execution, you should always bear in mind that the paint and the ink are there to compliment each other. The usual rules apply, however. Depth of field, light and shade and colour intensity should always be considered. Pay particular attention to keeping each area in harmony; don't labour too long over any one element within the painting. *Balance is the key*. This will come in time, but should be borne in mind from the moment you make your first mark.

PAINTING MERMAIDS

fig. 1 The rough sketch is an important part of the process. The elements within the painting should all be worked out at this point. Leaving very little in the way of guesswork will ensure the painting process goes smoothly. Remember, try a few different compositions and pick the one that works best—you'll very rarely get it right the first time.

fig. 2 We'll focus on the figure of the mermaid here. Note the way the drawing was deliberately transferred without the details. It's handy to have the original drawing next to you as you begin the painting process—refer to it as a tonal guide.

fig. 3 This lady is a redhead, but before laying down the obvious colour, give a little thought as to how it would look based on the lighting you've already established with the background. It's a good idea to actually use some of the darks you've used in the background for areas in shadow—this will keep things natural looking and tie the composition together. We want our mermaid to fit into her environment, not stand out.

fig. 4 This painting is an exercise in light and shade and in finding the delicate balance between warm and cool colours. Introducing the plum colour to her tail was a risky move that thankfully worked out, as it is a more neutral colour than I otherwise might have chosen. The gold of her armbands give our eyes a place to settle. Strong horizontal lines in the sky and water also help our eyes to follow her gaze.

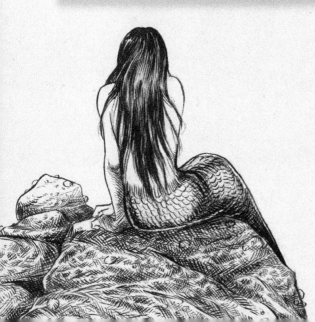

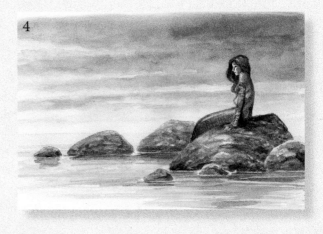

A simple, pleasing composition forms the basis of this painting.

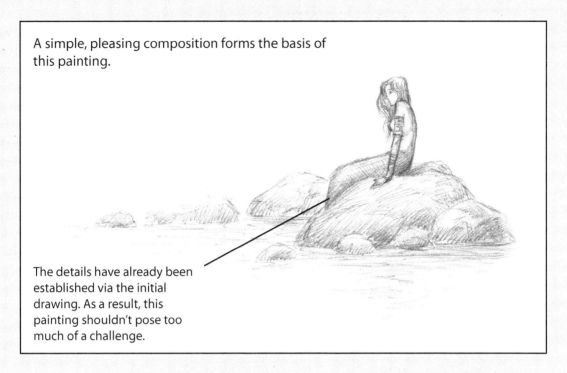

The details have already been established via the initial drawing. As a result, this painting shouldn't pose too much of a challenge.

The clouds have been applied in layered washes and have purposely been left 'streaky' to aid the forward motion of the mermaid's gaze. The light on the horizon breaks the painting up nicely. As her head is set against dark clouds, the left hand side of the composition is a lot clearer—this gives an 'optimistic' feeling. A lost love, maybe? There's still hope, I feel.

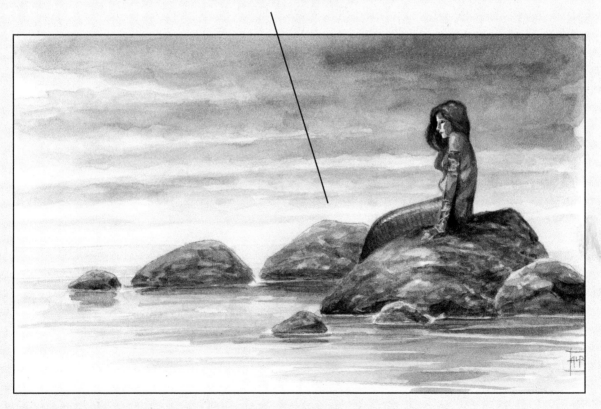

Paintings such as this are *ALL* about emotional impact. Colour choice, the pose of the figure, and the storytelling should all meet and agree with each other.

PAINTING FROM LIFE

Spending time getting to know your watercolours is of course a very good thing. Like any medium, it's worth exploring from every angle you can. One of the things I always recommend to new artists is 'drawing from life' or at the very least... drawing 'real things'. This can only serve you in your quest to eventually produce work from your imagination.

Make as many paintings as you can from what you see around you. Really 'look' at what you're painting. The more detail you can see, the more of the subject's 'essence' you can pick up; then, you can inject more of both into your own work. Remember, your mind is a data bank and it's helpful to fill it with things that will aid your artwork.

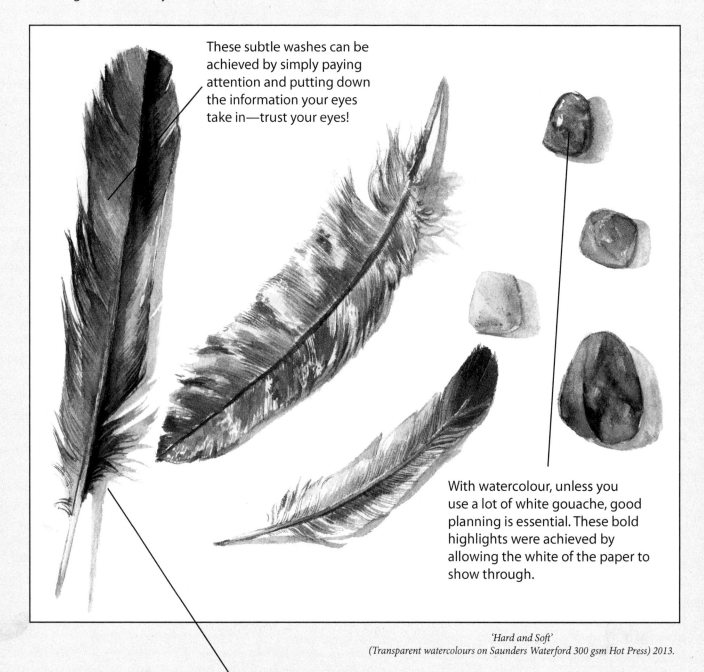

These subtle washes can be achieved by simply paying attention and putting down the information your eyes take in—trust your eyes!

With watercolour, unless you use a lot of white gouache, good planning is essential. These bold highlights were achieved by allowing the white of the paper to show through.

Are all shadows black? Really? Might be worth another look.

'Hard and Soft'
(Transparent watercolours on Saunders Waterford 300 gsm Hot Press) 2013.

116

APPROACHING THINGS DIFFERENTLY

Here we have two completely different paintings using the same medium, only the approach has been handled differently.

In 'The Sentinel' (top) I handled the painting with large washes, a technique which is completely at odds with the way I worked on 'Ladybird' (below).

'Ladybird' required meticulous planning and took the best part of two weeks to complete (a record for me!). 'Sentinel,' however, was painted in an afternoon. I remember it vividly—it was one of those magical paintings that just fell out of the brush onto the paper. It still sits on my studio wall and I'm quite reluctant to part with it.

The leaves in this one were initially sketched as a mass, and a large wash of pure water was then added. While the paper was still wet, different shades of green were dropped in, which resulted in a very satisfactory natural blending of colour. It's a shame the same can't be said of 'Ladybird'. This was one of those paintings that required more patience than I believed I was capable of. It became almost a challenge to complete, proving that sometimes, 'the best things really do come to those who wait'.

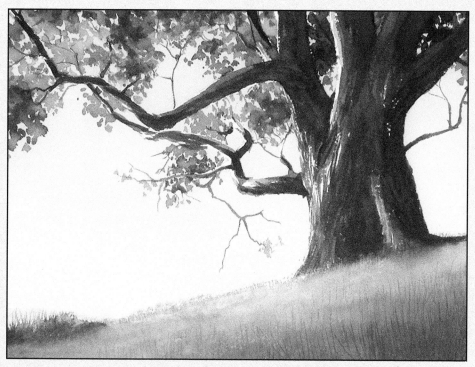

'The Sentinel'
(Transparent watercolours on Arches rough 300 gsm watercolour paper). 2007.

'Ladybird'
(transparent watercolours on Arches 300 gsm rough watercolour paper) 2011.

117

THE CASE FOR GOUACHE

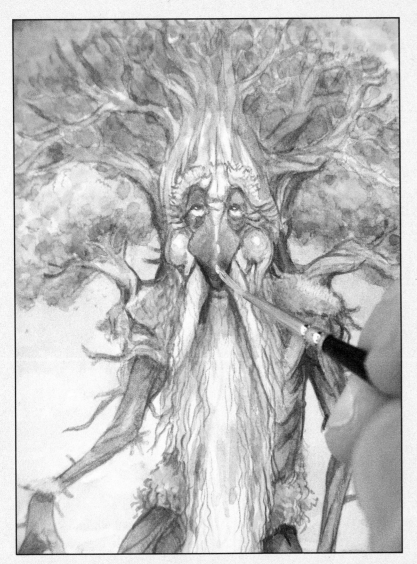

The purists'll tell you it's cheating. Just shake your head like I do and let it drip right off you. When you paint and draw pictures for a living, you soon realise that whatever it takes to make a painting work is just fine. Leave the purists to their nonsense. Of course, their way is quite valid. Leaving white highlights (via showing the white of the paper) is great, but if you aren't a meticulous planner with your watercolour paintings—and let's be honest, not everybody is—then you'll need another way to render those highlights. White gouache IS that way.

As an interesting side note, I've also saved many failed paintings by using gouache over seemingly doomed transparent efforts.

WHAT IS GOUACHE?

Gouache is a chalky, opaque watercolour medium, as opposed to its transparent cousin. It is favoured by illustrators for its covering power and versatility. It's worth experimenting with gouache in its own right if you have the time and financial wherewithal to purchase a few basic colours.

A quick cautionary note... If you aren't done with the transparent side of things, make sure you don't go too crazy with the gouache; it reactivates with water.

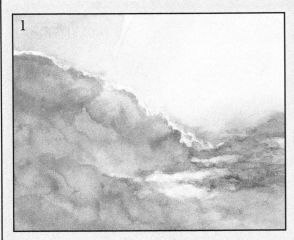

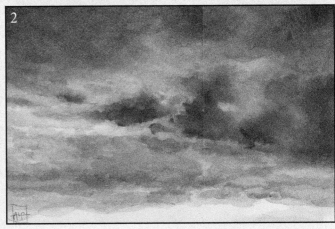

118

GOUACIIE, OR NO GOUACHE?

fig. 1 The Reference Photo.

fig. 2 Transparent version.

fig. 3 White gouache added.

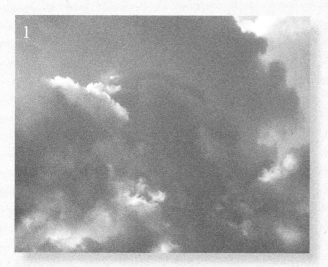

With this example, we've created a cloud painting based loosely upon the reference photo (above).

fig. 2 was painted using only transparent techniques.
fig. 3 Blended edges are achieved using white gouache.

Which do YOU think looks better?

I've used a variety of approaches here; see examples below...
fig. 1 Mostly transparent watercolour was used here; the sun area in the center was painted using white gouache.
fig. 2 I used a LOT of white gouache here; also mixing it in with Payne's Grey to create the graded darker colours and working up to the highlight areas.
fig. 3 This one has been painted 99% transparently. Touches of white gouache have been added to the tips of a cloud or two.
fig. 4 Another (mostly) transparent painting. The whites in this one were all rendered with white gouache.

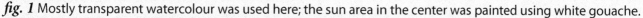

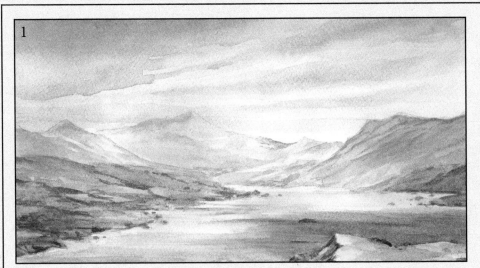

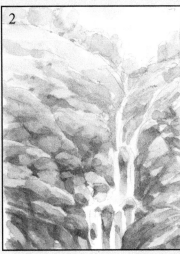

fig. 1 All transparently painted, this one. The goal was to achieve a sense of depth. This was painted on cold pressed paper as opposed to hot pressed—rougher papers encourage more 'wash' than detail.

fig. 2 This one was painted entirely in transparent watercolours; for the waterfall, the white of the paper shows through.

Each of the examples on these two pages was painted in the lounge while my wife watched one of her shows on the TV, (not my favourite thing in the world, watching telly). I use this time to a) Make sure I spend time with 'the wife' and b) Use my down time creatively. No-pressure painting can lead to an understanding of the medium you might otherwise never get if you painted 'seriously' all the time. Telly sketching is HIGHLY recommended; every stroke helps you further along the path. And it's fun!

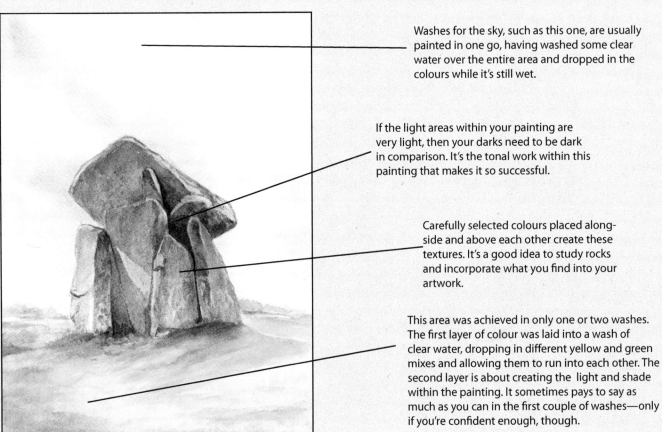

Washes for the sky, such as this one, are usually painted in one go, having washed some clear water over the entire area and dropped in the colours while it's still wet.

If the light areas within your painting are very light, then your darks need to be dark in comparison. It's the tonal work within this painting that makes it so successful.

Carefully selected colours placed alongside and above each other create these textures. It's a good idea to study rocks and incorporate what you find into your artwork.

This area was achieved in only one or two washes. The first layer of colour was laid into a wash of clear water, dropping in different yellow and green mixes and allowing them to run into each other. The second layer is about creating the light and shade within the painting. It sometimes pays to say as much as you can in the first couple of washes—only if you're confident enough, though.

This scene was painted using Arches 300 gsm cold press (medium) paper. The rougher papers are much more suited to large, washy strokes.

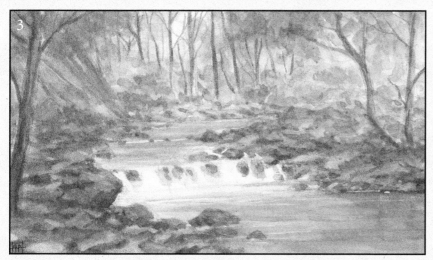

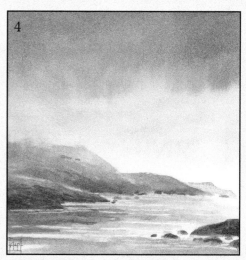

fig. 3 Always keep some kind of colour scheme in mind before you begin. Of course, things are subject to change as you move through the painting, but 'half an idea' is better than none.

fig. 4 A good example of 'wet into wet' for the sky. Limiting your palette can be very liberating too.

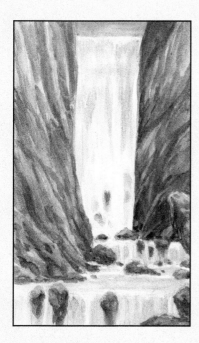

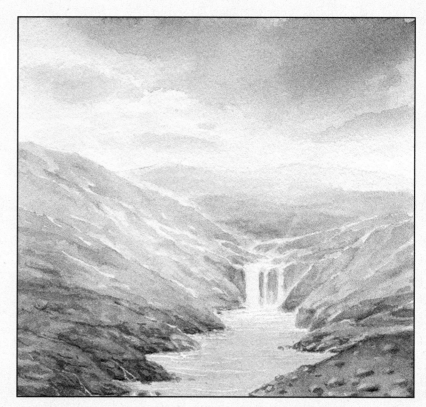

The two examples (left) were painted on Arches 300 gsm hot press (smooth) paper. This paper is far more practical for paintings with a lot of detail. You have to be particularly quick-on-the-draw, as it dries very, very quickly. The painting above was painted onto Saunders Waterford 300 gsm hot press paper (which has a lot more texture).

Experiment with different approaches, different papers, different brands of watercolour paints. It doesn't matter how much you learn, there's ALWAYS something new to try!

'THE DOORWAY'

This is the second time I've painted this one. The first time I painted it digitally, I felt it deserved to have life as a watercolour, so I set about having a go. See the steps I took (to the right) for its progress.

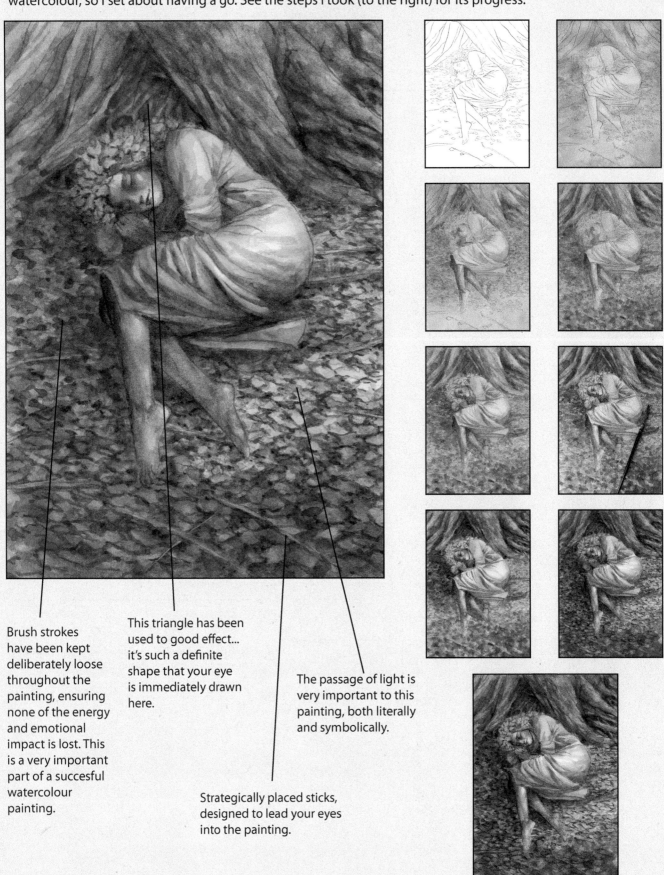

Brush strokes have been kept deliberately loose throughout the painting, ensuring none of the energy and emotional impact is lost. This is a very important part of a succesful watercolour painting.

This triangle has been used to good effect... it's such a definite shape that your eye is immediately drawn here.

Strategically placed sticks, designed to lead your eyes into the painting.

The passage of light is very important to this painting, both literally and symbolically.

PAINTING NATURE

When I first moved to Australia, I was immediately struck by the diversity of the wildlife here; I was so impressed, in fact, that I spent three years as a wildlife artist (to the exclusion of all else). The painting on the right is one of the pieces I made during that period.

I believe with all my heart that those three years of really looking (and seeing) the natural world around me provided me with some valuable lessons. I came to understand the importance of light and shadow within a painting, how much detail was necessary. But by far, the most important lesson for a fantasy artist was to understand the way animals move. As mentioned earlier, studying horses in great depth would surely lead one to paint a convincing Pegasus or Unicorn.

By its very nature, the natural world is where you'll be basing many of your paintings; in fact ALL of the outdoor ones will require a good understanding of nature to make them believable.

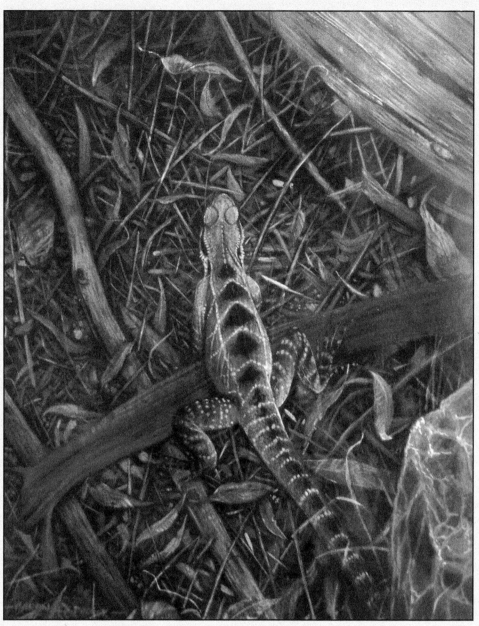

'Eastern Water Dragon' (2001) Watercolour and gouache on Arches 300 gsm hot press watercolour paper.

Painting the leaves on the ground...

fig.1 Lay in washes of colour, keeping brush strokes loose and interesting; we'll be using them (as you'll soon see).

fig. 2 With a dark mix of Phthalo Blue and Burnt Sienna, cut in around the left hand side of the brush strokes to create vague leaf shapes. Make sure the leaves look like the light is falling to the right and the shadows are falling to the left.

fig. 3 Work your way through the whole area doing the same thing. Add yellow and Leaf Green to the darker leaves to break the foreground.

PAINTING A MERMAID USING TRANSPARENT AND OPAQUE WATERCOLOURS

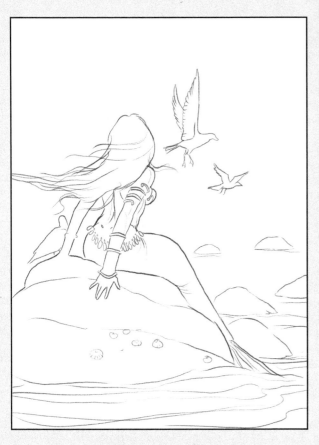

With this demonstration, we'll be focusing upon using watercolour in both a transparent AND opaque manner, hopefully blending the two together seamlessly. It's easy to go overboard with either technique, so as always we're striving to achieve that balance I so often talk about.

Before you begin, remember to take a moment to look at the image in your mind, and see it as clearly as you can.

COLOURS USED

Payne's Grey
Yellow Ochre
Phthalo Blue
Sepia
Ultramarine Blue
Cadmium Red
Burnt Sienna
Cadmium Yellow
Violet
White Gouache

WHAT YOU'LL NEED...

Sheet A4 Arches hot press
watercolour paper
Small pointed mop
Large mop brush
Size '6' round brush
Size '0' round detail brush
Size '2' old, worn filbert (or equivalent) for
drybrushing purposes

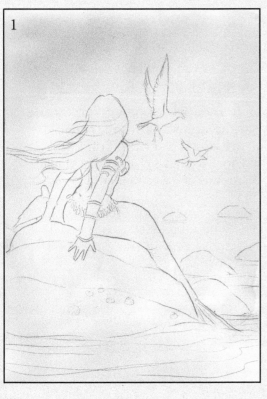

fig. 1 Having taped your drawing to the board, wet the paper throughly using your mop brush. While still wet, lay in a watered down wash of Phthalo Blue. Then lay in a watered down wash of Yellow Ochre alongside it, allowing the two to run into each other.

Let this layer dry naturally as it will take a little time for the colours to do their thing. It doesn't matter at this point if the colours run into the main portion of the artwork, as they will dry very faint.

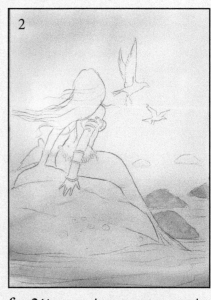

fig. 2 Now, work your way around the bottom portion of the painting, paying attention to the rocks and the water, keeping it loose.

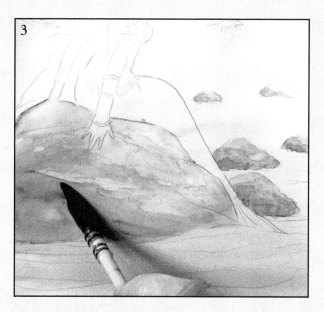

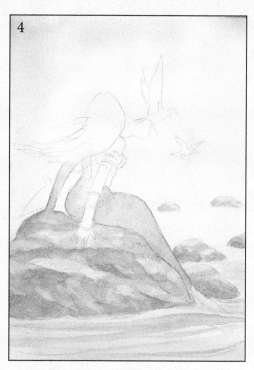

fig. 3 With your small mop brush, lay in washes of Ultramarine Blue over the rocks and the water, taking care to build it up in layers. For the rocks, jagged edges are achieved by adding hard edges with the brush (these will dry to a satisfactory texture). For the water, take care to keep things nice and smooth (we don't want hard edges here).

fig. 4 Work your way around the rocks now. Be sure to let one layer dry before adding another. For depth in your painting, leave the background rocks vague (very little detail) and add more detail to the rocks in the foreground. Using a mix of Ultramarine and Phthalo Blue, lightly paint some wave ripples into the scene—we'll build upon these as we go.

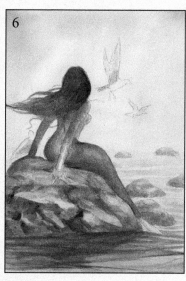

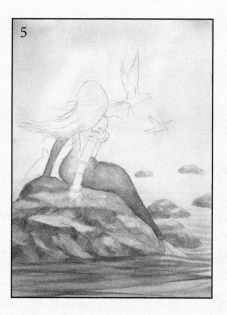

fig. 5 Pay some attention to the mermaid now. Wetting her tail fully, drop in light washes of Cadmium Yellow, Phthalo Blue, Burnt Sienna, and Violet. Allow all the colours to merge—we're hoping to achieve that 'shimmery' fish-tailed look here. Keep the tail darker as it nears the water and gently taper it off with clear water as it rises up her back. Lay a wash of pure water over the foreground and add a wash of Phthalo Blue. Once it's dry, add another layer. Allow this to dry.

fig. 6 We can see the painting taking shape here. Moving further with the mermaid, using the small pointed mop brush, begin adding skin tones with a mixture of Yellow Ochre and Burnt Sienna; drop in a wash of Phthalo Blue for the shadows. For her hair, we use a mix of Burnt Sienna and Payne's Grey, not worrying too much about details, but taking care not to go overboard—we'd like to keep the transparency of the background intact. Paint in the gold jewelry using Yellow Ochre and Burnt Sienna. Use a mixture of Payne's Grey, Burnt Sienna and Phthalo Blue for the shadows below the foreground rock.

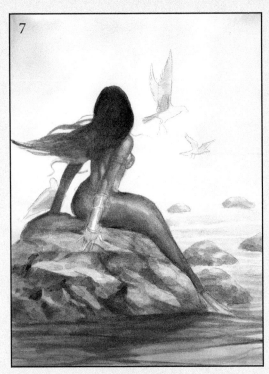

7

8

fig. 7 An important stage, this one. We now make the decision to add opaque paint to the image. First, we lay in white gouache highlights with our size '0' round detail brush, then blend them with a tiny amount of water on our old small filbert brush. This blending will create a far more realistic look. Once the highlights have been added, we then move back into the musculature and the skin shadows using Burnt Sienna. This warm colour for the skin is necessary to balance the colours of the painting. It also helps to draw the eye to the figure.

fig. 8 Shifting our attention back to the tail, we employ the services of our old filbert brush, scrubbing in various tones via a drybrush technique, again making sure to colour the tail darker at the bottom. For this we use Burnt Sienna, Payne's Grey, Ultramarine and Yellow Ochre to add highlights at the top.

These old brushes are great for dry brushing as you don't have to be too careful with them.

9

10

11

fig. 9 Add touches of white gouache for highlights on the metallic areas of the painting, just to make them 'pop' ever so slightly. It's easy to get carried away with highlights, so exercise some restraint.

fig. 10 A great way to achieve texture is to add a wash with plenty of paint, and then pull it out by dabbing a dry tissue against it. It's worth practising this on a separate sheet.

fig. 11 Using the drybrush technique again, scrub in some Burnt Sienna to warm the tail and achieve some balance between warm and cool colours. At this stage, pay attention to the mermaid's hair, using a mix of Phthalo Blue and white gouache, then neat gouache for the highlights. Begin adding details to the rocks using Phthalo Blue and Payne's Grey. This was always going to be a fairly detailed piece, but as usual, we don't want to go overboard (pardon the pun, please.)

For the seagulls, keep things nice and simple. For those in the background, we'd like to keep that transparent look, so only one wash will do. For the bird on the rock, treat it with a more 'opaque' approach, to match the foreground detail.

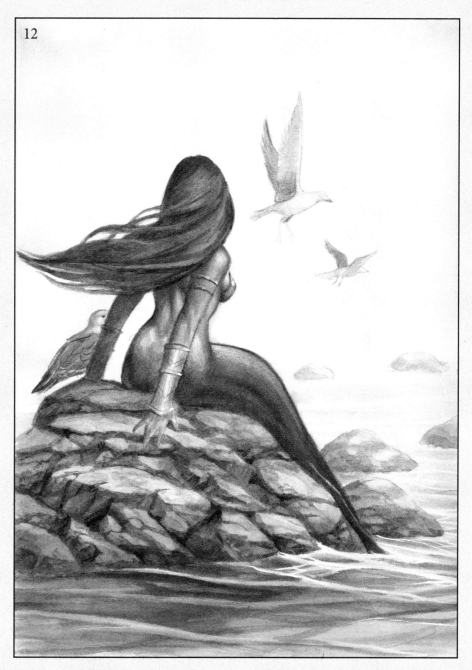

12

fig. 12 FINISHING OFF

First, the water needs some more work. Starting from the background, lay in some gentle washes using diluted Phthalo Blue, gradually darkening as we move into the foreground. White gouache is then applied to the sea to give the illusion of waves. Move back into the rocks and add a dark wash of Payne's Grey and Phthalo Blue in between the cracks; we want this area to look realistic, so a little more detail is necessary. Pull a few of those white gouache highlights into the rocks to hint at the waves gently lapping against them. The tail and the area below the mermaid's back could use a little work. With the white gouache, gently at first, dry brush in some highlight areas and become more pronounced with each pass. We want the tail to shimmer, but not so much that it's the only thing we see. Lastly, go through the image and see what else looks unfinished. All done!

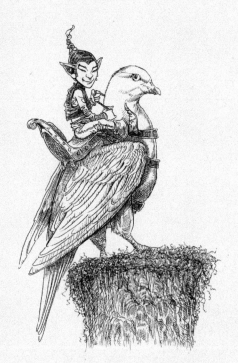

The original drawing.

Before you colour a piece of line art, it's always best to bear in mind the nature of your medium. Watercolour lends itself to many different techniques. However, if you want the paint to 'sing' its own song, and revel in the joy of being a watercolour, then it's best to keep the lines you plan to colour, as simple as possible. There is another option available to you, though—using them in an opaque manner.

In this example, we've taken the line art and exercised a few techniques in our quest to complete it.

Let's go through a bit of a rundown to see how well we managed it.

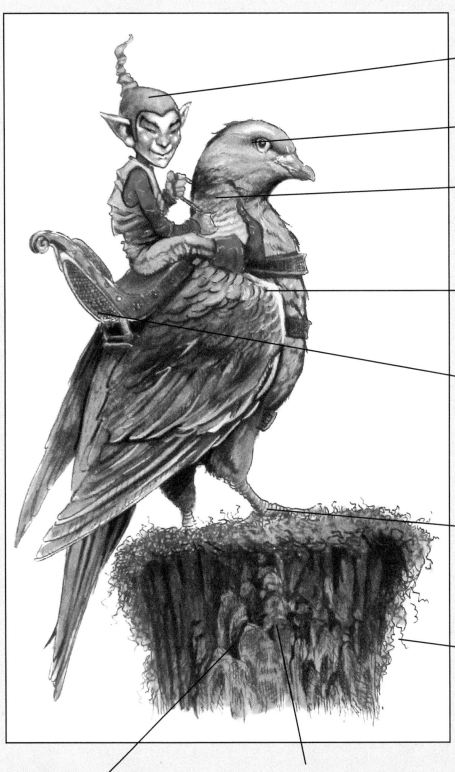

The bark texture is made by picking out the line art and strengthening it with bolder strokes.

The colours here have been applied using transparent watercolours laid into a neat wash of water, allowing them to spread and merge into one another.

Here, the darker green was employed first, then the light green was laid in over the top of it, (almost an oil painting technique). It's certainly a different approach to the usual transparent (dark-over-light) technique.

The highlight on the eye is a spot of opaque white gouache.

The feathers were achieved by mixing white gouache with some of the local (transparent) colour—a great way to add details.

Neat white gouache highlights, great for drawing the eye in, break up the darker areas nicely.

For the mesh on the back of the seat, we've left the line art as it is.

The pigeon's foot was painted with transparent yellow watercolour, allowing the under drawing to show through. Shadows were added afterwards (again) with transparent watercolour.

Mossy strands are made by allowing the line art to show through the watercolour.

Watercolour is a more versatile medium than you would think. It's not the first medium people would pick for opaque techniques, but it works beautifully.

I've tried painting solely with gouache and have found it to be far too dry and chalky for my liking. Mixing watercolour in a transparent *and* opaque manner allows you to achieve things you wouldn't otherwise have been able to, had you stuck to one technique or the other. Hopefully the example (left) illustrates that point.

It's always worth trying new mediums. They all have something about them the others don't have, but I've found watercolour to be more diverse and enjoyable than any of the mediums I've tried. There's something about the unpredictability of it, like taming a wild beast.

Learning the characteristics of watercolour is an incredible experience—and just when you think you've got it all down, there's more to learn. Enjoy the process; it never ends.

The best way to work with any medium is to visualize what you're trying to achieve with as much clarity as you can muster—then just experiment all you can. It will all fall into place eventually. Remember, 'rules' are meant to be broken, but it's a good idea to get some of those rules under your belt first.

VALKYRIE

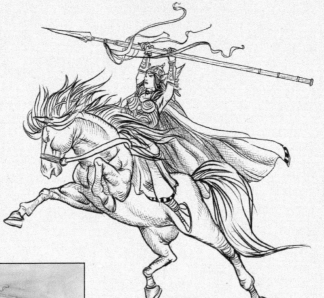

WHAT YOU'LL NEED:

Sheet of A4 300 Arches
watercolour paper
Pointed mop brush
Tissue paper
Size '6' round brush
Old, worn 3/8" filbert
brush

COLOURS USED:

Phthalo Blue
Payne's Grey
Cadmium Red
Yellow Ochre
Lemon Yellow
Burnt Sienna
White Gouache

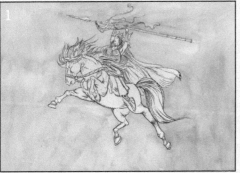

fig. 1 Once you're happy with the composition and you've transferred it onto your watercolour paper, lay down a wash of clear water and drop in some Phthalo Blue with your mop brush while it's still wet. Allow to dry and repeat the process. We don't want to achieve a nice flat graded wash here—any texture that comes through is to be encouraged.

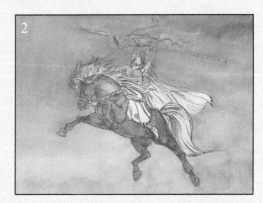

fig. 2 Spend some time loosely grading your sky wash from dark (top) to light (bottom) by adding more Phthalo Blue to a wash of clear water. For the horse, lay in a Phthalo blue underpainting using a size '6' round brush and add Burnt Sienna for the rest of its body.

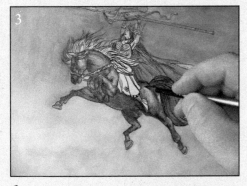

fig. 3 Now the fun begins! Model the horse's musculature using some Burnt Sienna, Yellow Ochre, and white goauche. Be subtle here; it's easy to take highlights too far. Drop in flat colours for the cape, (Cadmium Red and Lemon Yellow) at this point. We'll build them up as we move through the painting.

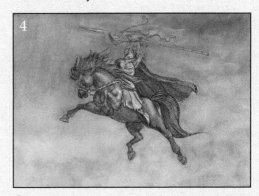

fig. 4 Allow the whole painting to dry. It's a good idea to sit and have a good look and see what needs working on—really LOOK—as flaws will make themselves known if you take the time.

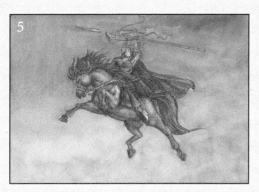

fig. 5 We're keeping an eye on 'realism' with this one, although we don't want to strip the painting of its line art quality. Go through and balance the colours out, adding warm colours to the cool areas and cool colours to the warm areas. Again, don't go crazy with the highlights.

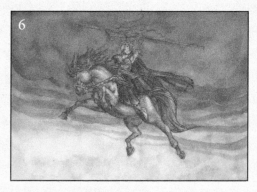

fig. 6 Carefully work around the figures by adding a wash of clear water to the sky using your pointed mop brush, (and a LOT of water). Then, while it's still wet, add a mix of Payne's Grey/Burnt Sienna; use the same mix to add those stylised streaks at the bottom.

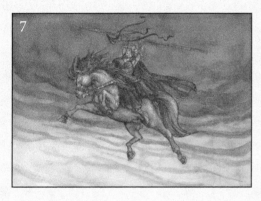

fig. 7 Go through the rest of the sky, adding even more streaks with more water and less pigment, fading them off as they near the bottom of the painting. Pay some attention to the ribbons on the spear—these flashes of red help to lead the eye into the painting. Overall, things now feel a lot more balanced.

We've gone through and toned down some of the darker areas and blended off some of the lighter areas. Remember, gouache is reactivated with water, so you can still work with it while it's dry if you need to.

fig. 8 Finishing up... Go through and finish off the figure with your detail brush. First, brush in some Cadmium Red and Yellow Ochre for the skin tones. (We can mute this, as we go, with white gouache).

For the armour and the wrist bands, use some Yellow Ochre, dropping in some Burnt Sienna into the darker areas (realism really is about the play of light and shadow). Add some Burnt Sienna to the spear handle and for the spear head, using white gouache. As I've mentioned before, the last part of the painting often takes the longest and is sometimes the hardest.

For the clouds in the fore-ground, lay down a wash of clear water, then drop in some white gouache with an old, worn 3/8" filbert brush (it will disperse, but that's okay, as we want soft edges). Allow it to dry and work in some more gouache. I'd recommend using a circular motion in certain areas for a more 'rounded' look. Build this up until it looks natural; allow the horse's legs to show through by not using the paint in too opaque a manner. Go through the painting again—if you see anything else that needs touching up, do it! (that white dot on the helmet, for example)

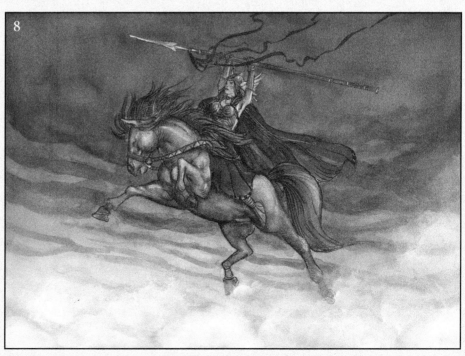

PAINTING ROCKS IN WATERCOLOUR

For this demonstration, we'll be focusing our attention on the rendering of rocks. I used to have a great deal of trouble with this in the past, but as soon as I discovered the secret to simplifying things, it became far easier.

fig. 1 Once your drawing has been selected, transfer it to your watercolour paper, taking care not to leave grooves in the surface. Keep the lines simple and uncluttered.

fig. 2 With your mop brush, put down a wash of clear water. While it's still wet, drop in some Phthalo Blue, Burnt Sienna and Yellow Ochre, keeping the strokes directional, following the rock formations.

fig. 3 Once the wash has dried, it's time to begin adding details. Mix up some Payne's Grey and Phthalo Blue and with your size '6' round wash brush, work your way through the rocks, keeping your strokes broad and loose for now. Drop in some random Burnt Sienna and Yellow Ochre into wet areas, to achieve that 'rocky' look.

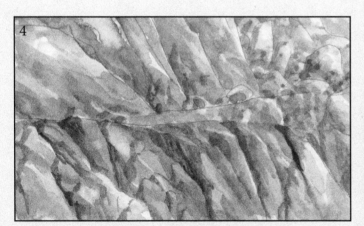

fig. 4 Work out the cracks in the rock now with a size '4' rigger brush, using a darker mix of Payne's Grey and Phthalo Blue. This is where things become interesting—and fun (if you're a patient person, that is). This process requires a fair amount of intuition. If you need reference while you work (as I often do), it's a good idea to open up some rock/mountainside photos from your collections or your Internet browser. It can often help immensely, although it's worth bearing in mind that you should avoid copying the photographs too closely— we're looking for the 'spirit' of the rocks you're looking at here. If it's your intention to copy a photograph to achieve a photorealistic style, then that's all well and good, but we're 'creating' this image and we only need a vague likeness of rock to pull this painting off. That said, pay attention to what you're doing and strive for balance—don't overwhelm the eye.

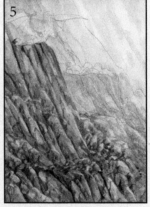

fig. 5 So, having spent a while chipping away at the rock face, we've reached a point where it's starting to look as it should. Vary your Payne's Grey/ Phthalo Blue darks as you go; this will help to create a natural rocky look. Keep the lines from looking too 'hard-edged' by adding some water to them before they dry—this will help the paint disperse.

WHAT YOU'LL NEED

A4 Arches 300 gsm hot press watercolour paper

Mop brush (approx size '4'-'6')

Size '6' watercolour brush

Size '4' Rigger brush (or round detail brush equivalent)

Tissue paper

COLOURS USED

Phthalo Blue, Burnt Sienna, Yellow Ochre, Payne's Grey, Violet, Cadmium Yellow, Cadmium Orange, White Gouache

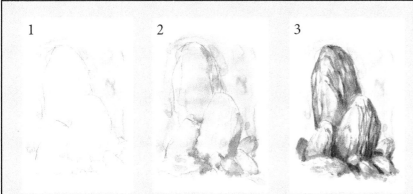

1 2 3

fig. 1 Having worked out the placement of your rocks, paint around them to cement their shape.

fig. 2 With the background colour, make an underpainting, laying in the shadowed areas. Add a wash of flat colour (streaky lines and uneven strokes are to be encouraged—these will add texture).

fig. 3 Details come last. Work your way around the image adding the cracks and creases, always bearing the light source in mind. In this example, the light source comes from the left; the shadows fall to the right.

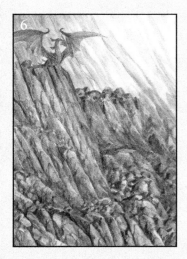
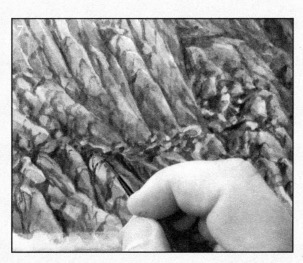
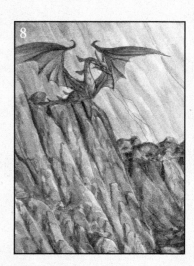

fig. 6 Work around the image now, varying the colours but working in very much the same manner. The rock formation (to the right) has much more Yellow Ochre and Burnt Sienna in the mix; this helps to break up the whole image, as using the same mix throughout would have been monotonous. For the dragon on the rocks, lay in some Violet for the wings and Cadmium Yellow and Cadmium Orange for the chest and the underside of the wings.

fig. 7 Here's a close up of the detail work that goes into rendering rocks. Note the way the light falls to the right and the way the shadows fall off to the left. This should be kept in mind all the way through the whole painting process.

fig. 8 Add more details to the dragon, without going too over-the-top with the colours. We want to know it's there, but not at the expense of overpowering the whole image, as it's only a small part of the painting. Mute the colours by adding them, then blotting them back with a tissue. This is very much a process of adding and taking away, adding and taking away. The highlights are carefully placed with white gouache. Again, take care not to go too far with it. Go around the rest of the painting and pick out areas that could benefit from having some light areas. Remember, here the light falls from the right.

fig. 9 This is where we begin to go around the rest of the painting and make any necessary adjustments, tighten any loose areas and balance everything out. Darken the area behind the dragon with a wash of Payne's Grey/Phthalo Blue, add more shadow and light around the rocks and pick an area or two that could help the viewer's eye move up from the bottom of the painting to the dragon (see lines at right).

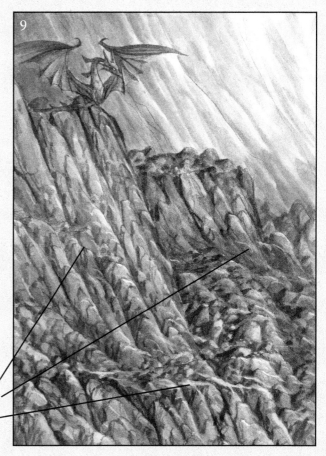

133

LINE AND WASH—'THE TROLL'

For this example, we're going to handle the 'Line and Wash' technique in a slightly different manner. That is to say, we'll be adding the pen marks at the *end* of the process, instead of at the beginning. The advantages of working this way aren't really all that pronounced—it's quite simply another way of working. The ink lines here will serve to strengthen the foreground elements. (But please bear in mind, this could also have been achieved by planning this in advance.) The painting process is really quite the same as any other watercolour process you may have seen in this book, so we'll skip through certain sections a little quicker than usual.

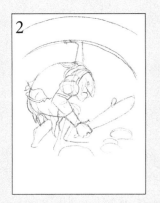

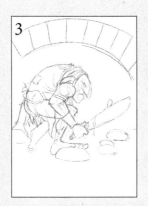

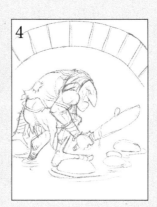

figs. 2-5 The working drawing in progress.

fig. 6 With a size 2 round brush, lay in a wash of Yellow Ochre.

fig. 7 With the same brush, lay in the skin tones and clothing colours. As we're working transparently, create the creases by working around them with darker washes of the same colour. For his skin, lay in a green wash, then use the same colour with more paint to create his musculature. A touch of Cadmiun Red to his nose will give him that 'worn' look.

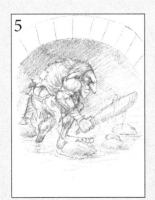

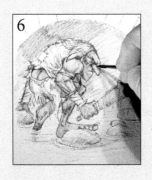

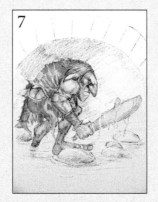

figs. 8-9 Lay in a wash of Ultramarine and Ochre into a flat wash of pure water for the bridge, a wash of Phthalo Blue for the water. Remember, always keep your washes loose when painting water. For the shadowy area under the bridge, make up a mix of Payne's Grey, Burnt Sienna and Phthalo Blue and lay it in using a couple of washes, allowing each to dry.

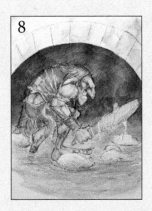

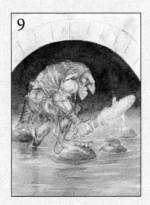

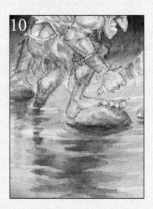

fig. 10 For the reflections in the water, lay in some clear water and create patterns using the colours from the figure above, mixed with the colours we used for the shadows beneath the bridge. This brings the whole image together nicely.

MATERIALS USED:

1 sheet 300 gsm Arches
hot press watercolour paper
Tissue paper
Size '2' round brush
Size '6' round brush
.1 drawing pen

COLOURS USED:

Ultramarine Blue
Burnt Sienna
Phthalo Blue
Leaf Green
Yellow Ochre
Payne's Grey

fig. 11 Having laid in a wash of clear water over the bridge area, drop in some more Yellow Ochre and Phthalo Blue. As it's drying, pull out some paint using a dry piece of tissue paper—this will create a lovely stone texture.

fig. 12 Time to work our way around the whole painting now. Picking up things we've missed, strengthening colours, tightening up loose areas such as the water, clothing, etc.

fig. 13 Moving back into the Troll's face. The fact that his skin is green is all well and good, but blood still moves around beneath it. Adding some red gives the impression that he's recently been active or is about to be (echoed by his body language and his gaze).

It's also necessary for some warm colours to be added to balance out the green skin tones. The warm colours in this painting draw the eyes in and hold them there.

EEEURGH!

A mix of Phthalo Blue and Sepia for the hair will finish the head off nicely.

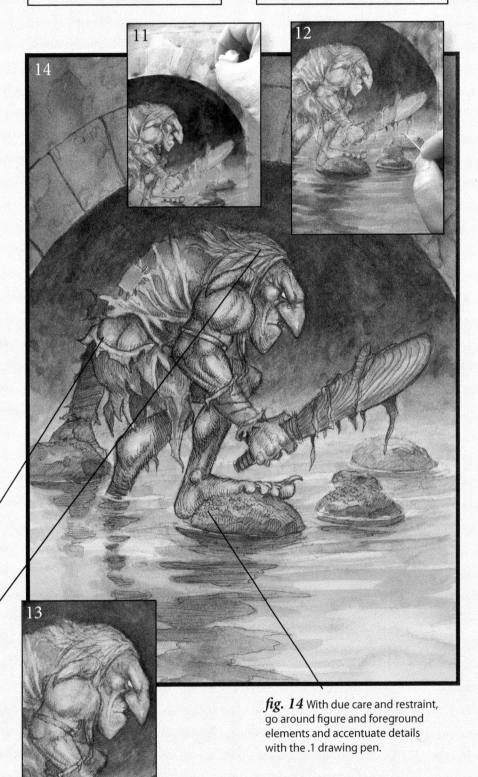

fig. 14 With due care and restraint, go around figure and foreground elements and accentuate details with the .1 drawing pen.

THE CAULDRON

With this demo, we're going to take a faster, looser approach. Shake up those arms and wrists, let's splash some paint around.

This one started out its life in another form and I wanted to repaint it, so it was important for me to make sure all composition flaws were ironed out at the sketch stage (see fig. 1 at left).

fig. 1 The working drawing. Notice how loose it is, and how underworked it is tonally? This is because the paint will do most of the work. Having too much of an underdrawing (especially when using watercolour) can cause your art to become muddy and messy. Avoid that by putting in only what you need to make the painting work.

fig. 2 Having prepared your paper, wet it completely again with your mop brush and lay in flat washes of colour into the water. Don't overwork them, though—just lay in the base colours at this point. The beauty of watercolour is that you build the colours up gradually. Remember, you can speed up the drying process with a hairdryer. Keep the colours pure and allow them to blend into each other without drying with hard edges. Once the first wash is dry, lay in another (gradual) tonal wash.

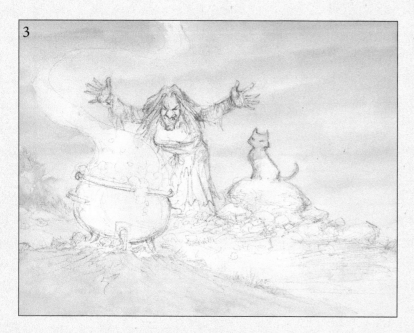

fig. 3 Having allowed the rest of the painting to dry, move back into the sky area. It's okay at this point (as our flat wash has already been prepared) to hint at streaks across the sky—nothing too hard edged, though.

WHAT YOU'LL NEED
Sheet of A4 Arches hot press paper
Mop brush
Size '6' round brush
Size '0' round detail brush
Tissue paper

COLOURS USED
Cerulean Blue, Leaf Green, Lemon Yellow,
Payne's Grey, Burnt Sienna, Cadmium Red,
Yellow Ochre, Cadmium Yellow, White Gouache

fig. 4 With your mop brush, lay in a wash of pure water and while it's wet, drop in a mix of Payne's Grey and Phthalo Blue. Don't be too concerned about the way it dries; however, try and avoid very hard edges. Before it dries, blot the bottom with your tissue paper to blend it off into the lighter colour below. It's worth pointing out that we aren't too concerned about painting over or 'through' other elements of the painting. The reason for this is because we'll be rendering some of it in an opaque manner.

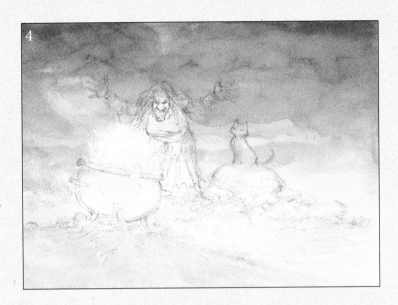

figs. 5 & 6 Now that we've established our base colours, we'll get to work on the underpainting. For this you'll need to mix up some Payne's Grey with Burnt Sienna (to create a nice neutral dark colour). Go around the whole image using the same colour. For the rocks, notice how we haven't painted the whole thing—just the right hand side, where the shadows fall. It's probably a good idea to pay particular attention to the light and shade of the painting from this point on.

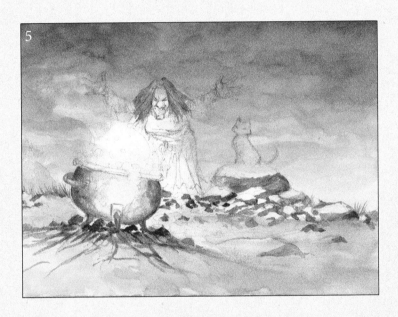

Make sure the underpainting isn't too heavily rendered. We're just looking for enough to show through the transparent colours we'll be painting on top. If you make the underpainting too dark, the rest of the painting will have to follow suit, or at the very least it will be difficult to tone back down. Gently does it. This is watercolour we're using here. Be careful not to overwork the bubbles in the cauldron—keep them simple for the moment.

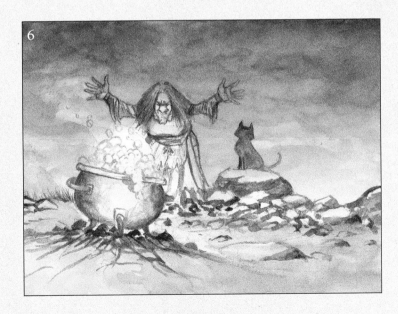

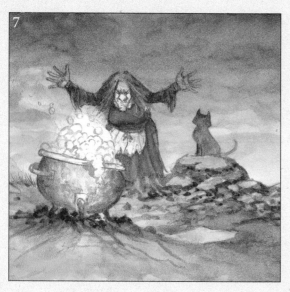

fig. 7 Pay a little more attention to the colours within the painting now. Still working transparently, with your size '6' round brush, lay down some Lemon Yellow and Leaf Green washes into the ground and the rocks. It's OK to lay some water down first if you'd like your colours to blend into one another. Blotting as you go with some tissue paper can create some great textural effects, although it's best to try this on a separate sheet first.

For the witch's dress, lay down a flat wash of Cadmium Red and Phthalo Blue at the bottom. Give the cat a flat wash of your 'underpainting' mix. With your size '6' round brush, drop some Yellow Ochre and Phthalo Blue alongside each other into some clear water for the metallic texture of the cauldron.

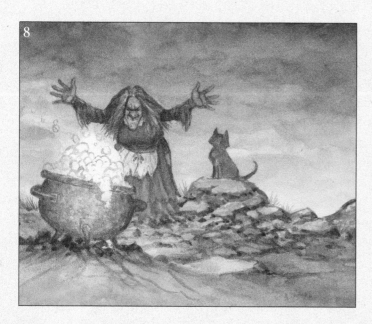

fig. 8 Focus on the Witch again here. With some Cadmium Red and your size '0' detail brush, paint in her nose and her cheeks to give her a nice warm glow, working around the red with the Leaf Green. There! Doesn't she look lovely?

Use the same colour for her hands. Lay in a flat wash of Cadmium Yellow for her tattered apron. With some Burnt Sienna, work around the rest of the cauldron to give it that 'worn' copper look we're after.

fig. 9 Before we do too much more, it's best to stop and assess how things are going. The flat washes are all looking okay, the shadows have been given enough attention, but the background needs some more detail. Now we'll begin to add some foliage and grass to wake the painting up a little. With your size '0' round detail brush, lay in some grass and some leaves, always thinking about how the light will affect them.

Paint in the cat's eyes with some white gouache. Then begin to render the bubbles in a little more detail. For the wispy smoke, first lay in the shape you're after with some clear water and then work some diluted white gouache into it, building it up with more opaque gouache nearest the cauldron, tapering it off at the top of the painting. Mix some Phthalo Blue and white gouache together to create the light blue for the randomly painted rocks in the background.

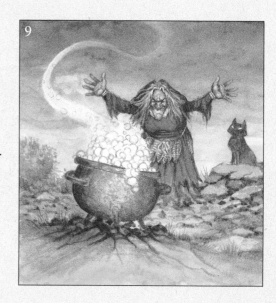

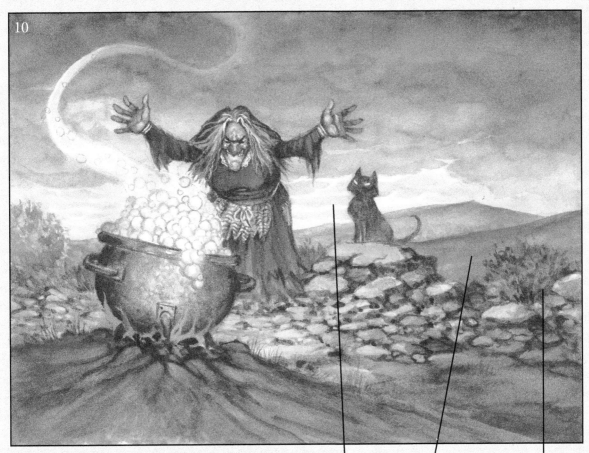

fig. 10 To finish, it's important we take the time to balance everything tonally, adding shadows and highlights, making sure that no particular area of the painting draws too much attention to itself (unless that's our intention). Begin with the bubbles in the cauldron—tone them down a little (where appropriate) by laying some Payne's Grey into the shadowed areas with your size '6' round brush.

You'll notice the addition of the mountains and foliage in the background. Sometimes these last-minute ideas can transform a painting. Looking back at the earlier steps, it's easy to see that this was necessary.

Adding the streaks in the sky with white gouache also wakes up the sky nicely. Add a wash of Pthalo Blue/Payne's Grey to the foreground beneath the cauldron to allow our eyes to focus upon the middle ground.

I'd go so far as to say that the last 5% of the time spent on the painting is often the most crucial part of the whole process.

The painting was lacking 'balance', so as an after-thought, I painted in the mountains, which resulted in a much more satisfying composition. The slope of the mountains also leads our eyes downwards into the centre of interest.

White gouache has been used here to add a few touches of clouds in the sky, breaking up the faded blue nicely.

I also felt the painting needed something to break up the foreground and the background. The bushes worked a treat!

THE BANNER

Sometimes an image comes so clearly and easily it's hard to shake it off. This one came just as I was finishing up this book. I didn't need another painting and with deadlines looming, I certainly didn't need more work—but it insisted on being painted. I would have loved to spend more time on it, but am happy to have photo-documented a few steps to show how I managed to paint it. All totaled, this is the product of approximately four hours' work from beginning to end—such is the nature of watercolour!

The trick to remember with landscapes such as this is to always have 'depth of field' in your mind. The distance between the background and the foreground should be properly represented. An easy way to do this is to use less detail for the background and more for the foreground. See how the mountains in the rear are just variations of one colour—and how more and more colour creeps into the mountains as they appear closer? It's also a good idea to add more light/dark contrast in the foreground for effect.

The real 'star' of this composition—for me at least— is the flag. That passage of red (red being the most dominant colour of all) really draws the eye in and holds it there; this also helps to separate the dimensions.

All in all, I'm quite happy with this one.

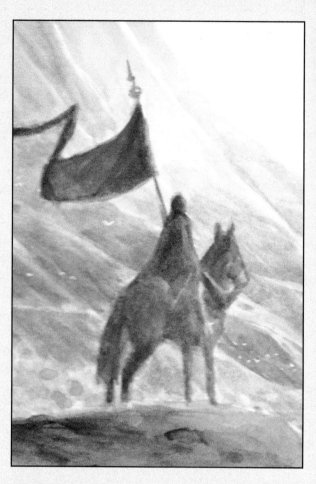

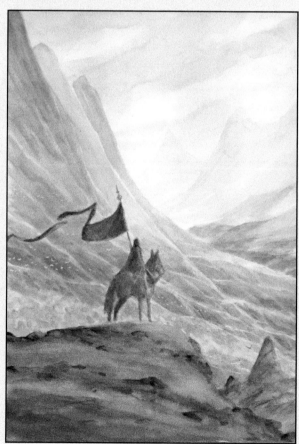

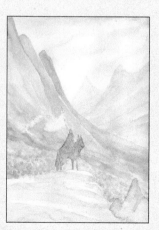

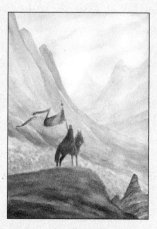

140

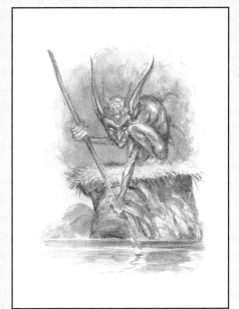

DESIGNING CHARACTERS

Due to its easy and immediate nature, watercolour particularly lends itself to quick sketches and it's perfect for conceptualising characters.

As I've mentioned elsewhere in the book, there are so many different approaches one can take, different levels of finish that can be achieved with watercolours. (The examples on this page alone should give you some idea.)

How easy is it to scribble up a quick sketch and throw some watercolour over the top? This guy (right) took approximately 15 minutes to colour up from a sketch—and that includes drying time. (He's also my favourite character on the whole page).

So next time you reach for your computer—or your colouring pencils— to colour up your character drawings, why not consider using watercolours instead?

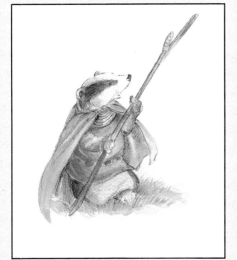

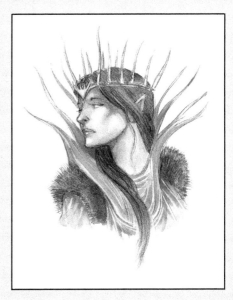

FROM ONE ARTIST TO ANOTHER...

GREEN MAN PRESS

AARON

THANK YOU FOR YOUR HEARTFELT
LETTER. I CAN REMEMBER THOSE YEARS OF AFTER
COMPLETING COLLEGE AND THE DESPERATION OF TRYING
TO MAKE A LIVING AT MY WORK. SELLING ETCHING ON
THE STREET, ACCEPTING ANY COMMISION THAT CAME
MY WAY. NOT EATING MUCH DURING THE OFTEN TIMES
SLOW PERIODS. DONT LOSS YOUR BELIEF IN YOUR
SELF AND YOUR VISION. YOU WILL ALWAYS BE
HAPPIER MENTALLY IF WHAT IS ON THE DRAWING
BOARD IN FRONT OF YOU IS WHAT YOU 'SEE' AND WANT
TO MAKE REAL ON THE PAGE. HOWEVER ACCEPT ANYTHING
THAT COMES YOUR WAY, YOU MUST EAT AND PAY THE
RENT. TRY TO BALANCE ART AND REALITY. ITS TUFF
BUT NECESSARY. I LEARNED MOST OF THE PRACTICAL
SIDE OF BUSINESS FROM FELLOW ARTISTS THAT HAD
BEEN AT 'IT' A LOT LONGER THAN I HAD. ASK AS
MANY QUESTIONS AS POSSIBLE (WITHOUT BEING OBNOXIOUS,
ALWAYS, ALWAYS TRY TO SEE AS MUCH ART AS YOU POSSIBLY
CAN. LONDON IS AN INCREDIABLE RESOURCE. THE V+A
PRINT ROOM HAS THOUSAND OF PIECES OF ART FROM THE
TURN OF THE CENTURY ILLUSTRATIONS. GO AND LOOK AT
THEM. I HOPE THE ENCLOSURES WILL HELP YOU ALONG
YOUR PATH
 ENJOY - Chris
 P.S. GREAT CASTLE BY THE WAY.

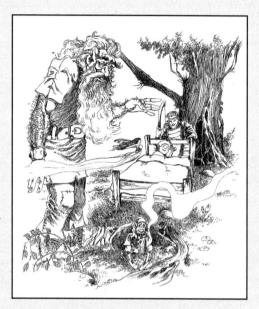

Here's the kind of thing I was creating back in 1996-97, very much under the influence of my favourite artist (above). Thankfully all of my influences have been absorbed well into my psyche and I'm now happy just being me. Most artists I've ever known started the same way, emulating their idols.

I'll wager my story isn't too different from yours...

I was born into a working class family in the South of England, was very shy and took to drawing pictures to bridge the huge gap between myself and my fellow human beings. As time passed, I became quite good at it. Then I discovered girls, joined a rock band, enjoyed playing live for quite a few years, and my art sort of took a back seat—until I befriended a very famous and well-respected illustrator who put me back on the path again. As this guy turned me on to a whole heap of great artists, my world was expanding (along with my ambitions). One of the artists he told me I needed to know was Charles Vess (a nice guy and artistic genius). I wrote Charles a very long letter telling him that I was determined to 'make it' (or words to that effect). I'm sure he received countless variations of that letter throughout his incredible career. I included a rather crudely drawn ink drawing of a castle (pretty much the best I was capable of doing at the time, I'm sure). Anyway, to cut a very long story short, while living in our little cottage in North Wales, in the middle of winter in 1996, I received a package from the postman. That package contained this letter, four of Charles' new publications, some pages he'd ripped from a book, and a whole heap of photocopies containing the work of artists he admired. My path was set. This letter indeed changed my life, and I've since told him so.

From then on, I've spent almost every spare moment focusing on my art and have, over time, tried my very best to help those people who could benefit from any assistance I'm capable of offering. What's that saying? Pay it forward? In short, I've made it my mission in life to make the world as creative a place as I can. My music is still inside me and I play as often as time allows. Creativity, to me, is as important as the air I breathe. More people could benefit from being creative, in my opinion. Creativity, in one form or another, is available to everyone. An artist is not born an artist—those skills must be developed. It doesn't matter if you come to it as a child, or find it in your 50s; it's there waiting patiently for each and every person.

So, if you're holding this book in your hands, and it belongs to you, there's a very good chance that you've been influenced by somebody or something, whether it be a successful artist or a painting you saw once at a gallery. At some point, a light flicked on inside you and you said (whether you remember it or not) 'I want to do that!' I remember being asked as a child what I wanted to 'be' when I grew up (I'm still waiting for THAT bit, the 'growing up' thing—which I hear is over-rated anyway). I replied, 'I want to be an artist.' I made that vow there and then and have followed through. Herein lies the lesson. Listening? Here goes, I'm only going to say this once. You can be anything you choose to be. However, decisions must be backed up by action. The amount of action required comes down to the effort you put in; effort usually goes hand in hand with time and with time comes maturity, peaks and plateaus. It's all forward moving—you can't possibly fail. It's simply impossible to get worse at what you do, and if you back it all up with sheer LOVE for what you're doing, you're simply guaranteed to succeed. 'Universal Law' in action, see?

If you've chosen to follow the artist's path, be prepared for a wild, exciting, emotionally-fueled ride into the unknown. Or simply set yourself a goal and stick to it unwaveringly, rigidly refusing to budge. Or open up to inspiration or 'the happy accident'. Me, I'd say go for the former, but the choice is yours. Each path leads you to where you need to be.

Here are a few things I've personally learned along the way (feel free to add any I've missed)...

AIM HIGH
Easy, really. Aiming for the stars and reaching the clouds shows progress.

PLATEAUS
The Universe has a funny way sometimes of making you wait, I mean, *REALLY* wait until the lessons have sunk waaay down deep before it lets you have that 'AHA!' moment, you know, the one where you just 'get' it. I call these moments 'plateaus'. It feels like you're climbing and climbing, but you can't see the top of the mountain. You know it's there, so you continue to climb, regardless. The Universe, in all its wisdom, gives you a plateau to break up your journey. A small success for your efforts—it keeps you going.

DEDICATION
There's no shortcut. Not one. Someone else can do your homework for you, but then you miss the lessons you need to learn.

WANTING IT
How badly do you 'want' it? Do you really want it? I've heard it said, a million different ways from a million different people, 'I wish I could draw. I can only draw stick figures'. You've heard that too, right? People also complain about the 'lack of time'. Here's the thing: when I began learning to play

the guitar, I picked it up for a couple of hours before I started school. When I finished school, I ran home, often literally, to play my guitar for hour upon hour. I did the same thing when I was learning to draw, or paint. I still draw and paint for up to 8-10 hours a day, every day. I have a wife and children also, and I think I do pretty well, considering. I also know many people in a similar situation who do what I do and still manage. Love WILL find a way. Ever hear the saying 'Time stands still'? Well it's true. And it's also true that you can 'make time'. Do yourself a favour and every time that little voice tells you why you can't do something, tell it to be quiet. Keep asking yourself, how badly do you want it.

TRY DIFFERENT MEDIUMS

You might find yourself at a point in your development when you feel the need for a change, or you feel as though you aren't progressing as quickly as you would like. There's a chance that you've hit a brick wall with the medium you're currently using. Trying something new not only backs up your artistic arsenal, it can also offer you ways to implement new skills with the medium you're used to using. For example, I learned glazing techniques by using transparent acrylic paints (as acrylic was my main medium for many years). I've since transferred this technique over to my watercolour painting process. See how one can aid the other? Glazing may well have been that very thing you were missing all along. Stay open, try new things—your artistic life can only benefit from it. I was well into my thirties before I gave watercolours a go.

PAINT FROM NATURE AS OFTEN AS YOU CAN

There are many reasons for this, not the least of which is that you can add more realism to your art; this in turn will make your work far more convincing. Studying nature will help your fantasy artwork no end. Trust me on this (see pages 116–117 and 123 for my own efforts).

A WORD OR TWO ABOUT 'INSPIRATION'

Inspiration: 'sudden creativity in artistic production'—Wikipedia

To be inspired, you have to be 'open'. Staying open can lead you to all kinds of wonderful insights. To have insight is an invaluable asset. You can apply these insights in many ways, for example, a surrealist or a symbolist might have a wonderful grasp of dreams, or symbols and concepts not available to the average person. When said insights are applied to artwork, the work then begins to take on a meaning of a more profound nature. Keeping an open mind allows subtlety to creep into your work, (often unbeknownst to you) and it will always give your work depth, and add layers. Inspiration can come from anywhere—from the sunset you're looking at to a smile from a child. From a piece of artwork you admire to a dream you once had—and all points within and without.

Keep your mind open.

TWO WORDS TO DESCRIBE 'AN ARTIST'S BLOCK'

Sheer nonsense.

Okay, I'll elaborate. 'Artists' blocks' are a figment of the imagination of those whiny, beret-wearing, wine-drinking, wannabe-arty farty types. All talking and no doing. If there's something preventing you from working on your art, it's a safe bet that there's something going on in your life that needs looking at. Give it a name, and you make it a 'thing'. Make it a thing and—like Victor von Frankenstein—you give it life. Bad move. Look at the problems he had!

What to do...

If there's something you're working on, and doubt has crept in, leave it for a while. Go away and sketch. Play golf. Wash the car. If that doesn't work and the problem has deeper roots, take a few days off. Or simply sketch. You're an artist, remember? If this is the case, I recommend stepping away from the serious stuff (that huge canvas you're actually earning good money for) and keeping things lighthearted. Idly 'sketch' for a while instead. Sketching will open up your mind, take your mind off the problem, and allow the 'issue' to gently float to the top of your head and out of your ears, back into the ether where it came from—and where it belongs.

WHAT NEXT?

Now we'll look at what steps you can take to being more pro-active with your artwork.

Okay. So you have artwork everywhere. It's your life. Your room is covered with it; your drawers are stuffed full of drawings and paintings. What do you do with it all? I'd like to offer a few suggestions, if I may.

First, pick out your best work. Make a pile. Put the rest to one side or in storage. It served its purpose; it helped you to get to where you are now—with your best work in front of you.

Next, separate it into genres—you know, children's illustration, Fantasy, Science Fiction, etc. Put them all into relevant piles. Weed out the ones that don't look 'quite good enough'. Trust me, if you're honest, there will be a few.

Once you've separated your piles, have a good look at them and see which one sings to you the most. Do you like the children's book illustrations you've worked on the most? The comic art? The Fantasy art? Okay, I'm going to go with the final option (as this is a book about Fantasy Art).

So, in your mind, you've just chosen your route: you've decided to become a fantasy artist. Put all that other wonderful art away—you won't be needing it, unless you backtrack and decide to take another route.

Now, sit down and decide what it is that you hope to achieve with your art. To make money? To become a book cover artist? To produce large canvases for sale at conventions and to create prints of your work? The list is as endless as your imagination and I urge you to make a decison and stick with it—for a while at least. A lack of direction usually leads to a lack of results, and let's face it, we want results. So, you've chosen to be a book cover artist? Great. How's that portfolio looking?

You have some great artwork there—that's for sure. Those pencil drawings of muscle-bound men and nubile women, wow! Perfect. What's that? You want to paint light fantasy covers for the teen market? Okay. Out with those then. It's time to work on some new stuff. Here's what I'd suggest...

Have a look at the kind of work currently being produced in your target market. Is it rendered in a 'painterly' manner? Is the current look 'slick' and tightly rendered? Can you produce this kind of work comfortably? If yes, go ahead and work on maybe ten different samples that will show an art director that you, too, have what it takes. How to get the samples to an art director? Read on...

a) **Go to conventions**, have a chat and personally hand copies of your work over, along with a business card and contact details. You might just get a call. Make sure the copies present your work in its best light.

b) **Send sample packs**. I've received many commissions this way. Always mark it for the attention of the Art Director (it's even better if you add the name).

c) **Send email samples,** if the company accepts submissions this way.

d) **Build a website and create a blog**. Art directors are always on the lookout for new talent. You never know... I picked up a great gig designing a set of six fantasy stamps for my country because I was fortunate enough to have had my work seen on my blog.

e) **Network**. Join social media pages such as Twitter and Facebook to get your work seen. I can't stress this enough. It's very important to have the right people on your side. Even if you aren't quite ready, people love to see progress. You never know when they'll be in touch. Build a fan base, accept criticism and keep an eye on the progress of other artists.

From one artist to another... I wish you the very best of luck!

LINKS

Brushes by David Jackson (The Brushman)
thebrushman@hotmail.co.uk

MODELS

Janna Prosvirina
kuoma-stock.deviantart.com

Alexandra Bibby
sitara-leotastock.deviantart.com

Ida Mary Walker Larsen
mizzd-stock.deviantart.com

Lindsey Hooten
http://lindensidhe.etsy.com

Elandria
elandria.deviantart.com

Freyia Norling
http://www.freyia.co.uk

More of Aaron's work can be found here:

aaronpocock.wordpress.com

https://www.facebook.com/aaron.pocock.9